THREADS

Clothes and the Irishman – A Woven History

PAUL GALVIN

Gill Books

Gill Books
Hume Avenue
Park West
Dublin 12
www.gillbooks.ie

Gill Books is an imprint of M.H. Gill and Co.

9780717192823

Designed by Bartek Janczak
Printed by CPI Group (UK) Ltd, Croydon, CR0 4YY
This book is typeset in 11.5 on 16.5pt, Adobe Garamond Pro

The paper used in this book comes from the wood pulp of
sustainably managed forests.

A CIP catalogue record for this book is available from the British
Library.

5 4 3 2 1

To my late mother, Kathleen.
To my wife, Louise, and our daughters, Esme and Elin.
To Margaret Heffernan.
To all the women who make men.

Contents

Contents

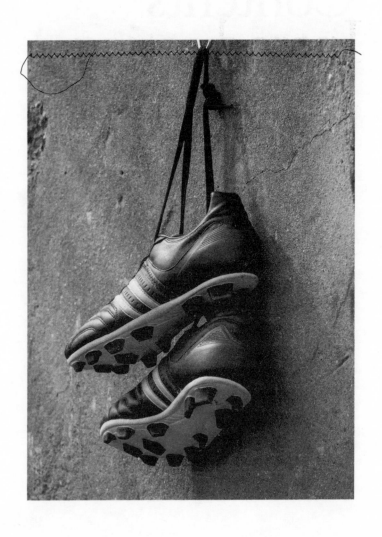

Introduction

The GAA groundsman –
designer and geometrician

The GAA pitch, fully lined and cut, is an exercise in design. Geometric, perfectly proportioned, easily-read and understood, pitches are made to measure – like a tailored suit. Lined with chalk at precise intervals around the parallelograms – or the big square and the small square, as GAA geometricians like to say – the D, the sidelines, the playing lines at 13, 21, 45 and 65 metres, the dash at midfield and the end-lines. There are shapes, proportions, angles, distances, volumes, letters, numbers and graphic design at play. There are 15 rectangles to be found between the lines of a pitch. The first 10 letters of the alphabet, A to J, can be spelt out by the lines on a GAA pitch. Of the remaining letters, L, O, P, Q, R, S, T, U and V can also be spelt out by the lines, as can the whole numbers 0 to 9. The groundskeepers at every GAA club around the country are designers and teachers of sorts. Either way, there is a lot of reading to be done between the lines of any GAA pitch. There's art, maths and English on the grass. Our understanding of Gaelic games lies on, along, over and in between these lines.

All the GAA groundskeepers I know are cut from a different cloth. They are tuned to a different frequency. They tend to be flinty and smart, and enjoy a close relationship with nature. Vince Linnane was the groundsman at Austin Stack Park in Tralee for 28 years. Vince was friendly with an uncle of mine. He came from Mayo but was married

to Kerry; not only to his wife, who was from Ballyduff, but also to the grass, soil and divots of Kerry. Vince was the groundsman and the kit man so he knew a lot about important things like the pitch and the jersey. Groundskeepers like those at the major GAA grounds in Ireland were discussing sustainability long before most people. They cared for and protected the grass, the soil, the worms and the birds. Every time they ran a gang of young fellas off a playing pitch with a roar, a clenched fist, a veiled threat or by driving a tractor lawnmower in their direction at top speed, they were practising early sustainability. I consider them designers too. They understand sward, colour and dimension, lining the pitch according to standard guidelines, and placing brand logos, club crests and numbers where they must. They measure grass length and match sward colours, creating a visual display for spectators while facilitating the playing of the game. If this doesn't demonstrate an intrinsic link between design and sport, what does?

Groundskeepers at more high-profile stadia around the world are highly educated. They are scientists – multi-disciplinary experts in biology, horticulture, climate, nature and design. They shape and cut the grass in patterns, create landscapes, and ensure balance, proportion and perfect geometry or trigonometry. They are geographers and environmentalists. To the groundskeeper, grass is more important than any player or match. Stuart Wilson, head groundskeeper at Croke Park, previously worked at Arsenal's

state-of-the-art Emirates Stadium and the Aviva Stadium. As part of his daily responsibilities at Croke Park, Stuart must consider air and soil temperatures, photosynthesis, moisture and salinity, across a playing pitch 145 metres long and 88 metres wide. In conjunction with Dublin City University and experts from STRI (Sports Turf Research Institute), the Croke Park pitch is regularly tested for firmness, torque and traction. To determine grass length, balls are dropped from 2 metres to test rebounding. A studded metal 30 kg plate is dropped onto the pitch to replicate what STRI deems to be the downward force exerted by a player as they sprint. The Longchamp penetrometer, used to gauge the 'going' at race tracks, is also used on the Croke Park pitch. Groundskeeping today requires knowledge of the natural environment, climate, science, technology and design in one.

The 'going' on a GAA pitch – that is, grass length, sod firmness, traction and absorbency – and the measurement of the pitch lines are of particular importance to free-kick takers in Gaelic football. A free-kick taker reads the lines of the field, measures distances and judges angles and arcs every time they place a ball for a free-kick. Each free-kick is made to measure, tailored specifically to the requirements of the situation. The pre-kick routine is an exercise in design in a way. The kick is pre-designed and measured in the mind. If the mental design and measurements are correct, the free will be successful. Like in the tailoring of a suit, leg length plays a key role as the free-taker custom-makes the kick. So does stud length. Football boots have

The art of groundskeeping

a standard stud length, and the grass is usually a similar standard length; if there is an art to free-taking, it may be fixed to the player's ability to brush the grass with the stud at just the right depth. If the standing foot is planted here, the kicking foot should fall on the ball there, meeting the underside at an angle, brushing the grass and sending the ball on a certain trajectory, curling to a precise arc, travelling the correct distance and falling between the goalposts.

Dublin's Dean Rock is the preeminent free-taker in the game today. Dean's father, Barney, also took frees for Dublin in the 1980s. Barney's grandfather, William Rock, served as a groundskeeper in Croke Park across the 1950s and 1960s. William was also in charge of the Croke Park match balls on game day. Dean and Barney Rock's forefather handled the match-day footballs and measured and laid the pitch lines that years later Dean and Barney themselves measured as free-kick takers.

After 31 seconds of the 1962 All-Ireland football final between Kerry and Roscommon, Kerry's Garry McMahon from Listowel scored the fastest-ever goal in an All-Ireland final. As the ball went in, the camera cut to a man in the crowd wearing a top hat, white penny collar shirt, perfectly tied black tie and black overcoat. He was dressed like a tailor or a landlord – and was both in a way. He was William Rock. This record stood until the 2020 final, when a goal was scored after 13 seconds. The scorer this time was Dean Rock.

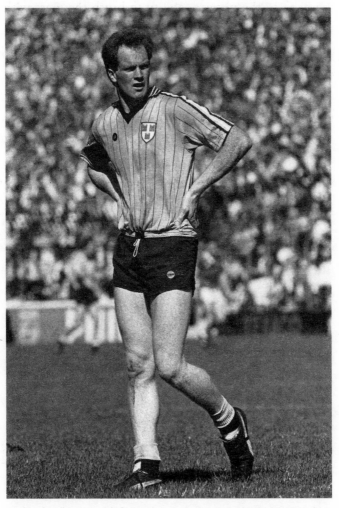

Barney Rock at the 1985 All-Ireland semi-final

Garry McMahon was the son of Listowel playwright, Bryan MacMahon, an esteemed teacher, a principal, poet, novelist and bookshop owner. Along with John B. Keane, Bryan founded Listowel Writers' Week. Among his written publications is an English translation of the Irish-language autobiography of Peig Sayers. Bryan was one of the few settled people capable of speaking Shelta, the language spoken by Irish Travellers. He once said that 'writing is a man or woman pausing to embroider life'.

If clothes and the Irishman are part of the same woven history, then men like the MacMahons and William Rock are the tailors.

Sport and design

My joining the clothing industry from a GAA background caused some confusion. The move made perfect sense to me.

Natural curiosity is a great teacher. It has taught me that nearly everything in the world around us is designed. Everything made was once an idea brought to life through design and manufacture. The relationship between design and sport is deep. It is a perfect collaboration – one can hardly survive without the other. The passion and emotions of sport can cloud how much it incorporates design. Sport couldn't exist without design. Design is the more influential of the two elements. It is tangible, while sport is experiential. The sporting experience is fleeting – the match ends and becomes a memory. But the stadium, the pitch and the jersey are enduring, thanks to design. When I

think of my own sporting experience, design is everywhere. It is intrinsic to the experience of playing, preparing and spectating. I look at an empty terrace and see the work of an architect and a builder. The stand is the work of a fabricator and an engineer. An empty dressing room reveals the work of a carpenter. Everything is designed – from my hurley, my sliotar, my football, my football boots, my club playing kits, the clubhouse, the dressing rooms, the pitch, the goalposts, trophies, medals, terraces, stands and stadia. In daily life, my shoes, jeans, shirts, books, mugs, kettles, plates, knives and forks, the bed I sleep on, the car I drive, the bike I cycle and the house I live in have all been designed and made. Without these products of design, sports could not be played and life would be very different. Realising this was an important moment of discovery for me.

Why do so many regard design in sport as inconsequential when it is so influential? It affects the fan experience greatly. Have you ever sat in a cramped, uncomfortable, too-small stadium seat, with a bad view, facing into a cold wind, the sun in your eyes or the rain on your lap, several minutes from the nearest toilet, bar, café or exit? That'll be down to bad design. Ever walked into a stadium like Wembley, sat down 50 metres from the pitch and felt like you were right on it, while still being close to a toilet and an exit? That's good design.

The relationship between design and sport is marked – literally, in the case of pitch design.

The surprise when I decided to enter the world of design from a sporting and education background was linked to the fact that GAA people didn't usually do what I planned to do. I had no sporting 'role model' to copy, but I didn't feel like I needed one because there were other people I could refer to. I knew of people like Tinker Hatfield, the former American college athlete and trained architect, who went into footwear design. Tinker influenced the footwear industry, the National Basketball Association, the world of design and American culture with his Air Jordan designs for Michael Jordan and Nike. Jordan, considered the greatest NBA player ever, was soon earning more from endorsing footwear than he ever earned playing for the Chicago Bulls. Hatfield's mind spawned not just new sneakers for Jordan, but a revolution in the interconnection between sport and design and how powerful the relationship between brand and athlete could be.

Iron my shoes: how a Belgian waffle maker inspired an iconic piece of footwear

How did Tinker Hatfield start? He was inspired by a person who was a coach, teacher and mentor in one. His college athletics coach at the University of Oregon, William Jay Bowerman, would become one of the most important and wealthy people in sports and footwear design. Bill Bowerman, as he was better known, kick-started the running and jogging phenomena in the United States in

the 1960s. During a 1962 trip to New Zealand, Bowerman saw people of all ages jogging and running for fitness. Shortly after returning, he wrote a three-page guide called *A Jogger's Manual* and later a book, *Jogging*, which sold a million copies.

Bowerman believed that the shoes his college athletes wore were hampering their performances, so he started making proper running shoes for his athletes in a janitor's shed at the university. He experimented with a Belgian waffle iron, ruining several in the process. He pressed the iron on the soles of the running shoes to create the waffle grid on the sole. Bowerman hoped that this would give the shoes greater grip and traction with the running track. After many more experiments and athlete trials, Bowerman went on to become co-founder of Nike, with Phil Knight, and is responsible for some of Nike's most iconic shoes. His design ideas led to the creation of Nike's first track shoe, the hugely popular Nike Cortez, in 1972. Tinker Hatfield had Bill Bowerman to lean on and learn from, and I had them both – they just didn't know it. I could use their journeys and careers as reference points when I needed direction.

I think about reference points in life from time to time. I've never fully grasped the term 'role models'. It implies a measure of role-playing or modelling the behaviour of another, which doesn't make sense to me. It feels like acting. I don't think modelling the behaviour or actions of another person is a realistic way to live your life. Better to be yourself. The concept also imposes a level of social

ownership of and expectation on the 'role model', which they might be uncomfortable with. The role model must act, behave and live according to the rules of being a role model, which no one ever defined or discussed with them. And if they fall short of these standards, they can be castigated as being a poor role model – when they didn't even want to be a role model in the first place. I have read many interviews with famous people who try to explain their discomfort with being in the public eye. I sense what they are trying to explain is their discomfort with others conferring upon them a certain status, which at times they may not be able to live up to.

A person being a reference point is something that makes more sense to me. I can read a *Forbes* article about a man like French-Syrian billionaire businessman Mohed Altrad, for example, and feel inspired and energised by him and his life story, his courage and his business career. I might re-read the article a number of times, and refer back to it, and him, every few weeks or months and feel energised again. I'm not trying to emulate Altrad's life, but I am mindful of his determination, his strength in overcoming adversity and his entrepreneurial streak. I would use Altrad, Harry Boland, Tom de Paor, Samuel Beckett, Luke Kelly, Mick O'Dwyer, Tinker Hatfield and others as reference points from time to time if I need guidance. Their stories reflect energy and initiative in different ways.

Artist and stage designer Es Devlin is another reference point. Her life and career in design is important and

Tinker Hatfield

impressive to me and to those working in the creative industry. I named my first daughter after her. Devlin's mind works in unusual ways – she sees things differently and, most impressively, makes them a reality. Chances are she has inspired you too, without you knowing. If you attended U2's Experience + Innocence Tour, Beyonce's Formation Tour, Adele's World Arena Tour, Kanye West's Yeezus Tour, Jay-Z and Kanye West's Watch the Throne Tour, Muse's Resistance Tour, Lady Gaga's Monster Ball Tour, Miley Cyrus's Bangerz Tour, The Weeknd's Arena Tour, Stormzy at The Brits, or The Rolling Stones at Hyde Park, you will have experienced her stage design. In sport, she has designed the closing ceremony for the 2012 London Olympics. Es has brought Louis Vuitton events to life, and has designed art events at the Tate Modern in London and theatre events at the Metropolitan Opera in New York. The UK's design pavilion at the Dubai Expo was her creation. In short, she is prolific.

The architect Neri Oxman is another inspiring figure. She is a professor at the Massachusetts Institute of Technology, where she develops new eco-materials for the construction industry. I have learned much about and from each of these people without them knowing.

I would rather look towards a reference point than follow a role model. Referring to someone's professional career for inspiration, as opposed to modelling their behaviours or lives, as 'role modelling' implies, seems more honest and realistic to me. There is also less social

ownership. When using someone as a reference point, you can acknowledge both good and bad behaviour. I feel that if you are a role model you are married to this notion of being only good – a positive example at all times – and anything short of perfect behaviour is unacceptable. It's impossible to be perfect even when you try to be, and if you slip and fall short of role-model standards you get caned. This can lead to frustration and rebellion against the standards imposed upon you in the first place.

Nearly all of my sporting mentors happened to be teachers. They were a huge influence on me growing up. These were neighbours and fellow club men, who had the most influence over me besides my parents. They shared a common trait in that they were all competitive people, all winners. I admired them for that and wanted to impress them. I grew up in a culture of teaching, mentoring and coaching, so it was no surprise that I pursued teaching, mentoring and coaching as a career.

Another influence on me was something my father said to me as a young boy: 'Be your own man, stand on your own two feet.' It was only later in life that I realised the imprint that advice had left on me. Some days, I literally stand in shoes I designed myself. In my early thirties, my influences and interests (sport, sportswear, brands, heritage brands, footwear, design, storytelling, writing) were more evolved than my interests had been as an 18-year-old (Gaelic football, hurling, sport in general). These new interests would take me on a new life journey that has rewarded me

every day since. Pursuing your interests is a great teacher, in my experience. You become a natural researcher, delving into subjects to find more meaning. It is often as simple as researching a word, checking my dictionary for more meaning or context to a word I want to use to unlock a design story. Etymology – the study of the sources and the development of words – probably relates well to what I do as a designer. From there, I move to reading a magazine article or watching a documentary on design, art, history, or wherever the word takes me, to find out more. Everything from here on is learning for me. I left teaching to pursue an interest in words and language, seeking to place an emphasis on meaning in the design of men's clothing. Making the decision was easy. Making it happen was not.

While I had plenty of reference points for becoming a teacher, I had none to help me navigate the switch from teaching to design and retail, beyond those people and stories I had read about. There was no one on my doorstep. Brands became my inspiration instead. Good brands can inspire people, behaviours, careers and lives. Adidas, Nike, Puma, Mitre, O'Neills, Levi's, Caterpillar, Doc Martens, Clarks, Farah, Kappa were all my reference points for the industry back in the nineties and noughties. New Balance was a big one, as it had a factory in Tralee when I was young and my cousin worked there. Today, brands like Patagonia and The North Face, and some of the bigger sportswear manufacturers, like Adidas, are actively involved in the business of protecting the natural environment from the

dangers of climate change, although these brands recognise they did much damage of their own along the way. Global brands nowadays behave more like third-level institutions, carrying out science-led research and development to create more environmentally friendly products. This environmental consideration from brands, mixed with the business of retail and my mission to bring meaning to the table, made the industry an interesting place to work.

I had some advantages in that, despite not having a mentor in design, I was aware of brands I could follow. I also had a clear vision of what I wanted to do. If you have a clear view of what you are bringing to the game, and you can articulate this well, it helps a lot. You can make up for any lack of experience or formal education if you present something new and interesting to the people that matter: brand or business owners, shareholders and, ultimately, consumers.

Winning in sport was my big vision or focus in my late teens. I had the drive to succeed at sport, which over-rode my career ambitions. I didn't ignore my career – I did what I had to do. It was just that my career had to allow for my sporting ambition. Ultimately, I had to be interested in what I did. Intuition or vision, or both, told me that I wanted to combine design and sport and work there. When I looked around I saw few people were doing this in Ireland. My interests were leading me towards the creative industry.

YMC: You Must Create

There is a British menswear brand called YMC. I follow their work, more for the name of the brand than for its clothing. YMC: You Must Create. I think it's a great brand name and an even better message. It captures the aspiration of design. It was this feeling of aspiration, creativity and possibility that made me want to be part of the industry. I refer to this brand in conversation with football players sometimes too. Stat charts and game analysis reports will often mention chances created and conversions, but rarely do we drill deeper into what creativity means in the first place. What does creativity on a football pitch look like? How is it defined? Can it be defined? Can it be measured? Why is it important? When you begin to refer to creativity and ask players questions around it, a lot can be discovered. My belief in the value of creativity is related to my experience as a designer, in that I have an understanding that creativity is a bottomless feast. You can't explain where it comes from, but it keeps coming. Power, pace and possession are key metrics in sport, all are measurable and understandable, and as a result, all can be countered. Creativity cannot be measured, therefore it cannot be countered.

Culture is critical in sports nowadays, and it is vital to have clearly understood codes of behaviour within a group. The business world is also culture-obsessed. As the boardroom saying goes 'culture eats strategy for breakfast', meaning a company's culture will determine its success regardless of how effective its strategy may be. Creativity

eats them both because it creates both. That is, ideas around the direction for both company or team culture and strategy are conceived and created. The brighter the creative thinking about company culture and strategy, the better the company culture and strategy will be.

To make a living in the creative industry I had to first satisfy myself that I had something to add. Then I started self-educating. I'd been doing this for years anyway, studying copywriting and marketing communications around men's sportswear and high street brands. I studied the footwear market closely. I studied how copywriting and marketing related to the products themselves and figured there was room for more storytelling and specificity between design inspiration and product descriptions. I could see product description become more relevant to the online shopping experience back around 2010 and 2011 given there was a virtual vacuum, one that is filled by the store assistant in the real-life shopping experience, so I put a lot of focus there in order to build a strong brand identity and customer relationship. I studied football clubs, their playing gear, stadia, crests and design in sport generally. It was clear that sportswear and menswear design was an exciting space creatively that was full of opportunity. That study, driven by interest, was my early education.

After observing, researching, reading and studying, writing was my next big step towards educating myself in the business of design. I started a website, and from there started writing about men's sportswear, design, brands,

trends, sport and style. This gave me a more nuanced understanding of the creative industry and brought me into contact with people who knew more about the industry in Ireland than I did. These people were connected with the things I wrote about – brands, designers, retailers, agencies and audiences. Bairbre Power, editor at the *Irish Independent*'s *Weekend* magazine, for which I wrote for two years, became an early mentor. Each weekly article required a huge amount of thought and research. This was fundamental to my learning process. From here, I was sure I wanted to be involved in the business end and to have a say in what young people wore. To do this, I would need a clear point of view as a designer and as a marketeer. To be part of the daily conversations of 18–25-years-olds you have to speak their language. Copywriting, content and marketing would be crucial to establishing this connection. Creating a brand vocabulary first, designing and marketing accordingly would be necessary to build a brand that meant something. Retail is a business that is driven by numbers, but I wanted to make words count too.

Tackling the language of fashion

Marketing was an area I wanted to tackle and bring a new voice to. The language of fashion marketing is designed to make products feel exclusive. The copywriting you find in print and online ads and in product descriptions can sometimes be exaggerated or clichéd. This can make the ad, the brand and the industry hard to relate to.

I focus on the male experience, as I have a men's brand and have experience in navigating the male clothing industry. Language is often a barrier to entry into this world. It's a bit like not being able to speak the language in a foreign country. A guy may feel excluded from fashion by the language of fashion itself, so he tunes out and moves on to something he can understand and converse in. I recently read *Esquire* men's magazine on a plane and saw two examples of how brand marketing copy can include or exclude readers. The first was an advertorial for a traditional womenswear designer who was moving into menswear. The copy said the designer's 'first menswear collection makes the case for elegant understatement'. Of the three models in the image, one wore a floral-print boilersuit, another wore stonewashed, heavily contrasted floral-print jeans and another wore a floral-print shirt, polo neck and high-waisted trousers. All three wore sandals. There was nothing wrong with any of what they wore, but none of the looks was understated, as the copy suggested. So the ad looks inaccurate, and if you're someone like me, who reads a lot of ad copy, it begins to read like a cliché. I lost interest at that point. The use of the word 'elegant' is another matter. I'm not sure 'elegant' is a word many men engage well with. None of my friends or peers uses it in any context, never mind for clothes. The copy didn't relate to the imagery so the ad (and the brand) didn't land for me.

Another feature in *Esquire* by Bang & Olufsen did the opposite. The heading read 'Setting The Tone'.

Underneath, the subheading read, 'Bang & Olufsen make white products (not white noise)'. The article goes on to describe how Bang & Olufsen's latest all-white collection was named 'Festive Nordic Ice'. The question was asked why, as a high-end audio company, they didn't call the collection 'White Noise'. While an obvious suggestion, and perhaps worthy, the brand were at pains to avoid the phrase, given its meaning and origins. Given that sound is their business, they didn't want their hi-fidelity audio brand associated with the harshness of white noise, be it TV static or a child's sleep aid or a hissing radiator. The article also explains that the word 'noise' is derived from the Latin for 'nausea' – which few brands would want to be linked to. The article outlines all the positive associations with the colour white, from cleanliness to mindfulness and peace, and finishes by explaining why the company called the collection the 'Festive Nordic Ice Collection'. Bang & Olufsen is a Scandinavian company, hence the ice reference, and the collection was released for the Christmas market. This, to me at least, is an example of good copywriting that seeks to include everyone in the brand story. Audio products might be an easier sell for men than clothing, but storytelling and a brand strategy like this help.

My friends are reference points for me in terms of how I communicate. I try to speak their language. You can see this in all the story titles I have used over the years. Naming collections is the most important step in the marketing process for me. All the rest of the brand copy follows from

here. VANGUARD, PUSH, BORN MAD, MISTER, SHELBY, BOGMAN, RAGLAN, TATTOOED MAN, BOXER, BIKER, SCAFFOLDER, BOLAND, DANCER, DOC, JACK – these are the words or titles that resonate with me and tell true stories. There are words, expressions, terms, clichés and copy that I avoid because I never use them day to day, nor do my friends or peers. Language creates barriers in lots of industries. My idea was to tackle the exclusivity at the heart of fashion, through the creation of a new vocabulary and a brand language that the guys in my local hurling and football clubs would understand.

I sometimes wonder who first used the word 'fashion'. I have never comprehended it properly or how it claims to represent the industry as I understand and experience it. Fashion to men might be better expressed as 'manufacture', 'production', 'making' 're-making', 'repairing', 'sourcing', 'supply', 'buying' and 'selling'. All the better if you can talk about construction, engineering, agriculture, factories, warehouses and dye-houses so you can understand, express and articulate the industry.

Let's take a scenario to illustrate what I mean. I am often asked, 'How's the fashion going?' My reply would be along the lines of how the supply chain is upside down, logistics are difficult, factories, ports, ships, oil, couriers, motorbikes and vans, and before I know it I'm deep in a conversation about production, manufacture, fabrication, weight, fuel prices, where and how my shirts are made, what the cost of production might be, what they're made

of. The supply chain is often one to open a discussion with. Supply has all sorts of solid associations. But the word 'fashion'! 'Fashion' reduces the industry because I don't think it represents well the reality of this business.

To combine the design and marketing processes through storytelling, build my own vocabulary and start new conversations around 'fashion' for Irish men, I needed to understand the conversations they were having. If I was to build and sustain a brand, I had to become a voice within those conversations. To use a sporting analogy, it is like focusing on underage development within a GAA club. The young talent becomes the foundations and the seeds for future growth, and you have to be able to speak their language. To speak their language you need to know, and even better, share their interests. I went about building out the brand vocabulary. It wasn't difficult, I just based it on the language I used day to day and built around words that resonated with me. Language would be the foundation of my brand and storytelling would be the walls.

I studied the industry online and offline – analysing websites and e-commerce descriptions and visiting stores. This taught me that brands produced garments that said little and meant little in terms of how they were designed and subsequently marketed. This was the gap in the market I would attack. I would take a 'teaching and learning' approach to design and marketing through what I termed 'cultural storytelling'. This was another form of writing and publishing – with clothes as the text. My next challenge

was creating and manufacturing the clothes. I needed to understand sourcing, design, manufacture, fabrication, supply chain, costings and logistics – the real, heavy end of the business.

How to start? Where to start? I started by travelling and following my instincts. These instincts took me to the Middle East – Dubai and Abu Dhabi in particular – during the GAA off-season in 2012. It was here in the heat of the Emirates that I discovered the cotton fabrics and shapes that would become the basis of the first Dunnes story, VANGUARD. I had no idea at the time whether I would ever achieve my goal. But the visual inspiration from the bazaars, the buildings, the heat, the language, the colours, the traditional clothes, the tribal prints and patterns, and the hope of realising my vision kept me going.

All of the travel and the fabric samples cost me money, but my interest sustained me. I bought a lot of the traditional dishdasha many Arab men wear and got a local Arab tailor to cut them up from their normal floor-length to waist-length so they were more wearable for me in the desert. I took them back to Ireland as samples to show to whoever might be interested. This kind of cotton overshirt was structured and made a good shape and would be something new in the Irish market if I could find a way to make them and sell them. Who would help me? I'd have to help myself until I reached a stage where I had something suitable to present to the market or to a retail partner. Weeks and months of travelling to Dubai's old

Traditional dishdasha

merchant quarters, out-of-town bazaars, backstreet tailors, and cutters eventually paid off. I had made eight shirts with varying design details, cuts, lengths and proportions. I was satisfied I had something with a definite point of view that I could stand over. I then had to find a way to market. Would I go it alone or seek a partner?

I met with my former editor Bairbre Power to show her the fruits of my endeavour, which by now were accompanied by some upcycled pieces that I had cut up and had reworked by my Irish tailor, Henry Dixon. Henry, of Paul Henry Tailoring, became a great mentor to me over the years. His tailoring house is like a university. He helped me to remake and reuse old fabrics to make new T-shirt and shirt styles. Old cotton-elastane trouser leg cut-offs were stitched onto cotton shirts to emulate a football captain's armband. Polyester tracksuit legs and trims were sewn onto sweatshirts to create panelled hoops like the band on the Kerry jersey. Second sleeves made from old compression sportswear pieces were stitched onto short-sleeved shirts for a layered-sleeve look, which was coming through in sports at the time. I got my cobbler to mould plastic and microfibre sheets and stick them to old trainer soles to create a new mid-sole trainer silhouette. Anything I could recycle and reuse I did. Eventually, I had 15 pieces – the number of players on a GAA team – born of initiative and intuition. Enough to satisfy me for my efforts. Enough to justify all the plane rides, the airport halls, the queues, the packing and unpacking, the lone travel, the currency

exchange, the language barriers, the security checks at Dubai International, the money and time spent, the thoughts and ideas. It was time to do something with it all.

All the solo travel had given me a sense of optimism and independence. I didn't know what lay ahead, but intuition was guiding me, and I knew whatever it was it would be good. By that time, late 2013, I had retired from inter-county football and had written my autobiography. It served as another body of creative work, a CV of sorts – one that taught me a lot about myself and gave me a further understanding of publishing, Irish culture and where the Irishman's mindset was at. I wanted to extend the idea of traditional publishing and writing and apply it to the clothing industry, bringing that same level of language, storytelling and meaning to men's clothing.

A cultural institution

Watching the Irish menswear market closely, I knew Dunnes Stores were doing huge work in promoting Irish design and offering a home to Irish creative talent. They were like an incubator for design talent. With Padraig Harrington and Paul Costelloe already in-house, they catered for the men's golf market and the wider men's fashion market. I wondered if they were interested in an offering for the university student, the young GAA player, the music follower, the style-conscious 18–30-year-old, and this is what I explored. The broader menswear market seemed to have little interest in storytelling or meaning.

This lack of interest was the gap in the market I wanted to attack with the help of Dunnes. I sent a copy of my autobiography and a note to the most important person in Irish retail and business, Margaret Heffernan.

I explained in my note how I had been at the vanguard of a new wave of interest in men's fashion and now wanted to move to the next level in business. My aim was to create a brand that spoke to young Irishmen in the same way I might, one that promoted Irish culture, meaning and creativity in the same way Dunnes Stores was promoting design talent. I saw this cultural institution as the perfect home for my cultural storytelling and the perfect place to tackle the language of fashion and create a space where young Irishmen could express themselves. Without Dunnes Stores' support, belief and know-how, the mission would be impossible.

Vanguard

Autumn–winter 2015

Vanguard

[van-gahrd] *noun*

1. the leading units moving at the head of an army
2. any creative group active in the innovation and
 application of new concepts and techniques in a given
 field, especially in the arts
3. to be at the forefront or cutting edge of a particular
 movement, the position of greatest importance or
 advancement, the leading position in any movement
 or field.

The word 'vanguard' and its definition has resonated with me for a long time. I can't recall where I first heard or read it, but it stayed with me. Its meaning bounced around my head for years, especially in the military context of leading the charge, of taking risks. This military context can be applied to life in general: life is about taking risks. They are what makes life exciting and worthwhile, but they can also make life difficult.

The anthem

Travelling to the deserts of the United Arab Emirates inspired the VANGUARD collection. The vanguard unit in a military formation is the lead unit that marches before the others to secure safe passage, often at the expense of their lives. These soldiers are the bravest of risk-takers. I tried to put myself in the shoes of these soldiers. Had I ever led? Had I helped to forge safe passage for anyone? I thought of the workers' compounds I had passed on the way to the bazaars in Deira, Dubai. These men left homes in India, Pakistan, Afghanistan and Bangladesh to make a living working in construction in the desert heat and secure the futures of their families. I could never claim to have such bravery as the soldiers going to war or those going off to foreign shores to make good for their families.

A different kind of vanguard came to me instead. I thought back to the many matches I had played for club and county. I came to the realisation that every time a GAA player stood for the national anthem before a big match he

or she was at the vanguard of a movement. They stood in representation of their team, their county and their people. I saw those matches, especially those we played with Kerry in Croke Park, as like life or death at the time. Not the best lens through which to view a sport, really, but that is how it was. We were vanguard soldiers and so were the opposition. We players had to clear the way so our team and our people could march on. When we marched behind the Artane Band as they played on All-Ireland final day, we marched as one. As soon as the band stopped marching, we, the players, had to lead. With our body language, our communications, our actions. Really, as soon as 'Amhrán na bhFiann' started, the game started. 80,000 people, perched on 80,000 tiny cliffs, surrounded us in the stands. About half of them were enemies. We took on that challenge. That part was non-negotiable. The enemy was waiting up ahead, wanting to progress at our expense. In those circumstances, you have to lead as an individual so your team can win and your people can enjoy better days. It was as black and white as that. The risk had to be assumed and the plan implemented.

The VANGUARD collection became a study of this idea of leadership, risk-taking and responsibility through the lens of our national anthem. Studying the history of the anthem was more education for me. Examining the lyrics, I learned much about our national psyche and our identity. The lyrics are a statement of identity. If you are a menswear brand or marketing executive in this country, you would do well to know the lyrics and translation of the anthem to

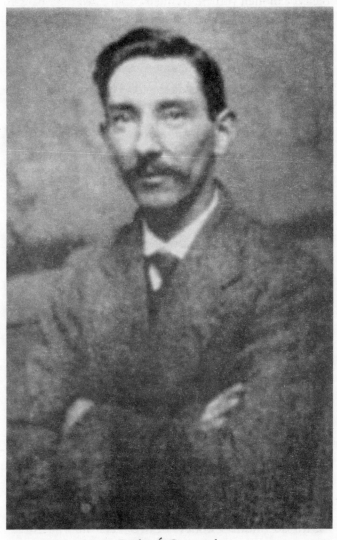

Peadar Ó Cearnaigh

properly understand the culture, psyche and personality of the type of men you are trying to have conversations with and do business with. VANGUARD sought to do all this by speaking of my experiences standing for 'Amhrán na bhFiann' in a full Croke Park as a footballer, face to face with the opposition before going to war with them, as my vanguard moment.

The storytelling slogans on T-shirts were translated lines from the anthem. Known as 'The Soldier's Song', the anthem was first written in English by Peadar Ó Cearnaigh in either late 1909 or early 1910. The music, composed by Patrick Heeney, was written around the same time. The song was first published in Bulmer Hobson's *Irish Freedom* newspaper in 1912 but was not widely known until it was sung by republican soldiers fighting in the General Post Office during the 1916 Rising. Liam Ó Rinn translated it into Irish in late 1916. Peadar, Patrick and Liam all lived within 200 metres of each other in Dublin's inner city. The Irish-language version was published in *An t-Óglach*, the Irish army magazine, on 3 November 1923. On 12 July 1926, the Executive Council of the Irish Free State adopted 'The Soldier's Song'/'Amhrán na bhFiann' as the newly independent state's official national anthem.

The first line in the Irish version, 'Sinne Fianna Fáil', translates as 'warriors are we'. The fifth line 'Faoi mhóid bheith saor' means 'Sworn to be free'. These lines became an extension of my storytelling narrative that started with the word 'vanguard'. My first collection became an expression

of Irish identity, culture, masculinity and meaning in Ireland, housed in an Irish cultural institution like Dunnes Stores. As I said earlier, I had no role models to speak of in doing this. I had only intuition and a few unlikely reference points.

The collection

The colour story for VANGUARD was a black-and-white base on an army camouflage print. The black and white represented risk-taking, and the camouflage print was an obvious military reference. There were a few obvious military pieces like heavy-gauge, ribbed jumpers with shoulder and elbow patches, bomber jackets, brass zips and buttons and a cagoule. The cagoule was like a canvas windcheater worn by soldiers in the trenches when it was raining. Some sweatshirts and T-shirts carried motivational slogans translated from the national anthem – lines anyone who has played or regularly watched matches would recognise. 'Sinne Fianna Fáil – Warriors are we' and 'Faoi mhóid bheith saor – Sworn to be free' were two examples of the storytelling, meaning and messaging that would sit at the heart of the brand. The national anthem is a misunderstood piece of storytelling and one we could all do with knowing more about. To understand the Irishman, the Irish retail market, or any international retail market, I think it is important to know the meaning of that country's anthem. Marketing is about understanding identity, and speaking to that identity in a language the people understand. For

many Irish people, their national identity is wrapped up in our anthem, whether we like it or not, woven into the fabric of both the lyrics and the melody. To understand the fabric of the Irishman, I had to understand his lyrics, what he stands for and, more importantly, what he doesn't stand for.

Push

Spring–summer 2016

Push verb
1. the act of applying force to move something away
2. forcefulness and enterprise
3. an effort to advance

In December 2020, a Kerryman called Paul 'Paudie' Fitzgerald passed away at 87 years old. His grandson, Paul Geaney, is an All-Ireland football medal winner with Kerry and a football All-Star. Paudie's passing resurrected the story of his Irish Olympic cycling adventures and the sport's relationship with struggle, freedom-fighting, politics and rebellion.

Fitzgerald was a legend of a famously tough and prestigious Irish cycling event called Rás Tailteann, winning it in 1956. Later that year, he was selected to represent Ireland in the team road race at the Olympic Games in Melbourne, Australia. However, the team was disallowed from the competition by the International Olympic Committee because the National Cycling Association of Ireland (NCA), the representative body that selected the Irish team, was not recognised by the Irish Olympic Council or by the International Olympic Committee. This was because of the NCA's political stance in claiming to represent a 32-county Ireland. Back then, all Irish Olympic teams represented the 26-county Republic only.

The team – Fitzgerald, Tom Gerrard and Tommy Flanagan – travelled Down Under anyway and planned to stage a protest at the stadium if they were not allowed to compete. Their plan included removing the Union Jack from the flag display at the Broadmeadows velodrome, and extinguishing the Olympic flame. The three riders got as far as the starting line before the Italian team noticed their presence and alerted race officials, who attempted to

remove them. They failed to do so until the police arrived and forcibly ejected the three Irishmen. The story garnered global media attention. Upon his passing, newspapers ran images of Fitzgerald in his old Rás Tailteann Kerry cycling jersey from the 1950s. It is a beautiful piece of sportswear design, even today.

A similar tale inspired PUSH, my second collection at Dunnes Stores. The more I researched stories like Paudie's, the more I realised that sporting stories told in this country regularly throw up tales of Olympic endeavour and achievement mixed with idealism, political tension and conflict. This is especially true of cycling. As a competitive sport, cycling has a deep history in this country, although, like most things, its history is closely aligned to politics — and pockmarked with conflict.

In 1912, a six-man Irish cycling team headed to Stockholm, Sweden, for the Summer Olympic Games. Fronted by Dublin-born Michael Walker and his younger brother, John, and accompanied by teammates Bernhard Doyle, Matthew Walsh, Ralph Mecredy and Francis Guy, this team pushed physical and political barriers.

There were two competitions raging for many sports-people in Ireland at the time: one for Olympic honour and another for freedom. Most Irish sportspeople had to compete as part of a Great British team. After its formation in 1906, the British Olympic Association (BOA) oversaw the affiliation of the Olympic credentials of three Irish sporting bodies: the Irish Cycling Association, the Irish

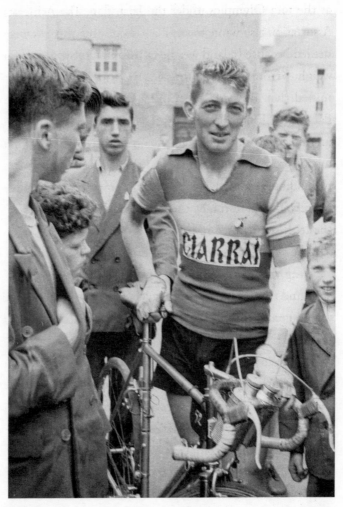

Paudie Fitzgerald in 1956

Amateur Athletic Association and the Irish Amateur Swimming Association. All three bodies sought to compete at the 1912 Olympics under the Irish flag. The Athletics Association also wrote to the BOA requesting this but were denied because Ireland were genuine medal contenders for weight-lifting and the triple jump. The BOA was determined that all medals would be won under the British flag, burnishing the sporting reputation of Great Britain around the world. The cycling team were seen as having no medal prospects and bearing no threat to Great Britain's medal hopes, so they were granted permission to compete as Ireland. Interestingly, the BOA did financially support the Irish six-man team.

The team travelled to Stockholm aboard the *Saga*, crossing the North Sea dressed in fine-wool three-piece suits and ties. The suits worn by Michael and John Walker would come in useful four years later as the 1916 Rising raged in Dublin City.

The race organisers were expecting a single British cycling entourage but instead had three separate teams. (Scotland were also allowed to compete independently.) This didn't go down well because in every other competition Great Britain competed with only one team. Despite objections, from France in particular, the Official Olympic Report stated that it:

> regretted that this concession had been made but declared at the same time that, as the teams from

the countries in question had come to Sweden
to take part in the event, the Swedish Cycling
Committee did not wish to prevent them from
doing so, and that the Swedish Cycling Association
intended to take the responsibility for their doing
on its own shoulders, should any steps be taken in
the matter by the Union Cycliste Internationale.

The race

It is hard to conceive of today, but the Olympic road race
of 1912 was a mammoth 315-kilometre affair that started at
2 a.m. on Sunday 7 July, with riders departing at two-minute
intervals. The eventual winner, a South African called
Rudolph Lewis, was the second rider off. He benefited from
better weather conditions than the later competitors, but
the route still took him a massive 10 hours and 42 minutes
to complete. Michael Walker was Ireland's first cyclist, and
he didn't push pedals until 3.20 a.m., by which time a
storm was blowing in the faces of cyclists. Walker was
Ireland's highest placed racer, in 67th place of 91 finishers.
Guy finished in 71st place, Mecredy in 80th, John Walker
in 81st, Walsh in 82nd and Doyle in 85th. The Irish team
were 11th overall, based on the first four riders home. The
winner, Rudolph Lewis, was later awarded the Iron Cross
for his efforts as part of the German Army during World
War One. This serves as another example of the relationship
between cycling and military struggle.

The men's finishing places do not tell the full story of the personal courage and physical endurance of the Irish team. Twenty-nine cyclists dropped out of the race at various stages and 28 did not start the race at all because of the weather conditions. The rough terrain around Lake Mälaren made the race more akin to an extreme sport than an endurance one.

The time-trial nature of the competition and the fact that it was a road race make this cycling event unique in Olympic history. It was the only time there was no track race event, so the road race garnered all the attention. Some 123 riders from 16 countries took part. The Irish were the only team whose full complement completed the race. This was a huge achievement, especially considering the paltry funding and inferior equipment they received compared to other teams. Sweden, the team winners, only got four of their 12-man team across the finish line. Two of the second-placed English team did not finish the race, and only one of 10 Russians got over the line. This affected the overall team standings, which saw Ireland finish above Russia, Norway, Hungary and Bohemia (modern-day Czech Republic).

Afterwards, in recognition of the gargantuan physical effort required for completing the race in such conditions, the race organisers awarded special merits to those riders who finished within 25 per cent of the winner's time. Four Irish riders received merits: the two Walker brothers, Francis Guy and Ralph Mecredy.

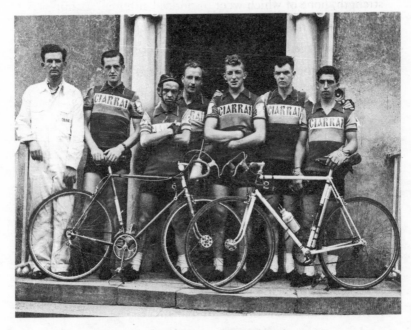

The Kerry team that won Rás Tailteann in 1956

The political aftermath

It is far from unusual for a sporting achievement – or a sportsperson – to be politicised. Propaganda was as prevalent in Anglo-Irish political relations in the early 1900s as it is today. While the Irish team did not bring home a medal, they had shown great honour, nobility and strength, none of which went unnoticed at home. Arthur Griffith, the editor of the *Sinn Féin* newspaper at the time, went to great lengths to celebrate the fact the Irish team were among the few teams to have completed the race – and had done so on Irish-made bicycles.

The bikes used by the team had been manufactured by John O'Neill at the Luciana Cycle Works on Pleasants Street in Dublin. Much was made by Griffith of the fact that the bikes withstood the unforgiving terrain and harsh weather when most other bikes and teams had encountered significant problems. The fact that the Irish team didn't have spare bikes or even spare wheels was a source of pride in the quality and dependability of Irish manufacture. The Luciana building still exists today and stands as a monument to Irish endurance. Following the race, a letter from one of the Irish cyclists stated how important the bikes were:

> None of us had the slightest trouble with our machines, although we had several bad falls, and I can tell you that numerous of our competitors' machines broke in two and forks, etc. gave way

during the course of the race, and as we were the only team who had no spare machines, our machines had to bear very close scrutiny from the other competitors, both native and foreign, who seemed surprised at the confidence we expressed in the ability of our machines to get through without any trouble. The result justified our confidence.

As Ireland's economic future and independence were being fought over at this time, Griffith, who would soon become president of Dáil Éireann, made sure people knew about this achievement. He wrote in *Sinn Féin*:

> One remarkable record comes to Ireland. In the long-distance team cycle race the only team all of whose members finished was the Irish team. Two-thirds of its team was mounted on Luciana bicycles – bicycles manufactured in Dublin. The riders of the Luciana raced on them for twelve hours in competition with the world. […] in the case of every other team most of the riders had to change bikes in the progress of the race. The Irish Luciana bicycle had thus made a world's record. And still in the city in which it is manufactured twenty foreign and inferior bikes are purchased to every one of the Irish machines, which beat the world at Stockholm. What slaves and fools to our interest we continue to be.

Even today, Griffith's remarks ring true and make a salient point about economic self-sufficiency.

The Rising

After the Olympics, the Walker brothers' cycling days were not done. Duty called them once more to represent their country, again using their bikes. This time they didn't have to cross the North Sea aboard the *Saga*. This competition took place at home, in and around Dublin's city centre, from St Stephen's Green to Aungier Street and Boland's Mills to O'Connell Street. It was the 1916 Rising.

By 1913, Michael Walker had set national records in the Irish 50-mile road race championships and was regarded as the country's top cyclist. He wasn't without a patriotic streak and when the Irish Volunteers were formed later in 1913 to challenge British occupation of Ireland, both Walker brothers, Michael and John, signed up to join the movement.

Three years later in 1916, the insurrection began, and the brothers found themselves posted to the Jacob's factory on Dublin's Aungier Street, just a few doors away from Dunnes Stores' head office, where I worked on creating this PUSH collection. The Walker brothers were under the direction of the leaders of the Rising, Thomas MacDonagh and his second-in-command, John MacBride. The brothers' physical talents as cyclists and their courage were utilised. They were dispatched as couriers, carrying messages from MacDonagh and MacBride to other bases around the city. They were in the vanguard of the fight.

On the Wednesday of Easter week 1916, the Walker brothers were exposed to life-threatening danger. A missive seeking help arrived at their Jacob's headquarters from Boland's Mills in the east of the city, where Éamon de Valera housed his battalion. In a witness statement given in 1948, Michael Walker described the drama of their journey from the city centre towards the mills:

> Members of the garrison with bicycles were selected for this sortie including my brother John and myself and we left the buildings some time in the afternoon. We proceeded [...] as far as Holles Street, where we dismounted and fired several volleys up towards Mount Street Bridge.

The entourage didn't get as far as Boland's Mills that day. Michael Walker recounted that, upon their return to the city centre, at the top of Grafton Street they came under heavy gunfire, which they managed to escape. Bullet holes from the gunfire can be seen to this day on the buildings around Stephen's Green and Grafton Street, including the Shelbourne Hotel and the keeper's lodge at the corner entrance of the Green and Stephen's Street.

The Jacob's factory was overpowered on Sunday, 30 April, and the leaders were forced to surrender. The Walkers escaped thanks to their trusty bicycles. They cycled as far as their homes on Bayview Avenue, Fairview, where they were later captured. They were sent to Stafford Prison

in Staffordshire, England, along with other Irish soldiers captured during the Rising, including revolutionary leader Michael Collins. Thomas MacDonagh and John MacBride were later executed.

Michael Walker went on to fight in the War of Independence. He received medals of honour for his bravery in taking part in both the Rising and the war. He died on 15 March 1971 aged 85. His various cups and medals for cycling are housed in the National Museum.

Athlete-soldier

My creative influences and intuitions were still unclear to me at the early stage of my design career with Dunnes, but after my first VANGUARD collection, and now PUSH, they were becoming clearer. Militants, freedom fighters, anti-oppression leaders – athlete-soldiers, if you like – were high in my estimations.

The Walker brothers were more than pedal-pushers. They were boundary-pushers and barrier-breakers. PUSH became the story of their lives, told through fashion. My search for meaning and my mission to add meaning to men's fashion were teaching me way more than I had expected.

In researching these stories, the photographs I discovered, along with the written history, were compelling and inspiring. They illuminated what it was to be an Irishman in the early 1900s. These images showed how Irishmen dressed and how differently men related to

clothing back then compared to today. It seems to me that men were more comfortable with what they wore back then. Whether this was down to lack of choice is another thing. We were once a nation of solid style. The Sunday-suit generation led the way. Photographs of the 1912 Olympic team in three-piece suits aboard the *Saga* en route to the Games shows stylish men at ease with themselves, as they should be.

Around the time PUSH was released, I was experiencing challenges in terms of changing my career and making progress in 'fashion'. Teaching, it was put to me, was a proper career, one people could make sense of, whereas fashion was not. Fashion was not a conventional path, and not a career everyone could understand. Most people I know have no idea how fashion works. Few people knew anything about the industry, and I didn't have the words to articulate it either, not like I do now. I hardly understood it myself. This is partly to do with the word 'fashion' itself, which I have always found clumsy, a one-size-fits-all way to describe a varied, complex industry. It doesn't inform as engineering does, or medicine, teaching, nursing, farming, veterinary, finance or media. It takes explaining, and this was part of the challenge I wanted to tackle. The pressure I felt starting out told me two things: one, doing something new is difficult; and two, it was important that I continued. I felt that young Irish men coming after me needed a reference point, someone to create breathing space for them and allow them the freedom to express themselves

in whatever way they wanted, through sport, design, dance, art, acting or by what they wore. And if they wanted to pursue this thing called 'fashion' in some capacity, they should feel free to do so. There is plenty of opportunity in the industry. I also didn't want young fellas growing up in a country where finger-pointing, name-calling, or being photographed unknowingly for what we wear or worked at was okay. Reading and researching the Walker brothers for PUSH, I got the feeling Ireland was always fighting oppression of some sort – and clothes were part of the fight. This inspired me to push ahead with what I was doing.

Dunnes Stores was the perfect incubator for me to start this movement away from what I felt was oppressive thinking, towards a place that could be more expressive, free-spirited and meant something more in terms of design. I got the first sign that we were doing something meaningful one day in early 2016 shortly after PUSH had launched. I got a phone call from Dunnes' head office to say an elderly man had called to the office to see me. He had left his name and address. It was Michael Walker Junior, son of Michael Walker, the Olympic cyclist and revolutionary. I called to see Michael Junior at his home in Dundrum shortly after and presented him with some of the cycle wear we had created in his father's and uncle's names. He was moved by the commemorative genesis of the collection and took me through all the paper cuttings and memorabilia belonging to his father. At 80 years old,

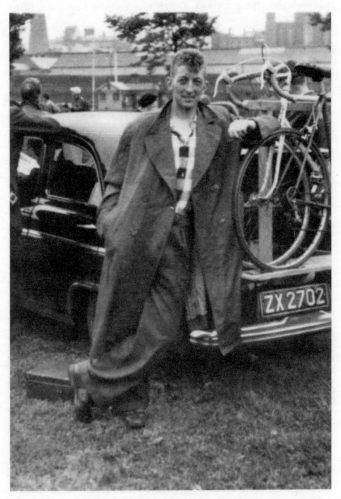

Paudie Fitzgerald, stylish and at ease

Michael Junior was still actively cycling and rollerblading when he could.

The collection

I called the collection PUSH to capture the urgency and energy of cyclists and activists like the Walker brothers and Paudie Fitzgerald. Men who had missions and were willing to push boundaries in that pursuit.

The PUSH collection was a fusion of cycle wear and formal wear that told the story of the Walker brothers' service to sport and Ireland's independence. It shone a light on the relationship between cycling and fighting political oppression. Sport and service, two sides of the same coin, inspired PUSH and convinced me to keep pushing in my own direction.

In creating the collection, we had to intersect the codes of traditional Irish men's dress in the early 1900s – central to which was the Sunday suit, or three-piece suit – and modern cycle wear. These two codes have different styles, fabrics, colours, silhouettes and proportions. They shouldn't have worked together, but somehow they did.

The subdued base of black, grey, charcoal suiting complemented the more vibrant colours associated with cycle wear: a tailored suit brand like Paul Smith or A. Sauvage meets a cycle wear brand like Rapha. The contrast is what made the collection interesting and wearable.

For the three-piece suit, we chose a knit fabric that gave the suit movement and flexibility around the joints.

This fabric was suitable for cycling in the city, just as the Walker brothers did during the Rising and as many modern office workers do as they commute to work. The cycling suit was a hybrid: the knit fabric was pliable and flexible like a tracksuit and performance-orientated while cut like a traditional suit. It felt ahead of its time, coming as it did before the advent of the athleisure movement. The accompanying pieces – team polo shirts, lightweight performance tees, old jersey materials, sleeve stripes, which are big in cycle wear and team wear identity – and a colour story of red, green, turquoise and black, inspired by archival cycling imagery, combined to nail a compelling cultural story.

Looking back now, it is clear that the three core subjects of my brand curriculum – culture, masculinity and meaning – were present. These three subjects make the brand what it is. The dedication to educating and adding meaning to menswear design gives the brand depth and a unique place in the fashion market. The language and the expression of the brand – using the right words, the right copy and the right content – were the next stages in both telling the story of PUSH, honouring the memory of the 1912 Olympic team and setting the scene of the further brand collaborations in the seasons to come.

PUSH shone a light on the relationship between cycling and freedom-fighting, and the struggle and madness inherent in both. There was a madness to what I was doing too. Trying to bring meaning to design, leaning on language and storytelling, creating original prints. Who

would even care about any of this at the end of the day? The Walker brothers might. Michael Walker Junior did.

I would push on with the madness.

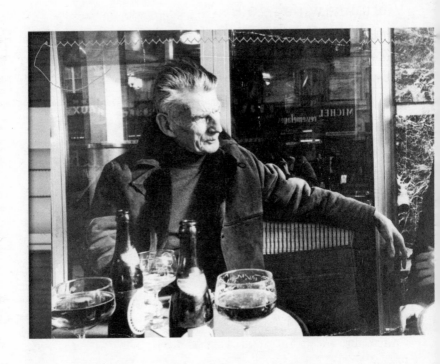

Born Mad

Autumn–winter 2016

'We are all born mad, some remain so.'
– Estragon

Waiting for Godot, *Samuel Beckett*

In researching my autumn–winter 2016 collection, I came across some images of the contrarian sportsman and playwright, Samuel Beckett. The camera- and media-shy Beckett was sometimes followed by photographers who would travel to London or Paris, wherever Beckett had decamped, in the hope of capturing his energy and style. Italians use *sprezzatura* to describe this ability to look dishevelled and well-dressed at the same time. Beckett had *sprezzatura*, and the average Irishman does too in a way.

John Minihan, from Athy in County Kildare, was to be one of the lucky few photographers to be granted an audience with Beckett. Minihan spent an hour with Beckett at his writing spot, Le Petit Café at the PLM Hotel on the Boulevard St Jacques in Paris. His 1985 photograph of Beckett coming up to his 80th birthday – reaching for an ashtray, eyes averted, face creased by age, the black-and-white contrast of the image as he sits outside the café – is considered one of the photographs of the century. Beckett fascinated photographers because he was reclusive but self-aware enough to know what made a good image when he did decide to be photographed.

Five years earlier in 1980, Minihan was based in London, working for the *London Evening Standard* and the *Daily Mail*. He heard that Beckett was in town to direct a production of his play *Endgame* at the Riverside Theatre. Minihan tracked him down to his hotel on Hyde Park. Ringing up and asking to speak to Mr Beckett, Minihan described himself as a 'newspaper photographer', to which

Beckett responded, via the hotel concierge, 'Tell him I'm not in'.

Minihan explained to the concierge that he was Irish and had been photographing life in the Irish town of Athy for years. This work included photos of a local wake that Mr Beckett might find interesting. He left the enquiry with the concierge. Minihan rang back the following morning to check with reception if the message had landed. The reply was positive. Beckett agreed to speak to Minihan, on the condition that he got to see the photos of the wake of Kathleen Tyrell of Athy, taken in 1977.

The men arranged to meet the following morning at 9 a.m. in room 604, where Beckett was staying. Minihan showed him the photos of 85-year-old Kathleen lying in repose in her own front room. The photographer hoped that the idea of photographing the wake might awaken some interest in Beckett, given his friendship with and admiration for James Joyce, author of *Finnegan's Wake*. The two had become friendly in Paris in the 1930s and 1940s. Minihan described Beckett as being friendly, at ease and aware of himself. He understood the power of his own image, how to sit and how to pose so as to be captured in his preferred light. Minihan shot him that morning in room 604 and later at the Riverside Theatre as he worked on the production of *Endgame*.

It was the study of these images that drew me to Beckett as the inspiration for the BORN MAD collection. The personal style that emerged in the images was equally

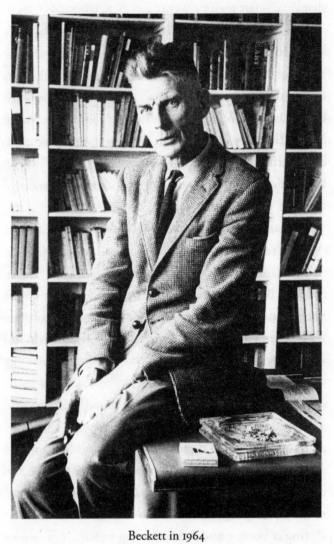

Beckett in 1964

compelling. Becket did not dress like a typical Irishman of that time – but then he wasn't a typical Irishman.

Before discovering Minihan's work on Beckett, a quote had been bouncing around my head: 'We are all born mad, some remain so.' I initially saw it on Instagram. I googled it and found it was spoken by Estragon, one of only two characters in Beckett's play, *Waiting for Godot*. BORN MAD, the story of Samuel Beckett, was born and would be told through clothing. The interesting visuals brought me to research his work and life story. It was through this research that I discovered the compelling, competitive sportsman beneath the slender frame.

Beckett the sportsman

Samuel Beckett was born in Foxrock, south County Dublin in April 1906. He attended Portora Royal School, a boarding school in Enniskillen, County Fermanagh. It was here that he gained a reputation for boldness, a certain oddness and a definite sporting prowess. He excelled at cricket and rugby. What surprised me most was that, while at Portora, Beckett was a champion boxer.

James Knowlson is the author of *Damned to Fame: The Life of Samuel Beckett*. Knowlson recorded an interview with a former schoolmate and boxing opponent of Beckett's, who told of being knocked clean out of the ring by him during a bout – and never boxing again. It is hard to reconcile the powerful boxer knocking opponents out of the ring with the bespectacled playwright, but there was much

more toughness and strength to the man than met the eye.

Rugby was a special interest of his – his south Dublin upbringing would have seen to that. Beckett's peer and drinking pal, the poet John Montague, told a story about Beckett's quiet love for rugby: an interviewer mentioned to Beckett that he (the interviewer) had played school's rugby with Irish rugby great, Ollie Campbell. The mention of Campbell brought Beckett to life, and he proceeded to discuss in great depth and detail the genius Campbell possessed at out-half. When the interviewer then asked how a man who professed to never watch television knew so much about Campbell's game, Beckett confessed that he did on occasion watch television but 'only for the rugby, only when the Irish play'.

The sport Beckett was most passionate about was cricket. He often sat in the Lord's Cricket Ground in St John's Wood in London. In describing Beckett's stage work, Knowlson makes observations on the relationship between the athleticism of sport and that of theatre, the actors as athletes, the stage as the pitch, and physicality and performance as one. Beckett was obsessed with notions of human frailty and death, yet was an energetic sportsman, excelling at cricket. He remains today the only Nobel laureate to feature in *Wisden*, a legendary (to cricket followers, at least) monthly cricket publication featuring results, live scores, fixtures and news on the game. It's a directorial kind of sport, so you can imagine the theatre and gesticulations of cricket appealing to the artist and director in Beckett.

Samuel Beckett and André the Giant

Growing up in Coulommiers in rural France, 60 kilometres north-east of Paris, André Roussimoff was six feet three inches tall by the time he was 12 years old. Born to immigrant parents – his father was Bulgarian and his mother was Polish – André was diagnosed with gigantism. He left school in his early teens and began to work on the family farm. School had become difficult for him. He had often been driven to school in his neighbour's pick-up truck as getting on and off the school bus was awkward because of his size.

At 17, André moved to Paris and took up wrestling, where his size and talent were spotted by Canadian promoter and wrestler, Frank Valois, who became his manager. André was soon a recognised wrestler, featuring in matches in Japan and Canada. After winning a wrestling match at Madison Square Garden in New York as André the Giant, he became a global phenomenon, just as WWF (World Wrestling Federation) had begun to capture huge international audiences. André the Giant, seven feet, four inches tall and weighing 238 kilograms, was now a bona fide wrestling superstar. He later became a Hollywood movie star, starring in films such as *Zorro*, *The Fall Guy* and *Conan the Destroyer*.

But who was that neighbour who drove André to school? It was Samuel Beckett, playwright, novelist and Nobel Prize winner for literature. Though it has been

embellished over time, the story goes that Beckett and his young neighbour forged a bond over cricket during these school rides. What is known for sure is that Beckett often drove the boy to school, but he also dropped other neighbours' kids to school.

British actor Cary Elwes starred alongside André in the 1987 movie *The Princess Bride*. In an extra feature on the DVD release of the movie, Elwes claimed that, while it is true Beckett and André had bonded over a shared love of cricket, André liked to embellish the details of his childhood and his friendship with Beckett. According to Elwes, André also claimed that his father built Beckett's country cottage, though this is disputed by André's brother.

What is indisputable is that Beckett had a deep relationship with France – not just Paris but its suburbs and the French countryside too. What is really mad is what happened to Beckett during World War II.

Soldier Beckett

In August 1942, Samuel Beckett fled to the Marne Valley outside Paris with his future wife Suzanne Déchevaux-Dumesnil. He did so as his life was in danger. Why? Having left Ireland at the outbreak of World War II and returned to France, Beckett joined the French Resistance to fight the Nazi occupation of his adopted country. He worked as a liaison agent translating secret reports within a Paris-based cell codenamed Gloria SMH. Beckett's work as a translator of secret reports was known to only a select

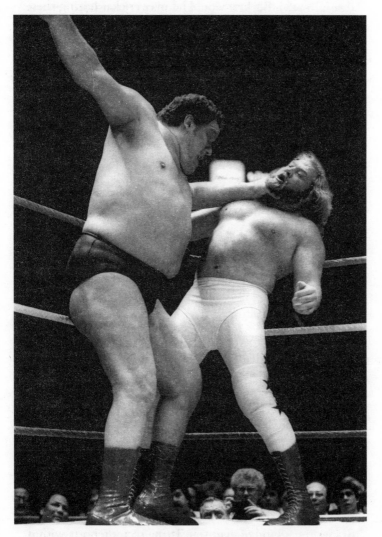

André the Giant in the ring in 1985

few of his closest associates, even up to the time of his death in 1989. Beckett would hand over translated reports of German activity to a street photographer nicknamed 'Jimmy The Greek', which were then microfilmed and sent to a Special Operations headquarters in London. The street where the handover happened was later named Allée Samuel Beckett.

The cell was infiltrated by a Nazi collaborator, a Catholic priest by the name of Robert Alesch. As many as 80 members of the cell were arrested and deported to concentration camps. Beckett escaped capture and made a break for the countryside. There, he lay low. Many members of his cell died in the camps. His closest ally, former French assistant lecturer at Trinity College, Alfred Péron, survived the camp but died during the long march to freedom upon his release.

Many are unaware of the medal for bravery, the Croix de Guerre, awarded to Beckett by the French government after the war. Though he later dismissed the award and his role as 'child's play', it was a huge achievement for a man associated with the stage. Beckett also underplayed the intellect required to translate such complex, strategic code from one language to another, not to mention the complexities of managing relationships in wartime France.

Beckett's time in the French capital was rife with drama and a kind of madness. There is another story about the time in 1938 when he was stabbed by a pimp named Prudent. Beckett had been walking home from the cinema

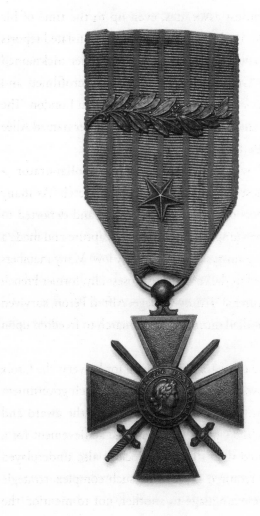

Croix de Guerre

with friends when they were approached by Prudent, who hassled them to follow him. Eventually growing irritated, the 31-year-old Beckett pushed the pimp away, who responded by plunging a knife deep into Beckett's chest. There he left him, lying on Avenue de la Porte-d'Orléans, bleeding heavily. Recalling the incident in *Damned to Fame*, Beckett said:

> This pimp emerged and started to pester us to go with him. We didn't know who he was until later, whether he was a pimp or not. This was established later, when I identified him from photographs in hospital. Anyway, he stabbed me. Fortunately, he just missed the heart. I was lying bleeding on the pavement. I don't remember much about what happened after that.

Beckett lay in a critical condition in L'hôpital Broussais. Newspapers soon heard the news of this prodigious young Irish writer hovering near death. *Le Figaro* newspaper covered themselves in glory by reporting that 'Samuel Peckett' had been stabbed. James Joyce was among his hospital visitors and paid for Beckett to have a private room. Joyce even brought him his own reading lamp, so that Beckett could continue to edit and proof the novel *Murphy*, which he was working on at the time.

If the headline in *Le Figaro* came close to making light of the almost-fatal incident, the transgressor, Prudent,

nailed it at his court appearance. When questioned by the victim as to why he had attacked him, Prudent answered, 'Je ne sais pas Monsieur, je m'excuse' (I don't know, sir, I'm sorry). Though Beckett chose not to press charges, Prudent was jailed for this assault and served time in the Santé Prison in Paris. The flippant non-reason given by the assailant is thought to have perplexed the writer and left a mark that would materially impact his future work. James Olney wrote subsequently in *Memory and Narrative: The Weave of Life Writing* that the stabbing was a turning point in Beckett's work:

> It was not the near-death experience that makes the incident significant but the non-committal response about the reason for the assault ... 'I don't know' or equivalent expressions are everywhere in Beckett from this point on.

The Irish literary giant John Montague, born in Brooklyn to Irish parents and raised in Garvaghey, County Tyrone, moved to a neighbourhood near Beckett's in the 14th arrondissement of Paris in 1961. In April 1994, almost four and a half years after Beckett's passing in December 1989, Montague wrote a *New York Times'* tribute to his old neighbour, recalling their last encounter at a Paris hospital just before Beckett's death. It tells of friendship, fellowship, literature and drinking. The first three paragraphs are worth retelling:

I am in Paris, and although I am staying in Montparnasse, the scene of most of our meetings and nocturnal revels, I am reluctant to call on Beckett. His last note said that he was in an 'old crock's home' but hoped to be 'out and about under my own steam and back for the boulevard and fit for company again'.

But word is out that he is dying indeed, and I am loath to say goodbye to an old friend of over a quarter of a century's standing. Besides, I have a broken leg and am barely mobile myself. But I have a mission to accomplish as well: to enlist him in 'The Great Book of Ireland'.

A message comes to me that he wants to see me, so I hobble and swing over to the taxi rank beside the Dome, where we have so often sat drinking and talking. Then down Raspail, another of our routes, to the lion of Denfert Rochereau. At night he would go left, down Boulevard St Jacques, as I turned into the Rue Daguerre, with 'God bless' as his last and uncanny salutation, a familiar Irish phrase made strange by his worldwide reputation for godlessness.

The collection

Basing a clothing collection on Samuel Beckett is not difficult. He had a distinctive style and identity. What was difficult was capturing that identity and understanding the proportions and shapes that made his look distinctive and identifiable. He wore certain colours that strengthened this identity. Capturing these would be important to give the range a true feel, though it would be difficult given that most photos of him are black and white. Certain textures come through in the photographs though – tweed and wool, particularly – certain patterns and prints too, like tartan. He wore Clark's Wallabee shoes that are still available today.

To really capture his look and style, we included in the range a tweed blazer, lightweight cotton-elastane roll necks, crew neck wool jumpers, Aran wool jumpers, tartan check shirts which he had been photographed in and a boot style close to what he wore himself. The fabric weights were lighter, in keeping with Beckett's slender frame, and the compositions were more athletic, which reflected his life as a keen sportsman turned writer-director. 'Athletic artwear' is how I would describe the overall direction: artist, writer, director and actor as a performance athlete. The colour story was sombre and somewhat austere, but the story of his life, from sportsman to wartime secret agent to street stabbings, was madder than you could make up.

Mister

Spring–summer 2017

'Don't worry, Mister, we'll win it all.'
– *Andrés Iniesta to Pep Guardiola*

The power of a word

How does the story of a near-forgotten Irishman in Spain in the early 1930s become a clothing collection? Where do fashion design and marketing come into the story of footballer and manager Patrick O'Connell? The style of modern professional football managers has become hugely visible, with many wearing designer suits on the sidelines and clubs entering into partnerships with European fashion brands from Hugo Boss to Armani, DSquared2 to Zegna. O'Connell dressed like a modern-day manager even though his heyday was almost 100 years ago. He was at the crossroads of football and style in how he dressed.

Style is a consideration for most top football managers today, none more so than for Pep Guardiola who wears Stone Island, DSquared2 and Puma on the sidelines at Manchester City, a far cry from the tailored suits he wore at Barcelona. Atletico Madrid manager Diego Simeone is famous for his all-black suit and puffer jacket sideline look. Julian Nagelsmann is younger but wears a variation of a wedding suit at Bayern Munich. All these names, and every football manager in his own way, represent the relationship between design and sport in how they dress. There is a word that captures for me what is happening at this intersection. That word is 'Mister'.

I read a story about an encounter in the late summer of 2008 between Barcelona footballer Andrés Iniesta and newly appointed Barcelona manager Pep Guardiola. After Guardiola's first two games in charge, Barça had amassed

just one point. The pressure on him was mounting: 86 per cent of club fans polled in an online survey felt he was the wrong appointment for the club, and that rival José Mourinho would have been a better bet as manager. As Pep sat deep in the bowels of the Camp Nou, combing through the reasons for the defeat and the draw in his first two games, analysing his ideas and performance, maybe even doubting himself, there came a knock on the door. Iniesta, his diminutive midfield general, struck his head in.

'Don't worry, Mister,' said Iniesta, 'we'll win it all. We're on the right path. Carry on like this, okay? We're playing brilliantly, we're enjoying training. Please don't change anything.' Iniesta finished by saying 'Vamos de puta madre', which translates as 'Let's fucking go!' Guardiola subsequently stated how much that conversation and gesture meant to him. Barça went on to win La Liga, and all six available trophies that year.

It wasn't Iniesta's closing words that captured my imagination but his use of the term 'Mister' to address his manager. This term of address is commonplace in football in Spanish-speaking countries. In Gaelic games, players usually call their managers by their first names, but in Spanish football, players refer to the manager only as 'Mister'. And one of the first managers to be dubbed 'Mister' was Patrick O'Connell in the 1930s.

My next collection had unlocked itself. MISTER would tell the story of O'Connell, and the looks and style of the collection would be based on the modern football manager,

especially Pep Guardiola with his distinct personal style, but also José Mourinho, Zinedine Zidane, Diego Simeone, Antonio Conte and Luis Enrique, all of whom dress the part. The truth is any successful modern football manager controls how he dresses as he realises this plays a part in how he is perceived by his players, fans, owners, media and opposition.

For today's professional football managers, the sideline is a catwalk. It's not that the managers treat it as such, but the brands that pay huge money to partner with the clubs of these managers do. Take a look at some of the European footballing powerhouses partnered with European fashion powerhouses and you get a sense of how significant the football–fashion relationship is becoming. Manchester United and Paul Smith, Manchester City and Dsquared2, Chelsea and Hugo Boss, Liverpool and Hugo Boss, Real Madrid and Hugo Boss, Barcelona and Thom Browne, Paris Saint-Germain and Balmain and Jordan Brand, Arsenal and Lanvin and, more recently, FourTwoFour on Fairfax. The PSG relationship with Jordan Brand (the brand created and designed by my reference point for the industry, Tinker Hatfield) has boomed to become a cultural juggernaut. There are plans for the partnership to become a luxury brand in its own right, with its own global stores. It has become a reference point for many future collaborations between sporting organisations and brands.

In recent years, we are seeing more and more that the key to this relationship is less focused on the players and

José Mourinho in 2010

more on the 'mister'. Managers are cultural style icons, and it was time to tell their stories, from Patrick O'Connell through to Pep Guardiola.

The first Irishman to ever play for Manchester United

Patrick O'Connell was born in County Dublin in 1887. Little is known about his childhood, other than that by age 10 he had moved to live with his aunt and uncle and become a promising footballer on the Dublin underage scene. O'Connell signed his first contract with Belfast Celtic, along with another player called Peter Warren, for a combined fee of £50. By 1914, O'Connell had become the first Irishman to play for Manchester United, signed for a fee of £1,000.

When United spotted him, O'Connell was playing not for his club at the time, Hull City, but for the Republic of Ireland in a British Home Championship tournament. He played centre-half in a 3–0 win against England. Having already beaten Wales in the first game, Ireland drew with Scotland in the final round to give them tournament victory for the first and only time. What impressed the Manchester United scouts more than anything else was the fact that O'Connell competed in the tournament with a broken arm.

O'Connell's career at United was reasonably successful but marked by occasional controversy. He became captain in 1914 and was well regarded as a leader and speaker. In

April 1915, United played Liverpool in a game they needed to win to avoid relegation. It is reported' that early in the game spectators began to jeer at the non-competitive nature of the game, with missed tackles, misplaced passes and a seeming lack of intent on both sides. Bookmakers later reported a flurry of bets on United to win 2–0. United did win 2–0. The club avoided relegation, condemning London clubs Chelsea and Tottenham to that fate.

Shortly after, suspicions were raised and questions asked as to the non-competitive nature of the United–Liverpool game and a peculiar turn of events around a penalty awarded to United, when they were 1–0 up. O'Connell himself, not the regular penalty-taker nor known for his goal-scoring prowess, insisted on taking it and achieved a glaring miss. He booted it so far wide that match officials halted the match. They even discussed calling it off, such was the farcical nature of the game. As would be the case many times throughout his life, mystery surrounded Patrick O'Connell. Why would he insist on taking the penalty out of the blue? Did he know of the match-fixing? If so, why would he snub the chance to make the score 2–0 as fixed? Or did he know another goal was imminent and so deliberately missed it? These were some of the questions raised in the aftermath.

The Football Association launched an investigation and it was found that a former United player who had moved to Liverpool, Jackie Sheldon, was central to the match-fixing scandal. The FA rejected players' claims that they

undertook the match-fixing in fear of the season being cancelled and their livelihoods being lost due to World War I. So it came to pass that the season was cancelled because of the war, but not before the FA banned seven players (three United, four Liverpool) for life, on evidence given by Liverpool captain, Fred Pagnam. Of the United players interviewed, club legend Billy Meredith stated that he was quite surprised during the game when teammates who would normally pass him the ball instead seemed to avoid doing so. O'Connell himself was found not guilty of any impropriety but the story of match-fixing followed him throughout his career.

Patrick O'Connell, Harry Boland and the 1916 Rising

Both Patrick O'Connell and Harry Boland were born in 1887 – Boland in Dalymount Terrace, Phibsboro, and O'Connell in 11 Jones' Terrace, Drumcondra. Today, Jones' Terrace is one of the approach roads for sports fans to enter and exit Hill 16, the iconic terrace at the north end of Croke Park.

The two men played a lot of sport together growing up. Boland was a keen hurler and also played soccer for Frankfort, which was O'Connell's club as a junior. The club was founded in 1900 in Frankfort Cottages on Amiens Street, across from Connolly Station. Oscar Traynor, who was a member of the first Irish government, also played for Frankfort. Traynor went on to play in goal for Belfast

Celtic, where O'Connell also played. Traynor, whose name lives on in Irish schoolboy soccer today through the Oscar Traynor Cup competition, hung up his boots to fight for Irish independence. All three men were friends and founding members of the League of Ireland 100 years ago in 1921–22.

Patrick attended O'Connell Secondary School down the road from Gills Pub near Croke Park, while Boland attended the famous Synge Street School off Camden Street on the south side of Dublin. At the time, it was unusual for people to go to secondary school, never mind a fee-paying school as in the case of Harry Boland, who attended De La Salle College in Laois after he left Synge Street following a dispute with a brother who was teaching there. Disputes, or the resolution of disputes, were central to the lives of both men and would reconnect them years after O'Connell left Dublin to play professional soccer in the United Kingdom.

During this period, footballers didn't get paid during the off-season, so during the summers of 1914 and 1915 O'Connell had worked for Ford in Trafford Park in Manchester, a stone's throw from Old Trafford. This gave O'Connell access to a car, and he was one of the first people in the Harpurhey area of Manchester to have such a prized possession. He used to let the kids in his Church Street neighbourhood ride around in the car.

In 1915–16, after football was suspended due to World War I and ahead of the Easter Rising; O'Connell was making guest appearances for Leyton Orient (then known

as Clapham) in London and working in a munitions factory in Silvertown. Silvertown was in the East End of London and was infamous for an explosion in 1917 that killed a number of workers. Boland and Traynor had retired from sports and were at that time full-time members of the Irish Republican Brotherhood. They tracked O'Connell down to Silvertown and hatched a plan: O'Connell would ship ammunition home to Ireland ahead of the Rising.

O'Connell took the weaponry from Silvertown and drove to the port of Garston in Liverpool. His car was probably put on the boat by crane – this was before the days of the roll-on/roll-off system. He landed in Dublin weeks before the Rising and passed the weaponry to the IRB.

When the war ended in 1918, O'Connell had difficulty finding a club. When he eventually found a job, it was in the north-east of England with Ashington Town. He retired as a player soon after joining and moved into coaching with the club. At this point the mystery deepens, as O'Connell's whereabouts were unknown for a period of time – even to his family. It wasn't until his wife, Ellen, and four children began to receive letters in the post containing money sent from Santander that the family learned where he was. He had moved to the north of Spain to pursue his coaching career without telling anyone.

Vamos

Fast forward to the years between 1931 and 1935, and we find O'Connell managing Real Betis in the southern city

of Seville, known at the time as Betis Balompie. He led them to the Segunda División title in 1932 and then to their one and only Spanish first-division La Liga title in 1935. This was a historic achievement for the club and in Spanish football. To give it a modern-day context, while O'Connell scraped a living, the top managers today live on multi-million euro contracts per season, with bonuses, image rights' payments and pay-offs if sacked, and they are among the best-known people on Earth. Names like the now-retired Alex Ferguson, Zinedine Zidane, Carlo Ancelotti, Pep Guardiola and Diego Simeone roll off the tongues of football fans around the world, while hardly anyone remembers the man christened 'Don Patricio'. For further context, Real Madrid, Barcelona and Atletico Madrid are the top teams in Spain today, global brands in their own rights. Comparatively, Real Betis are a modest club and have not won a league title since 1935, athough in 2022 they won Spanish football's premier cup competition, the Copa del Rey, or the King's Cup.

O'Connell versus General Franco

O'Connell's success with Real Betis attracted the interest of FC Barcelona, who hired him for the 1935–36 season. He led them to the regional Campionat de Catalunya title and the Copa de España final, where they were defeated by Real Madrid. O'Connell faced the same challenges in his management career in Spain as he had in his playing

career in England. During the 1936–37 season, La Liga was suspended because of the Spanish Civil War, which began when General Franco's fascists led a military junta against the republican government. Barcelona is located in Catalonia. Franco, a Real Madrid fan, saw all things Catalan, and FC Barcelona in particular, as a threat to his regime. He vowed to destroy the symbol of Catalonia by repeatedly bombing its stadium. The structural damage and the loss of income from games had a ruinous financial effect on the club. Drastic action was required to save its future.

In early 1937, FC Barcelona received an offer from a businessman, Manuel Mas Serrano, via one of their players, Josep Iborra. Serrano proposed that the club play a series of exhibition matches in Mexico and the United States, for which the club would be paid $15,000, with all costs covered. FC Barcelona's travelling party consisted of 16 players, plus O'Connell, trainer Ángel Mur, Rossend Calvet, the club secretary, and Modest Amorós, the club doctor. In Mexico, they played against Club América, Atlante FC, Necaxa and a Mexican XI among others. In the United States, they played against Brooklyn Hispano, Brooklyn St Mary's Celtic and an American Soccer League XI. They finished the tour with a game against a Hebrew XI.

The financial success of this tour meant that FC Barcelona cleared their debts and were able to rebuild the club. They literally had to start from the ground up following Franco's bombing campaign, which destroyed their home stadium. The playing staff was the next

Francisco Franco

challenge: when O'Connell returned to Spain, he only had four players remaining. The others had chosen to go into exile in Mexico and France. This was a huge obstacle but by no means the only one facing Don Patricio. The FC Barcelona president Josep Sunyol, who had hired O'Connell, had been captured and killed by pro-Franco forces as he drove from a political rally in Valencia. Sunyol had been an envoy on behalf of the president of the Catalan parliament Joan Casanovas. It was weeks after the event, while O'Connell was holidaying in Ireland, that he received a letter from the club informing him of the death of his friend Sunyol. The club told O'Connell that they understood if he did not wish to return for his own safety. But he already had experience of political activism from his procurement of arms for the Easter Rising, so return he did.

By the 1937–38 season, the region held by the Republicans had been reduced and competitive football was impossible to organise. However, a Liga Catalana was organised, featuring just Catalan teams. Despite a depleted squad, a half-built stadium and a greatly reduced competition, O'Connell and FC Barcelona won both the Liga Catalana and the Campionat de Catalunya. Catalonia is still locked in a fierce battle for political independence from Spain. And Barcelona and Real Madrid are still consumed by the intense politico-sporting rivalry which took root on the watch of an Irishman.

The life and times of Patrick O'Connell after football is also shrouded in mystery. We know he returned to London

from Spain in 1949. Letters to his old clubs Real Betis and Barcelona suggest that money became an issue. It was common in the 1940s and 1950s for players to write to former clubs seeking support in hard times, which clubs nearly always provided. Both clubs offered O'Connell financial support.

In November of 1955, the Spanish national team arrived in Dublin to play Ireland in a friendly match. After the game, which ended 2–2, Spanish players were socialising in a pub when a young Dan O'Connell entered. On seeing the Spanish players, Dan asked if they had ever heard of a relation of his. The relation in question was his father, Patrick O'Connell, whom he had not seen in years. All the Spanish players knew him as one of the country's top coaches. He was by then in charge of Seville, Betis's city rivals. Dan went to Spain to find him, according to Sue O'Connell, wife of Patrick's grandson Mike. The reunion didn't go well, and Dan returned to Ireland no closer to his father.

Sue O'Connell wrote *The Man Who Saved FC Barcelona: The Remarkable Life of Patrick O'Connell*. Published in 2016, it is a comprehensive account of the man they called 'Mister'.

O'Connell died in London after leaving Spain. He had turned to alcohol after his management career ended and died alone, buried in an unmarked grave in St Mary's Cemetery in Kilburn. In 2014, his plot and grave were recovered and restored by a trust fund set up by family and supporters to honour his memory and career.

Pep Guardiola in 2015

The collection

For me, once the story and name of the collection are defined, everything else flows from there. The collection is unlocked and I get clarity on colour and prints. Each season I like to find a way of communicating the story through print. For MISTER, we used a geometric repeat of a hexagonal shape to resemble the shape of FC Barcelona's home stadium, Camp Nou from above. This was repeated on shirts and T-shirts.

The MISTER colour story was simple. It was based on the colours of FC Barcelona with the famous 'blaugrana' (blue and burgundy in Catalan) being central. We also included Barça's away kit colours – turquoise, mint, navy and grey. The colours all combined well with the summer season and provided a visual identity in keeping with the story of the collection. Pep Guardiola and his sideline style was the reference point for the modern-day Mister and for the looks within the collection. The longline puffer coats that Guardiola and Simeone – and most elite football managers – wear on the sideline was the main piece of the range. Lightweight polo sweaters were also included, as were round neck jumpers, more casual sweatshirts and stretch chinos, which are another item regularly worn by managers like Spanish national coach Luis Enrique. Sports socks and a vintage Barcelona-style jersey were also included. On the whole, MISTER was less about the clothes and more about the man. The manager. The leader. At this elite football level, they live with constant attention,

pressure, criticism and praise. 'Mister' is a term of respect, and managers must deal in respect to get players to buy in. They must lead with their words first, in the personal connections, the delivery of their tactics, the articulation of their ideas. I have always respected the power of words, and of clothes. The writer Mark Twain said clothes make the man. And they can, but the man must want to make a man of himself first, and he can do that using clothes, or more specifically, a uniform. So maybe it's truer to say that clothes make the leader, and a uniform is a key weapon in any leader's arsenal.

Shelby

Autumn–winter 2017

Grace: How much did you pay for the suit you'll be wearing?
Tommy: Oh, I don't pay for suits. My suits are on the house or the house burns down.

Grace Burgess asks Tommy Shelby a question of style and gets an answer of substance in season 1, episode 2 of Peaky Blinders.

The epigraph for this chapter is a piece of dialogue between Tommy Shelby and Grace Burgess that happens in the context of the upcoming Cheltenham Races, to which Tommy has invited Grace as his guest. It later gives rise to a scene in which Tommy visits his tailor, Mr Zhang, under the premise of inspecting and buying some new suits for himself. Tommy knows Mr Zhang is also making Cheltenham suits for Billy Kimber, a local rival businessman, bookmaker and racketeer, so he shows up at the same time as Kimber, and a business meeting of sorts unfolds. Tommy feels the fabric weight and texture of Kimber's new suits and proposes a strategy for collaboration. It would be an uneasy alliance, manufactured to take on a common enemy, the Lee family, who were also coming to Cheltenham with the aim of shaking down Kimber's bookmaking operation.

That the conduit and backdrop for these discussions around gang culture, strategy and alliance is a tailor's shop is interesting. Tailored suits are a lens through which we can examine men's relationship with clothing. The tailored suit and horse-racing also go hand in hand, and they combine to create an environment in which many Irish men feel comfortable. Nearly everyone is dressed the same way, for a start, so few stand out. Standing out for what you wear is a fear for some Irishmen. There are few as paranoid as the man who has just stepped out in public unsure about what he is wearing. He is full of doubts and questions and should be left alone to ease into the afternoon, of course,

but other men can't help but make him feel more uneasy by pointing out whatever defects his outfit might have.

While *Peaky Blinders* is a fictional television series, we know the relationship between men and their suits is a real one, central to many of the big occasions in our lives – from communions and confirmations to job interviews and weddings. Suits mean business to men – they are our uniforms. Historically, Irish men have placed a huge stock in tailored suits. Photography from the early 1900s shows us how central the three-piece suit and overcoat were in the lives of Irish men. They were part of everyday life, especially on a Sunday. There was an indigenous tailoring industry, which meant tailored clothes were more common. Men had fewer clothing choices back then too, leading to a more uniform way of dressing.

Suits were a feature of Irish life, especially in a military context. Much like the *Peaky Blinders* scene between Tommy Shelby and Billy Kimber, suits and tailor shops were central to military subterfuge and strategy. Harry Boland, the republican politician and military activist, was a trained tailor and held many strategic council meetings under the guise of business from his shop on Middle Abbey Street during the War of Independence.

Who were the Peaky Blinders?

The Peaky Blinders, or the Small Heath Peaky Blinders as they were originally known, emerged from the many 'slogging gangs', or 'sloggers', who ran the streets, dancehalls,

bars and racecourses of Birmingham in the late nineteenth and early twentieth centuries. 'Slogging' was a Victorian term for fighting and is defined as 'striking with a heavy blow'. It wasn't just fists that were used but foreheads, belts, boots, bricks, knives and socks filled with locks.

Newspaper reports from April 1872 record the first mention of slogging in Birmingham, when a gang of 400 youths descended on Cheapside to throw stones and brick bats through shop windows and at passers-by. *The Birmingham Post* wrote about the riot and the 'large body of roughs' who 'threw bricks, bats and stones at the windows of the hucksters [general stores] and confectioners that were open'. The gang was eventually dispersed by police but the slogging continued over the following days and weeks. Arrests were made and boys aged 13 and 14 were caught throwing stones at policemen. Thirteen-year-old John Gibbon, an engine driver, and fourteen-year-old Michael Lowry, a filer, were imprisoned for 14 days each.

Birmingham historian Carl Chinn, who grew up in the area of Small Heath, heard tell of many gang members throughout his childhood. His great-grandfather was a Peaky Blinder. Chinn described an incident on the night of Christmas Eve 1893, when two gangs fought outside a dancehall on Park Street, an area known today as the Bullring in Birmingham City. The Park Street Gang were inside the dancehall when a local Barford Street gang showed up at the door. Both sides took to the streets and a member of the Park Street Gang, a teenage nail-maker

named John Sherry, was stabbed and killed. At this time, there were up to 50 small family gangs in and around the city, fighting turf wars and running racecourse rackets. The number of gangs would soon be greatly reduced as a result of arrests but, no matter how many were active, two things would remain constant: the clothes and the fighting.

What these slogging gangs wore was used and abused for fighting purposes. Birmingham in the early 1900s was an industrial town. Belt-making was one of the main industries. Belts were worn to keep high-waisted trousers in place but doubled up as weapons. They were swung overhead and the buckles were used to slash and maim. Boot-making was also, and still is, a big industry in Birmingham and the Midlands generally. Stomper boots were not just worn for fashion but for actual stomping and kicking during fights. Even socks were weaponised, and filled with locks to hit opponents. But the 'weapon' closely associated with the sloggers, and their fighting way of life, was their caps.

Before the peaked cap now synonymous with the TV series, the gangs wore a different style of cap, known locally as a billycock. This style was more akin to a bowler hat and was worn by older gang members. As younger men joined the gangs and hairstyles became more of a consideration, the peaked cap became more prevalent on the streets. How these caps were worn gives insight into the vanities of the gang members. These men were particular about their hair and mostly had quiff hairstyles with undercut shaved backs and sides. The hairstyle is said to have first originated in

WWI military camps, where soldiers had to shave their heads to prevent the spread of lice.

These adapted quiff hairstyles were not brushed or slicked back, as you might see today, but worn as side-fringes, slicked down to one side. To show off their slicked-down quiffs, the sloggers wore their caps tilted to one side, covering one eye. According to Carl Chinn, the term 'Peaky Blinder' actually originates from this quirk of hairstyling rather than being linked to the gangland habit of keeping razor blades tucked into the lining at the back of their peaked caps, as the series and urban storytelling suggests. Chinn states that this method of attacking foes by slashing them with the back end of their caps while holding the peaked end, as portrayed in the series, was never actually utilised.

As shown in the series, men's clothing of the time was linked to fighting. Bringing this old world back to life showed us a new way to dress. Traditional television – the BBC – produced the series, but this sector has been disrupted forever by Netflix. BBC iPlayer and Netflix allowed viewers to watch programmes on demand and made the show more accessible to a global audience. The Peaky Blinders became the great influencers as a result, giving new meaning to men's style and making new rules for men to live by. They did it all through haircuts, caps, boots, braces, penny collar shirts and, of course, tailored suits.

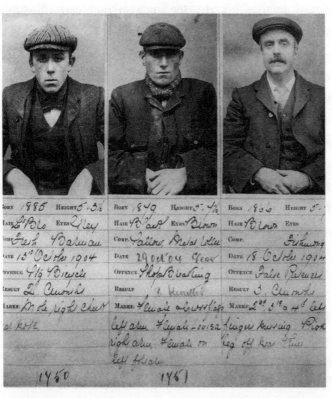

Mugshots of the Sheldon Gang, the original Peaky Blinders

Tommy Shelby, influencer

Cillian Murphy is a Corkman and an actor. Tommy Shelby is a Brummie and a gang leader in 1920s Birmingham. So real and transcendental is Murphy's portrayal of Shelby that the two men have become one in people's minds. It is almost impossible not to see Shelby when you see Murphy or Murphy when you see Shelby. What was it that made the character so strong and compelling, so inspiring? Put simply, it was his clothing and the language he uses. Shelby was the great influencer: quotable and well-dressed.

Clothing and personal style play a strong part in the Peaky identity. The suits worn by the gang not only created an armour but also allowed them to build their identity as men of power. In dressing like Tommy Shelby, you were following in the footsteps of a soldier turned entrepreneurial gangster. Costume designer for the series Stephanie Collie based her styling and creative direction for the looks worn on the show on original police mugshots taken in the early 1900s. The level of detail in the images – from the caps and hairstyles to the jackets and coat lapels, shirts, collars and cufflinks, ties, tie-pins and textures – was rich source material as Collie sought to recreate a look and an era.

Many of the looks were similar: a dark, heavy overcoat – herringbone check or Donegal tweed fabric or sometimes plain – was the first component. Colours were subdued, in keeping with the times. One reason for this was the fact that Birmingham was an industrial town burning a lot of coal. The air was heavy with soot that covered outdoor

surfaces with a coat of silty grime, making it difficult for people to keep clothes clean. Shelby's gang dressed in an understated way. The stylists went for extra length in these coats to capture the energy and drama of gunslingers, with their coats flapping in the wind as the protagonists burst through the saloon doors before facing off at high noon, or in the case of the Peaky Blinders whatever time of day was necessary. These long, oversized coats were also used for hiding weapons.

The suits worn by Cillian Murphy in the show were handmade by a great tailor called Keith Watson. Everything was cut and fitted to measure, yet everything felt loose and moved with the same urgency and energy of Murphy himself. Shirts were another central component of the look. Penny collar shirts – a bridge between grandad collars and traditional pointed collars – were the favoured choice. Cropped, loose, sometimes high-waisted trousers were worn with a six-piece section baker boy cap and lace-up boots. Anyone who watched the series will know and recognise it as the Peaky uniform.

In the show, the Shelby gang didn't dress to stand out from their Small Heath community – they merely wore cleaner, much more expensive, versions of what everyone else wore at the time. Their working-class roots were important to them and their uniforms reflected this, promoting who they were and where they came from. They were a working-class gang and proud of it.

But perhaps what really resonates with audiences are

the language and intellect displayed by Tommy Shelby. His way with words was as compelling as the suits he wore. Tommy cursed, he threatened and he drank, but he also used language to make opportunities and money and to cut to the quick of the human condition. He has become one of the most quotable characters on television.

In reality, there is more than a grain of truth in the clandestine meetings held between faction leaders in tailor shops as portrayed in *Peaky Blinders*. During the Irish War of Independence, many strategic councils were held in the tailor shop owned by Irish revolutionary Harry Boland at 64 Middle Abbey Street, in Dublin City centre. From here, Boland met with other key republican figures, who would often arrive at the shop wearing one suit and leave wearing another. Aside from strategising, Boland also made suits for the backs of Éamon de Valera and Michael Collins. The tailored suit meant business. It was sometimes a cloak for crime and more times a uniform for soldiers and peace-keepers alike. (You can read the full story of Boland's life later in the book.)

In *Peaky Blinders*, two enemies – Shelby and Kimber – would create an uneasy alliance by coming together to defeat the Lees. Kimber resented the need for the alliance but knew it was necessary to survive. Tommy knew the alliance was just a step towards ultimately superseding Kimber and taking his London bookmaking business for himself. The pact was born in a tailor shop, so the phrase 'cloak and dagger' literally applies. First coined in the 18th

century to describe a genre of early theatre melodrama in France and Spain, the phrase points to the close relationship between men's clothing and crime, alluding as it does to the wearing of a full-length cloak by early criminals and thieves as a means of concealing identity and the weapons they carried underneath. In these plays, the cloak was often used as part of any attack as the assailant would throw it over the head of whomever he was attacking. The heavy woollen, bonded cloak fabric also acted as a defence from any counter stabbing or slashing. Charles Dickens himself is credited with bringing the expression to the English language. In his 1841 novel *Barnaby Rudge*, Dickens makes reference to the use of cloak and dagger to create a sense of subterfuge, deceit and trepidation for the audience. The exchange goes as follows:

> … his servant brought in a very small scrap of dirty paper, tightly sealed in two places, on the inside whereof was inscribed in pretty large text these words: 'A friend. Desiring of a conference. Immediate. Private. Burn it when you've read it.'
>
> 'Where in the name of the Gunpowder Plot did you pick up this?' said his master.
>
> It was given to him by a person waiting at the door, the man replied.
>
> 'With cloak and dagger?' said Mr Chester.

Still from *Peaky Blinders*

And so it was between Thomas Shelby and Billy Kimber in *Peaky Blinders* and indeed between Harry Boland and the Crown Forces in real life during the War of Independence. Clothes were a form of military strategy.

The series did a great job of highlighting this attention to style that men of the time held. It also showed us that horse-racing is a great leveller. Going to the races is a time many men will lose their discomforts and inhibitions about clothing and embrace the art of 'dressing up', though few would describe it as such. I don't believe most men, especially most Irishmen, are ever happier than when they are jumped up in a new suit for the races. Getting dressed up for a wedding comes a close second, but there is something about a day at the races in a new suit for a man and his friends. Normal rules don't apply. Just ask the Peaky Blinders.

Netflix

In researching this collection I was interested in Netflix as a cultural vehicle. By late 2016 it had become a driver of conversations. I began to see the platform as a positive influence, democratising how creators got to work and affording them more opportunities to produce content that could be seen around the world, and also democratising how people like me choose to consume it. It offered opportunities and choices. I liked having choices about what channels or platforms I watched, what I could watch on those platforms and when I watched them. The absence

of time constraints, routine, traditional scheduling and ads appealed to me. The library experience of the Netflix format also drew me in: choosing a series felt like choosing a book from a library shelf or a magazine at a newsagent. As the world of library-style content opened up before me, I began to learn more while viewing. Netflix was influencing my habits and behaviours positively, answering to my interests and helping me learn through those interests. It allows us to travel to cities, countries, oceans, mountains and jungles, restaurants, hotels and museums, learn languages and new skills, explore new careers and cultures, learn about tech, business, history, geography, maths and science. A whole world of discovery is available at your fingertips while sitting at home.

Through this new content library, we can run the spectrum from home improvements to mindfulness, travel to tidiness, art to architecture, real-life crime documentaries to brilliantly written gangster series like *Peaky Blinders*. We can find everything we could want to educate ourselves or lose ourselves. It felt like going back to school, with lots of learning and discovery. Netflix was a cultural game-changer, a democratic platform elevating new creative talent and the viewer alike. Where once creators and filmmakers were at the mercy of individual powerbrokers who held the finances to dictate whether their work would get made or not, and whether their careers could progress or not, new platforms like Netflix, even if powerbrokers in their own way, created a new opportunity. I wanted to talk about this, reference

it and celebrate it as a platform for expression and opportunity. Anti-oppression was becoming a theme within my storytelling at this point in 2017. The national anthem, the Walker brothers, Beckett's work in the French Resistance, Patrick O'Connell's efforts during the Spanish Civil War — they were all anti-oppression in their own ways.

Having spent the previous four seasons with Dunnes looking backwards at past cultures, people and events, I wanted to examine a contemporary issue and study the people who matter now. Who are the people driving change, inspiring youth, creating employment opportunities, creative opportunities, new technologies and possibilities, and rewriting the rules of how we live, work and consume?

Having watched the full season of *Abstract* on Netflix, I wanted to base the autumn–winter 2017 season on this design series initially. I thought the content was interesting. How Tinker Hatfield, a former college track athlete and qualified architect, turned to footwear design after injury curtailed his running career. How Hatfield had got into the psyche of prime Michael Jordan to drive the creative process which made the Air Jordan brand a cultural and commercial juggernaut in the '80s through to today. How Es Devlin designs stage shows, from Jay-Z and Kanye West's Watch the Throne Tour to creating the spectacular closing ceremony for the 2012 London Olympics. How Bjarke Ingels was redefining architecture through apartment blocks that swoop like ski-slopes and

a power-plant in Copenhagen you can actually ski down. By the end of this new decade, Ingels's company BIG will have built a permanent lunar base for NASA astronauts. What a challenge and what imagination. Christoph Niemann, @abstractsunday on Instagram, the *New York Times* illustrator and graphic designer, was showcased, along with Ralph Gilles, the Chrysler automotive designer, the photographer Platon, and Paula Scher, the graphic designer responsible for hundreds of music album covers and New York City street signs. *Abstract* is full of imagination and creativity, but it was probably a bit too abstract as a means of storytelling and marketing a men's clothing collection.

Marketing is a conversation or a series of questions and answers. Every season you try to parse what your friends, contemporaries and peers are talking about. What are they interested in, active in, committed to and inspired to action by? In the case of my business, I need to know what Irish men are talking about in their spare time and to figure out what I want to say to them. I ask myself what they are discussing – why this and not that? Are they thinking about business, travel, sport, GAA, rugby, NFL, MMA, Netflix, RTÉ, art, architecture, football boots, trainers, shorts, socks, jocks, tech, watches, design or finance? Why aren't they talking about X? How do I start a conversation about Y? How can I partake –why does any of this matter? I was sure some of the answers to these questions could be found on Netflix. Netflix is where I often search nowadays if I am curious about something related to design, sport,

travel, architecture, art or business. It contains answers to most of the things I'm interested in. It is like a library of my interests that can be searched, scrolled and studied, driving the conversations I am having offline in real life.

I searched Netflix for a series upon which I might be able to base a collection. *Suits* was another potential series to study, but if *Abstract* was too abstract, then *Suits* was too literal a source of inspiration. The answer appeared in the form of *Peaky Blinders* and the two men central to its creation and ultimate success. One was front and centre on the screen, the other had to be discovered behind it. Stephen Knight, the show's creator, was unknown to many until the show became a hit. Lead character Thomas Shelby, played brilliantly by Cillian Murphy, became a cultural icon for how he behaved, for his cunning and craft, for style, his hair and also for the things he said. His cultural penetration was image-led and stylised but he was also, thanks to Knight, hugely quotable. Both men were leaders of the pack in differing ways, and strong reference points for other men, especially those working in the creative industry. Between them, they created a new world, or rather re-created an old world, that was 1920s Birmingham, and made it look, feel and sound new.

But let's start with Knight himself, a man so creative it is hard to keep up. Because it is through him and within him and his life story, that *Peaky Blinders* (and Thomas Shelby) came to life in the first place. Many of the Peaky Blinders gang members on whom much of this series is

A mugshot of a young member of the Peaky gang, Charles Lambourne, pictured in 1876

based were Irish, having moved to Birmingham for work as Ireland spiralled into poverty. Many worked in steel yards, factories and warehouses. Others carried on the old Irish trade and tradition of shoe-making for horses, having learned it as boys in the traditional, stone-built forges that dot my own home parish of Lixnaw in north Kerry and the Irish countryside.

Stephen Knight and the mobile forge

Knight was born in 1959 in Wiltshire in England and raised in nearby Small Heath, Birmingham. His father, George Knight, was a blacksmith until the UK's soldering industries went bust. George went to work in his brother's car garage as a mechanic for a short time before displaying the optimism inherent in all entrepreneurs and returning to the blacksmith trade with a new way of shoeing horses. In the 1960s, George built a mobile forge that allowed him to get around the city and visit the stables rather than have horses and owners come to him. Stephen was eight at the time. It was while watching his father shoe horses in the stables, farmyards and scrapyards of Birmingham that *Peaky Blinders* was born.

Knight has described how following his father in and around these scrapyards and stable yards exposed him to the reality of life in Birmingham, the undercurrent, one full of real-life characters who would ultimately inspire the characters central to the show. Knight describes these yards as being:

… full of the remnants of what Birmingham used to be, stolen stuff, scrap metal, all kinds of things. It was like an Aladdin's cave. As my dad shoed horses, I'd hear them talking. There was Charlie Strong, who I've used in the series, and Curly, who was my great, great uncle. Very, very funny people. It was that flavour of the last of that old Birmingham that I tried to put into *Peaky*.

The visual and human inspiration Knight discovered as a young boy comes through strongly and gives the series the strength and depth that makes it so compelling.

The Shelby family central to the show are also based on a real-life family, the Sheldons, which included the uncles of George Knight. Stephen recalled them from his childhood as sharply dressed gangsters, often sitting around drinking gin and whiskey from jam-jars while counting their earnings gained from illegal bookmaking. They carried the guns and blades and haircuts of war, shaved to the skull on the back and sides. In portraying them, Knight looks beyond the crime and danger to romanticise their day-to-day lives. In making *Peaky*, he wanted to preserve a past both he and his father knew, but also to promote an aspirational mentality.

The entrepreneurial streak evident in George Knight with his mobile forge ran in the veins of his youngest son, Stephen, too. Knowing he wanted to be a writer of some sort, Stephen left Birmingham for University College London

to study English. Long before he reached *Peaky Blinders* fame, he wrote novels and award-winning screenplays and created TV shows and board games. For example, do you remember the quiz show *Who Wants to Be a Millionaire?* In 1998, Knight, along with two others, created this ITV show that has been a cultural touchstone for decades.

After attending college in London, Knight went back to Birmingham to work at an ad agency writing radio ads and later wrote novels. It was in the middle of his fourth novel, which he was writing in the present tense, that Knight realised he was in fact writing a screenplay. This novel-turned-screenplay became the indie-movie *Dirty Pretty Things*. Set in London, the film follows the lives of two immigrants and was nominated for an Academy Award for best original screenplay in 2003. It also won many independent industry awards.

Knight noticed the global trend for men dressing like one of the *Peaky Blinder* gang members, in three-piece suits worn like armour, statements of intent. His entrepreneurial streak led to him creating a tailoring brand called Garrison Tailors based on the Shelby family and best worn by Tommy himself.

Even with all his other achievements, Knight is most important for creating Tommy Shelby, the character who would boot open the saloon doors to start new conversations and inspire new styles of dressing, grooming and speaking.

The collection

The SHELBY collection was closely based on the key *Peaky Blinders* looks. Beyond the obvious suits and waistcoats, the collection also included oatmeal long johns worn by men in the early 1900s. We included sleepwear, which featured on the show too – for example, in Tommy's nightmare sequences when he was transported back to fighting in French mine shafts.

Small Heath, the borough of Birmingham from where the gang originated, was incorporated, using its geographical coordinates – 52.4737N, 1.8552W – on jacket sleeves. Given that on the show members of the Shelby family served in World War I and were soldiers at heart, we included a military overcoat and lace-up boots worn by Tommy in the series. Place was important to the Shelbys. Identity was equally important: their names, the family name, the nicknames. To capture a sense of this identity, we incorporated the Shelby family crest on overcoat buttons. It was also embroidered on shirt plackets and shirt pockets and was the ultimate expression of the identity so important to Tommy Shelby.

Boxer

Spring 2018

'Take the time to train your mind.'
– *Floyd Mayweather*

Routines are a precarious business. There's a routine for everything. Morning routine, daytime routine, night-time routine, sleep routine, waking routine, work routine, exercise routine, driving routine, training routine, breakfast routine, lunch routine, dinner routine, coffee routine, bath routine, shower routine, breathing routine, living routine, surviving routine. If you have too many routines, *you* become a routine. I need a routine, but I also need to not have a routine. It's a balancing act. Too much routine, you get bored; not enough, you get into trouble. The best plan is to know when to fire routine out the window and do something different and when to get back on track.

In the winter of 2016, I was beginning to grow tired of my gym routine. The whole process of getting up, getting dressed, walking, running, cycling or driving to the gym and doing the same exercises began to feel boring. That's the trouble with routines. It began to feel like an inefficient use of time. My body was getting its hit every session, but my brain wasn't exercising. My enthusiasm for going to the same place and doing roughly the same things three or four times a week was waning. When that happens, I take it as a message to change routine. When you tune into the energy around your routines, you get insights that can help you to redeploy your energy in a new way. I felt there was a more efficient way to do what I needed to do. My routine with traditional gyms had hit a wall – my home would soon become the gym for me. I went to the

design and development team at Dunnes to create a range
of home-gym accessories focused on resistance exercises
that could replicate a regular gym routine. We based all our
exercise accessories on a sport many would like to master
but few ever do, one where routine and spontaneity are
equally important – boxing.

Pugilist

Boxing stories are inspirational, and boxing as a sport is
often inspirational too; it's the source of many a movie,
song and book. It has inspired some legendary sportswear
brands that still exist today. Back in late 2016, as I began
to tire of my gym routine, I started boxing classes. I'm not
sure what worked harder throughout these sessions – my
arms, my legs or my brain. It's great to experience the true
demands of a boxing session from a proper trainer. It is
so anticipatory that to think of it as just punching does
it a disservice as a sport. There is chess-like planning and
counter-planning that goes into preparing for every round.
There is a thoughtfulness and creativity behind the violence.
I think a person who grows up with boxing training carries
an advantage. Not necessarily just the ability to look after
yourself by throwing a punch, but rather the ability to see
a punch before it lands and to avoid getting hit.

Computing instructions from a trainer for the combi-
nations of punches, head movements and footwork while
punching and swinging until you are physically empty is a
great workout for mind and body. You can feel your brain

working as it does the maths on combinations according to the trainer's instruction. The frontal lobe is found at the front of the brain and is responsible for controlling and producing voluntary movements, among many other complex control and reasoning functions. It is the frontal lobe that also bears the brunt of boxing's brutality.

'Boxing and the Brain', boxing writer David Noonan's seminal piece published in June 1983 in the *New York Times*, perfectly synopsises the cruel contradictions of boxing as a brain game.

> A gelatinous mass suspended in cerebrospinal fluid and floating inside a hard bony skull, the human brain is particularly vulnerable to the rude physics of the sweet science. Subtle in its functions beyond our understanding, the brain is the most complex thing in existence. It is a charged and delicate web of electrochemical cells – neurons – that fire in the endless patterns of life itself, and there are few things worse for it than to be punched around. Ironically, while boxing at its best provides an excellent showcase for the remarkable capacities of the brain – simultaneously requiring balance, co-ordination, fast hands, fast eyes and a combination of memory, instinct, strategy and creativity – it also constitutes the most purposeful and sustained assault on the brain in all of sport.

Brawn game

Surprisingly, at the time this article was written in the early 1980s, boxing was still somewhat underground, loosely regulated and lacking in professional rigour. Noonan recounts a gruesome time for the sport in 1982. On 18 November, South Korean Kim Duk-koo died four days after his lightweight bout against American fighter Ray Mancini. The previous day, a WBA junior welterweight bout between Alexis Argüello and Aaron Pryor had gone 14 rounds and was so violent Argüello was unconscious for four minutes after it and suffered a concussion. The fight went down in history as one of boxing's greatest but most brutal. Pryor's trainer, Panama Lewis, known for bending the rules ringside, was later accused of switching water bottles and giving Pryor a drink laced with an antihistamine to increase his lung capacity. Within two weeks, Larry Holmes spent 15 rounds pummelling Randy Cobb in a historic and ugly mismatch. Coming so soon after Kim Duk-koo's death and Argüello's concussion, it finally forced boxing to reform. American politicians and sporting bodies reassessed regulations and legislation around the sport. They brought in a series of federal bye-laws for the examination of the health and medical records of boxers, licensing requirements and minimum ring-safety standards to make the sport safer and more professional. However, many more deaths have happened in the ring since, and the long-term negative effects of boxing can be seen in the quality of life of retired boxers living with brain injuries.

Brain game

When you contrast this unconscious brutality with the conscious capability and creativity of the brain, as showcased by the best boxers, you begin to understand something more of the 'sweet science' of boxing. I watched an interview on YouTube with a boxer called Andre Berto, who described in detail what it was like to 'fight' against Floyd Mayweather Jr. Berto's main takeaway was Mayweather's constant state of alertness and observation during a fight: as Berto threw punches, Mayweather was so consciously alert and aware and able to predict punches so early, he would watch a punch go by as he slipped it. Berto also spoke about Mayweather's ability to focus on things other boxers wouldn't. For instance, when Berto took the centre of the ring and thought immediately of going on the offensive by landing punches, Mayweather did not throw punches. Berto described feeling after every round that he hadn't fought at all, such was Mayweather's elusive style of head movements, slips and fake shots. These combined to delay and stall Berto's own shots as he antic-ipated punches from Mayweather that never came. Berto also clocked Mayweather checking the time on the stadium clock four times a round and coming in for clinches at the same time every round. Mayweather breathed deeply in Berto's ear every time. Asked about Mayweather's punching power, Berto described it as sharp enough to keep you alert but not powerful. Energy conservation was everything to the older Mayweather, but his overall method speaks of

Floyd Mayweather (right) fights Andrew Berto

a highly conscious, brainy boxer, who moved clockwise when every other boxer moved anticlockwise. He was a counter-thinker, who thought contrary to convention. We don't see a lot of counter-intuition in sport.

There is a myriad of brainy boxers whose craft is based upon intelligence and consciousness in the ring. Guglielmo Papaleo, or Willie Pep as he was known, was an Italian-American who boxed lightweight from 1940 to 1966. He is regarded as the brainiest, brightest boxer of all time for the fact that he rarely boxed at all. Pep's unorthodoxy confused every opponent he met in a 241-fight career. That he won 229 of those fights over 26 years speaks volumes of his ability to not get hit. He became a pioneer for defensive boxing with flair, and famously coined the phrase, 'he who hits and runs away, lives to fight another day'. Such was Pep's mastery that judges once awarded him a round even though he hadn't thrown a punch. Through footwork, head movements and an adapted boxing style designed to confuse, Pep moved in a multi-directional manner without ever losing rhythm or balance. He constantly changed stances from orthodox to southpaw. One minute he was leading with his right hand, but he would then change stance and switch lead hands, which confused his opponents and walked them into punches. Many top boxers at the time were made to stumble against the ropes as Pep shuffled to change stance as the boxers engaged. Central to this unorthodoxy was his habit of standing with his feet close together, so that it was impossible to predict

Willie Pep (right) squares up to Sandy Saddler

which direction he would turn and which hand he would lead with. Watching videos of Pep now, it appears that he was ambidextrous and used this to create confusion.

Pep's style of counter-boxing inspired many martial artists and is even recognised in the style of many of today's mixed martial artists and UFC fighters. Angelo Dundee, the trainer of Muhammad Ali, has publicly stated his admiration for Pep. Dundee incorporated some of Pep's unorthodox movement patterns and defensive tricks into Ali's repertoire.

Ken Norton famously beat Muhammad Ali in 1973 by consistently predicting Ali's left jabs. Norton later revealed he did so by watching for twitches in Ali's left pectoral muscles, which preceded the shot. This shows that boxing more with the brain and less with the body can still be entertaining and successful – and less damaging to that same brain. Might we ever see a change in boxing rules that limits the number of punches per round or offers more points for predicting and slipping punches than for landing them?

Ali himself transcended the sport to become a cultural icon, capturing the popular imagination in a way no other athlete has ever done. His intelligence was a key factor in his success. Ali also had moral courage beyond the norm. But style – both boxing and personal – also played a part in his success. One style fed the other, in a way. Some of the most iconic photographs of him display his power and charisma through what he is wearing. A famous image of him in the

Muhammad Ali is commemorated on a 2006 postage stamp

Royal Artillery Gym in London in 1966, as he trained for his bout with Henry Cooper, shows him wearing all white, arms draped across the top of a punching bag. The sleeves of his sweatshirt have been cut off and his arms display his physical strength. Ali knew the power of image and how good personal style added to the boxer's armoury.

Brand game

We see the role costume plays in boxing more today than ever. Ring-walks have become a fashion parade of robes, caps, logos, embroidery, tape and jewellery. Brands recognise the opportunities and want their name or logo associated with the boxer. The most identifiable part of a boxer's costume is their shorts. These are part of the performance, the persona and the business, given the number of brands who line up to sponsor the shorts of the world's best. Ad space on a top boxer's shorts is lucrative real estate. At the height of his powers in 2015, Filipino boxer Manny Pacquiao could command bidding wars for ad space on his shorts due to the global interest in his bouts with Floyd Mayweather. A six-by-four-inch patch of fabric on the back of his shorts was valued at $300,000. Smaller logos at the front commanded €150,000. It all adds up when you consider that, at various stages of his career, there were six major company or brand logos visible on his shorts.

Some of the world's most iconic sporting brands have their origins in boxing. Lonsdale is one of the oldest and more readily identifiable boxing brands. It was founded by a

former boxer named Bernard Hart, who sought permission to name the brand Lonsdale after Hugh Lowther the 5th Earl of Lonsdale. Up to 1891, boxing had been a bare-knuckle affair. That year, three young men had died in bare-knuckle bouts in the UK, and this inspired Lowther to introduce padded boxing gloves to British boxing.

An eccentric, adventurous character, Lowther did much to promote boxing in England, but he was not the inventor of what we know today as the boxing glove. That honour lies with Jack Broughton, a boxer from London, who in 1743 taught boys how to defend themselves without inflicting the damage of a bloody nose or a broken jaw. Broughton boxed during a time when, though hand-to-hand combat was seen as a noble way to settle a dispute rather than duelling with guns or swords, it was still brutal and without rules. He was regarded as a skilled fighter and one of the few who sized up opponents' strengths and weaknesses before engaging. He accidentally killed an opponent in 1741, and two years later he devised 'Broughton's Rules'. Rules included never hitting an adversary when he was down, banning everyone but the fighters and their seconds from the ring, giving a felled boxer 30 seconds to recover and the use of primitive gloves that lessened the impact of punches. The design for these 'mufflers', as they were first known, is believed to have been taken from Ancient Greece, where gladiators entered hand-to-hand combat wearing studded gauntlets on both hands. In medieval times, knights who disagreed on matters of chivalry or personal honour challenged each

other to combat by removing one armoured glove (gauntlet) and throwing it to the ground at the feet of their enemy. The expression 'throwing down the gauntlet' derives from this. This was a grave insult, a challenge to masculinity and an offer to fight. To accept the challenge, the offending knight would 'take up the gauntlet'.

Nicknamed 'the father of the science of the art of self-defence', Broughton died in 1789 and was buried on the grounds of Westminster Abbey, in respect of his contribution to British boxing. 'Broughton's Rules' survived until 1838, when they were superseded by the London Prize Ring Rules.

Lowther, whose mother, Emily Susan (née Caulfied), was the daughter of Mr St George Caulfield of Donamon Castle of Roscommon, had a rich life in more ways than one. Lowther's father also had enormous wealth, owning coal mines in Cumberland and 75,000 acres of land across the UK. At age 25, Lowther succeeded his brother St George as Earl of Lonsdale. To his credit, Hugh Lowther was a founding member of the National Sporting Club (NSC), which did much to establish boxing in the United Kingdom. He also founded the Automobile Association. The NSC was a private members club, originally headquartered at 43 King Street in London's Covent Garden. The first bouts took place after dinner, in complete silence, as members watched on. Lowther was a lover of the high life and squandered much of the vast family wealth on betting. His life took a turn when he was asked by Queen Victoria to leave the country for a while after he became embroiled in

a high-profile public affair, and so he left for an expedition to Kodiak, Alaska. When he came home, Lowther sought more excitement and challenged John L. Sullivan to a fight. Sullivan was a ferocious Irish-American boxer who had a 10-year unbeaten heavyweight record. Legend has it that Lowther won, though accounts of the bout are disputed and Sullivan's reputation as a boxer is legendary. Lowther's contribution to boxing is lasting nonetheless. He donated the Lonsdale Belts, which are still awarded to British boxing champions today, he insisted on the introduction of timed rounds and a code of rules known as the Marquess of Queensberry Rules, which eventually superseded the London Prize Ring Rules. Maybe his best-known legacy is the boxing apparel brand Lonsdale, which has been worn by boxing greats like Muhammad Ali. Late in life, Lowther became chairman of Arsenal Football Club.

As a further thread of storytelling, John L. Sullivan's father, Michael, came from Laccabeg, Abbeydorney, just down the road from my family home near Tralee in north Kerry. Starting out his career, Sullivan had dominated bar-rooms and the bare-knuckle scene. He became bare-knuckle heavyweight champion in 1882, defeating the reigning champion Paddy Ryan from Thurles, County Tipperary. The fight took place in Mississippi. As was the custom at the time, the challenger, Sullivan, threw his hat into the ring before entering. It is from this old boxing tradition that the saying 'throw your hat in the ring' comes. Ryan, a blacksmith, was a bar owner and brawler feared on

the New York bare-knuckle scene, winning his heavyweight crown in West Virginia in 1880 after 87 rounds with rival Joe Goss.

The collection

It was through this lens of boxing that I opened up the discussion with my design team about the possibilities that lay in the idea of home-gym accessories. BOXER would include items that required no heavy-lifting, packing, unpacking, setting up, taking down or putting away. You wouldn't have to leave the house, and you could totally own your routine. It would consist of power bands, speed bands, trigger point balls, a stretching mat and a balance cushion. Speed bands and power bands allowed you to carry out full-body exercises, replicating a deadlift, a squat, a dumbbell exercise or an Olympic bar exercise with varying degrees of resistance according to the strength of the band. The lighter speed bands allow for lighter work, more specifically targeted to smaller muscle groups around the hips and glutes, or a simple arm workout. The stronger power bands, 5 centimetres wide by 1 centimetre thick, enable you to replicate a squat or resisted jumping exercises. All modified work that could support and complement your gym routine, allowing you to work out at home if the routine or time pressure involved in attending the gym was impacting your ability to enjoy exercising. All items were easily storable, which was another consideration for the many people living in apartments or shared accommodation. So, we aimed

for pocket-size, easily stored, easily used, multifunctional accessories to supplement, support or even replace the twice- or thrice-weekly trip to the gym whenever you were stuck for time or needed a change of routine. We took advice from physiotherapists and gym instructors as to how best to use these power bands and perform these exercises.

The accompanying workout apparel was based on boxing gear. Short-sleeve sweaters with ripped hems, compression wear, shorts, socks and boxing mitts, a track top and trainers – the typical boxer workout pieces you see when media visit a boxer's camp pre-fight to watch them spar or train. Often the fighter will go through a routine, throwing combinations, giving the cameras what they need, talking the talk before they must walk the walk. Acting, after all, is second nature to the best fighters.

Bogman

Spring–summer 2018

'I'm a bogman,
Deep down, it's where I come from'
From 'I'm A Bogman' by Luka Bloom, 1998

You don't hear too many designers talk about bog-holes inspiring a collection. Many fashion brands are born of the outdoors – Barbour, Hunter, The North Face – but the bog is not a place for most people's creative inspiration. I doubt a bog would inspire the NCAD fashion school much. Too agricultural, too sweaty, too much grunting. There's nothing elegant about your trousers falling down while sweat runs down your nose like snot as you cut a bank a turf with a sleán, and you haven't enough hands to either pull up your trousers, wipe your nose or cut a fresh sod. I fell into a deep bog-hole one day as a young lad and I felt very inspired. I was very inspired to drag myself out by any means possible as it was deeper than I was tall. A friend helped me out in the end. I remember I was wearing a pair of burgundy New Balance trainers with two Velcro strap fasteners and they were ruined. Not ideal shoes for the bog but you live and learn by trying to jump bog holes.

When I first heard Christy Moore singing 'I'm a Bogman', it stayed with me because it is so unusual to hear anyone sing about the bog. It was a statement of identity and an expression of pride in rurality. I have lived a largely urban life in Dublin for the last 10 years or so, but my roots are rural. I later found out 'I'm a Bogman' was written by Christy's brother, Luka Bloom. To hear two men from the Bog of Allen in Ireland's midlands sing the praises of their turf was great. I decided to make a similar statement through a clothing collection. I didn't have too many references to study until I discovered this song and its lyrics.

When I went looking for more visual references, I found many. Some of them appeared through pieces of art and architecture I had never seen or heard of before, others appeared through the work of an old acquaintance of mine.

Perry Ogden is a photographer and filmmaker I have admired for a long time. Some of his work has captured the spirit of boglands and bog people in the West of Ireland. His photography, in particular, proved to be a great source of visual inspiration for the BOGMAN collection. Perry has a great belief in celebrating rural life, rural communities and minorities. 'There's Plenty of Cloud on the Mountains Abroad' was a 1992 series of portraits of the men of Connemara at work in the bogs of the western Gaeltacht. Their faces are contoured like maps, weathered like the landscape in which they work. The clothes they wear are traditional for the time but worn in an improvised way: woollen worker's jackets worn over blazers, patterned knitwear, Aran jumpers, plain white T-shirts and high-waisted wool trousers held up by old cord ropes as belts. The way these bogmen are dressed is unpretentious and true to life in the West of Ireland – but they still look as if they are in a magazine shoot. This was just how they dressed on a daily basis. In the Connemara portraits, Perry manages to capture the landscape of the bog, the face of the human spirit and the personal style of the Irishman simultaneously. That is the skill of Perry's work. Something about this series reminds me of home and the men who worked the bogs where I grew up. The series is now part of the

permanent collection at the Irish Museum of Modern Art.

Fí

Perry has worked for fashion brands, art galleries and magazines all over the world. One of his home-grown projects was a fashion film called *Fí*. *Fí* is the Irish for the verbal noun 'the weaving'. The film was commissioned to showcase traditional Irish textile design talent. The opening scene features a young red-haired Irish boy performing a sean-nós style dance on a hardwood platform in a bogland environment. He wears a traditional Aran cardigan, tweed trousers and hard-soled shoes. While there is a youthfulness to the scene, it has a similar energy to the Connemara portraits, in that the boy looks at home in his environment.

Perry's 2005 film, *Pavee Lackeen: The Traveller Girl*, became a huge success. The documentary-style film follows Winnie Maughan, a young Traveller girl living on the roadside in the West of Ireland. Ten-year-old Winnie Maughan played herself in the film, as did the members of her family. It is a true-to-life account of the life of a Traveller family with Winnie, taking us on a journey with her from school suspensions to petty theft. Winnie was nominated for an IFTA for Best Actress. *Pavee Lackeen* was awarded an IFTA for Best Film and Perry won the Breakthrough Talent Award for his direction.

There was a blanket bog where I grew up in north Kerry. It spread out for acres from the end of Penny Lane, the road we lived on, until it became forestry on the Causeway

side. That bog provided work, rest and play for us. The men along our road cut into it for turf to heat our homes, they told stories, drank tea from Lucozade bottles, and worked on. When we were old enough, the young boys of the road joined the men and shared the labour. I wasn't as romantic about the bog back then as I am now. Cutting, laying, turning, stacking, gathering was physical labour – and it was skilled. Cutting was not an exact science, but sods had to be cut uniformly. While there was a degree of free form to the hand-cutting using a sleán, there was also measurement, judgement, accuracy and some design at play in the head of the turf-cutter. The turf-cutters had to know their ground and their sod weights. This was all innate, unspoken intuition. It was a craft.

There also had to be an element of design in what the men called 'stooking'. This was the stacking of sods in aerated heaps for drying. The right cut was needed for uniformity, which was key to stooking and drying the turf. The stooks had to be built and balanced to hold their sway and not collapse in the wind. The base sods had to be measured and placed with certainty to withstand the pressure of the wet sods placed on top. And they had to dry quickly with the help of the weather. The weather was a constant source of curiosity back then between the men drying turf and the women drying clothes. If there was good drying, there was good form.

Aside from the physicality of the work each day, there was a connection in the men's work too. They were

connected to each other and to the sod of their community. They knew the ground and understood it. Land is sacred to most rural people. John B. Keane captured this spirit in *The Field*, which is essentially based on a fight between a farmer and an American over a piece of bogland. The sound of bog was like music to John B. and the men of north Kerry in particular. The slice of the sleán splitting the topsoil like a surgical knife. The clump of the cutter's boot on the timber foothold. The noise from the burst of ground. The slurp of the sod as it's shucked from its waterbed. Turf-cutting is man at one with his environment. On top of this connection to nature, the men connected with each other through the shared labour and through the storytelling and conversation. Community spirit came to life in the bogs of rural Ireland.

My aim for the spring–summer 2018 collection was to catch this spirit and to get a sense of what bogs, boglands, turf, turf-cutting, nature, connection and storytelling meant to communities like those I know around north Kerry.

In reading and researching for inspiration on bog culture, I discovered Tom de Paor, a man named by the Royal Institute of British Architects (RIBA) as 'the leading Irish architect of his generation' and his *N3* exhibition. This became a reference point for the BOGMAN collection.

Turf-cutting is man at one with his environment

Bog architecture

In the year 2000, Irish architect Tom de Paor was invited by Irish exhibition curator Raymond Ryan to participate in the Venice Biennale of Architecture. The piece of work de Paor created is still regarded as one of the finest the Biennale has ever seen. De Paor did it all using peat briquettes.

N3 (pronounced 'N cubed') was a pavilion made of 40,244 peat briquettes donated by Bord na Móna. At the end of the exhibition, de Paor burned the pavilion to the ground as a gift of soil to the people of Venice or, as de Paor himself described it, 'a donation from the land-rich island of Ireland to the land-poor city-island of Venice'.

The brief for any architect creating for the Biennale is to reflect national identity in a modern, contemporary way. De Paor did so intelligently, using place in the most literal sense by transporting soil from one place to another and cross-referencing inspirations common to both Venice and Ireland. De Paor constructed a 'martyrium in peat', as his own website describes the pavilion. A martyrium is a shrine built over the tomb of a Christian martyr.

The structure was laid out in an N shape in a north–south orientation. There were many other references, some obvious, some hidden. The main one lay in the corbelling, which is an ancient Irish method of construction used in beehive huts and out-houses. There was also a reference to Saint Nicholas. The peat briquettes donated by Bord na Móna came from a coal and fuel merchant located in the shadow of the Church of St Nicholas of Myra on Francis

Street in Dublin. Not far from where the N3 pavilion stood in Venice was the Monastery of San Nicholas of Lido.

Some other hidden references included wooden confessional boxes and John Hinde postcards. Hinde was an English photographer with a nostalgic style that drew him to Ireland, the Irish landscape and Irish culture. This relationship with the Irish countryside began during the part of his life that he spent in the circus. Travelling across Ireland in the 1940s and '50s, Hinde learned that the country had become a popular tourist destination, and black-and-white postcards abounded. He was a colour photographer – one of the pioneers of the style – and sought to tackle the prevalence of black-and-white photography.

Hinde wanted to capture the colour of the Irish country-side while still retaining the sense of national identity and stereotypes, which black-and-white photography portrayed. He photographed stereotypical Irish scenes, many of which included bogs, turf-cutting, turf-gathering, donkeys, and all the natural colours associated with these landscapes. He would regularly set up scenes to photograph, using a handsaw to remove any bushes, implements or anything that obstructed, interfered with or affected his vision and aesthetic. His photographic series of the Irish rural countryside and way of life was a big success.

The dispersal of the briquettes at the end of the Biennale was symbolic and performative. It added a layer of meaning and intention to the work. A gift of Irish soil to a city where

there is hardly any. This resonated with Venetians and the architectural community at large.

So Tom de Paor's bog architecture was the main inspiration for the collection, but there were others. Bogs are full of history and stories, and sometimes bodies.

Bog bodies: Tollund Man

When Tollund Man was discovered in a Danish bog in Silkeborg in 1950, the turf-cutters saw 'a face so fresh they could only suppose they had stumbled upon a recent murder', according to *Smithsonian* magazine, which featured photographs of the remains. Grethe, Viggo and Emil Højgaard had in fact discovered a bog body that was 2,300 years old. The body was so well preserved that the skin, hair, nails and even the brain were intact when autopsied. The plaited noose found around Tollund Man's neck gave an insight into how he had died but the mystery remains as to why he was killed and buried in a bog.

Tollund Man now resides in a glass case in Silkeborg Museum. Visitors have been known to faint on viewing him. His face is fixed in a peaceful smile, as if ignorant of the fact he died so violently, preferring to focus instead on a life well-lived. During the autopsy, Tollund Man's brain and intestines were removed, examined and replaced. Archaeologists and scientists continue to study his body for information on the past. They want to know more about the place he came from and the life he lived. Modern forensic methods, dual-energy CT scanners and strontium

Tollund Man

tests of his hair have provided some information. There is a belief that at some point in the near future Tollund Man may reveal his secrets.

The scientific reason bog bodies are so well preserved for so long lies in a combination of soil type and climatic factors. Low temperatures in Northern European countries like Denmark and Ireland combine to make perfect natural laboratory conditions for preservation. The Cashel Man and Clonycavan Man discoveries in Ireland were found in raised bogs with poor drainage and an abundance of sphagnum moss and acid but little mineral richness or oxygen. Cashel Man was found by a turf-cutting machine operator in a bog near Cashel in County Laois in 2011. It is thought to be the oldest bog body discovered, dating to the Bronze Age around 2000 BC.

The National Museum of Ireland on Dublin's Kildare Street is home to many Bronze Age and Iron Age bog bodies and artefacts. Alongside Cashel Man, sit Old Croghan Man and Clonycavan Man. As part of Ireland's Bog Bodies Research Project established in 2003, the museum's specialist researchers analyse these bodies, using CT and MRI scans, palaeodietary analysis, fingerprinting, and histological and pathological testing.

Seamus Heaney's poem about the aforementioned Tollund Man struck another note of reference and inspiration for the BOGMAN collection. In the last verse, Heaney mentions Jutland and 'the old man-killing parishes'. Heaney also wrote of the Irish bog. In 'Boglands', Heaney

describes turf-cutters as pioneers who 'keep striking/ Inwards and downwards'. Irish bogs have inspired many a poet, painter, artist, playwright, musician and architect as in the case of Tom de Paor. Arguably the most famous artist to reference bog landscape as art was Joseph Beuys. Internationally renowned in the 1970s and 1980s, German-born Beuys moved to Ireland and found inspiration in its bogs, not just the flora and fauna, birds and animals, but the bog as a place of storage, mystery, chemistry, change and preservation of ancient history. His sculpture *Irish Energy* was made from peat briquettes buttered together like two slices of bread, using real Kerrygold butter.

Unlike Heaney, whom lots of people studied in school, Beuys wouldn't be well known in the GAA world. Though since the Covid-19 lockdown we have seen a change occur in terms of how art is appreciated, it still represents a challenge to many Irishmen. Art and artists are under-appreciated to an extent, which is a pity as historically art and the Gaelic Athletic Association fit together like hurley and sliotar. Young Irish artists like the former Roscommon footballer Neil Patrick Collins and former Dublin hurler David Sweeney are re-invigorating the cultural connection between art and Irish indigenous sport. Sweeney's *Transilience*, a commission in commemoration of the Bloody Sunday massacre at Croke Park on 21 November 1920, when British Army troops entered the Croke Park pitch and shot dead 14 people, shone a light

on this relationship. Gaelic games, Gaelic football, and handball and hurling in particular, are art forms in their own rights.

Kerrygold is another Irish institution, an export as famous around the world as Guinness. Beuys' use of butter as cement between two peat briquettes like they are floors on a building is a very Irish thing to do. Mixing cement, laying blocks, building, plastering, burst knuckles and butter are all in a day's work if you have ever worked the sites. Nowadays building sites are like social media content hubs with phones capturing scenes (real or staged) of builders and tradesmen going about their business. Some building and construction-inspired Facebook pages are so popular it's worth asking whether the real business is construction or social media. Beuys' peat briquettes and butter stack in *Irish Energy* are not widely known of or spoken about in Ireland. If a site labourer bought a pound of butter and used it as cement between two bricks just for fun on a Thursday morning around the 10 o'clock tea break and posted a process video to 'On The Tools' Facebook page, he'd go viral and be lauded around the site for the rest of the week. Joseph Beuys did it with peat briquettes and called it art. When a conversation enters the realm of art, you can lose people. The Beuys' art piece couldn't be more Irish. You're talking about soil cut from the belly of Ireland by turf-cutters and produce farmed from the fields of Ireland by farmers. It goes to make the point that art, like clothes, can be intrinsic to the Irishman, but it depends

on how you communicate it.

There is art in the bogs. Stooks stand in rows like buildings, laid out at intervals like city blocks, positioned just right so each will receive enough sunlight and wind. The first two sods form the foundation, the next two are laid at right angles for balance and so on until the stack is eight or ten sods high, full of see-through passages at intervals for aeration. It could be a scaffolder, a block-layer or a carpenter at work as easily as a turf-cutter. These are the kinds of references or comparisons I use in the marketing process.

To express the ideas behind the design process, I use language my friends can relate to and speak. If I used the conventional language of fashion marketing it could alienate my friends from home first and foremost, which means it could alienate the regular Irishman too. My story-telling business is built on language that can include my friends. To have a chance at succeeding in this business I was better off forgetting about fashion itself as the starting point and building a vocabulary that would feel natural to men who lay blocks, play hurling, cut timber and burn turf. There are a lot of them out there.

The Faddan More Psalter

Eddie Fogarty set out to cut turf in Faddan More bog in County Tipperary on a sunny July morning in 2006. Eddie cut by machine at a much faster rate than by hand. While cutting turf, Eddie made a discovery so rare and interesting

it would place Ireland at the heart of the discussion among historians, archaeologists, professors, universities, museums and churches. The Faddan More Psalter, as it would become known, was a book of psalms, believed to roughly date from the 8th century. Its discovery would shine new light on the lives of early Irish scholars and priests and their links to ancient Egypt. But first Eddie Fogarty's find had to be saved.

Eddie spotted the book in the bucket of his peat extractor and knew what to do. He slowly lifted the bucket and laid the peat containing the manuscript on the raised bank. He then called the bog owners, brothers Kevin and Patrick Leonard, who had discovered artefacts and relics in the bog before. They knew how to keep the book covered in the peaty soil that had preserved it for centuries. From there, the men contacted the National Museum of Ireland and a team of expert archaeologists landed on the bog the following morning. They were astonished at the significance of the find.

After extensive study and careful analysis, the discovery was found to be made up of 60 sheets of vellum, each measuring 30 by 26 centimetres. Vellum is a heavy, cream-coloured parchment prepared from calf-skin and used as paper in medieval times. The production of vellum would only have been possible through skilled and knowledgeable management of cattle and livestock. The sheets were gathered into five bundles known as quires. Scientists discovered that the inscriptions were made using black inks

made from oak galls, which are like oak apples. It was found also that these inked letters or inscriptions had the effect of preserving the vellum, while pages without inscriptions were destroyed. It was in the analysis of the thick, heavy book cover that archaeologists and historians discovered most. John Gillis, a manuscript expert from Trinity College Dublin, undertook months of painstaking analysis by way of MRI scanning, microscopic inspection and testing to find that the cover was lined with papyrus. Gillis sent fragments to the British Museum, which confirmed it. This use of papyrus linked Ireland to Egypt and the Nile Valley, where papyrus originated. The main use of papyrus was as paper. Up to this point, the general consensus was that papyrus had been used only by Egyptians, Romans and Greeks. Its discovery so far west in Ireland led to new theories and possibilities around voyage, communication and shared practices between the Catholic and Coptic Churches.

The conservation of the psalter took years of expert management. It remains in good condition today on permanent display at the National Museum of Ireland and stands as a reminder of the mystery and richness of our boglands – culturally, spiritually and archaeologically.

The collection

BOGMAN was a spring–summer 2018 collection. If there is a difference between the spring and the summer in Ireland, you have to look closely for it. Growing up near

The Faddan More Psalter

a bog, you had to be attuned to weather and climate. Just as on the building sites, there were days when rain was welcome. The collection was made up of outdoor pieces and lighter summer wear. Loose cotton trousers, belts, vests, braces, lightweight check shirts, work-boots and heavy socks made up the 'bog look'. You need rainwear to be safe from the Irish weather even in the height of summer, so we included a bonded camouflage print raincoat with a hood and a windcheater. A cable knit jumper was included to capture the visual of rows of turf being laid to dry like overground cables.

The bog landscape informed the colour story for BOGMAN. Light grey, the dark green of conifers, the brown of the sod, and the orange and red of the evening sun are all colours of the bog. Tom de Paor's *N3* typography was commemorated on a half-zip tracksuit top. Sleáns, the original handheld, turf-cutting implement, were printed on shirts. Shirts and T-shirts also carried a peat briquette print in memory of the Bord na Móna peat briquette, a vital member of the Irish homestead. Thousands of homes nationwide were warmed by the flames of a peat briquette fire on a winter's evening. When news came through in January 2021 that the peat briquette was to be decommissioned and discontinued by 2024, a chapter of Irish life closed with it. I felt I knew this rural tradition and the rural Irishman. But who is the urban Irishman? This is what I wanted to explore next.

Raglan

Autumn–winter 2018

'His voice, his repertoire, his passion, his politics, his generosity, his crankiness, his laugh, his clothes, even the way he'd walk into a pub. That's what made him special.'
– *Christy Moore on Luke Kelly*

Luke Kelly was never sure of his date of birth. His official birth certificate states that he was born on 17 December 1940. According to his mother, he was born on 17 November 1940. Luke took her word for it and went with November. As he put it later in life, why wouldn't he believe her, she was there at the time? There is even debate over his age when he died. Some reports say 43, others – his bandmate John Sheahan among them – say 44.

Born on Sheriff Street in Dublin City, Luke Kelly Junior grew up in a harsh inner-city environment where everyone knew poverty and inequality. Kelly finished school at 13, left Ireland for England at 18 and worked with his brother Paddy in the construction sector, tying steel on a site in the English Midlands town of Wolverhampton. It was in the English Midlands and north that Kelly discovered folk music – or a version of it at least. Skiffle was a genre of folk music which underwent a revival in the north-east of England in the late 1950s. It was the match that lit the musical fire within Luke Kelly.

Skiffle is thought to have originated in New Orleans in the early 20th century as part of the African-American blues scene. It was off-beat, bombastic music that captured Kelly's imagination the day he entered the Bridge Hotel in Newcastle in 1960 and heard it for the first time. Skiffle gave him the distinctive ability to make a song, old or new, sound like something people hadn't heard before.

The improvisation and rebelliousness of skiffle appealed to Kelly's nature and inspired him to further develop the

genre in his own style. The instruments associated with the original skiffle from the Deep South of America – washboards, basins, jugs, tubs, music saws and fiddles – created a wild, distinctive sound. By now, Kelly was sure he wanted to be a musician, greatly influenced by Ewan MacColl, the British folk singer who wrote 'Dirty Old Town'. Kelly had bought a banjo and begun busking and was soon back in Ireland, where not just music but theatre performance and political justice would become his life's blood.

Christy Moore recalls first becoming aware of Kelly in O'Donoghue's on Dublin's Baggot Street in 1964. Moore saw him as the second coming of the Clancy brothers, with similar spirit and wit, not to mention style. Moore has described being in awe of 'his voice, his repertoire, his passion, his politics, his generosity, his crankiness, his laugh, his clothes, even the way he'd walk into a pub.'

Aside from skiffle and singing, Kelly also had a keen sense of social justice, formed as a boy on the inner-city streets of Dublin, where housing, water and a warm bed couldn't be taken for granted. He fought inequality and oppression of every form and took the plight of homelessness, especially, to heart. Moore recounts another story of meeting Luke at the door of a pub, The Two Parlours, in Salford, Manchester, where Kelly was filming a TV special. Now part of the Dubliners, Kelly invited the younger Moore to appear in the show as his special guest. He also put Christy up in his hotel room that night.

When Christy woke, Luke was gone but had left a fiver on his guitar case. The two had formed a lifelong connection.

The father of Ireland's greatest ever balladeer had a rare life story of his own. Luke Kelly Senior was lucky to have the adult soccer career he had, given what happened to him as a boy. Described as a tireless worker and incisive passer when playing in the midfield pivot position for Jacob's FC, where he worked all his life, Luke Senior was a respected player in the League of Ireland in the 1920s. He was also musically inclined. Paddy Kelly, brother of Luke, describes their father as having a talent for singing what he called 'negro-spiritual' songs around the house.

On 28 July 1914, Luke Senior was one of a group of young lads playing football in Fairview Park on Dublin's northside when a group of military men known as the Scottish Borderers passed by en route to the city centre. Luke Senior recalled in an interview many years later, how he and his friends had jeered and thrown stones at the brigade. The Borderers were under orders to tackle and disarm a group of Irish Volunteers who had intercepted and taken possession of a cache of weapons at Howth Harbour. The Dublin Metropolitan Police had been ordered to confront the Volunteers but many refused due to a shared sympathy with the nationalist cause.

According to an article on A Bohemian Sporting Life website, some Metropolitan police did confront the Volunteers, resulting in a street fight in which batons and rifle clubs were used but which only lasted around a

minute. The police who engaged the Volunteers withdrew. The Borderers then tried to disarm the Volunteers and also failed. By then, a large crowd had gathered, including nine-year-old Luke Kelly Senior, who had followed the march from Fairview Park with his friends. More taunting and stone-throwing ensued. As the Borderers retreated towards Richmond Barracks, they opened fire on the crowd on Bachelor's Quay, killing three people and injuring 37.

Among the injured was nine-year-old Luke Senior. He was taken to the nearby Jervis Hospital with a gunshot wound to his back, and a priest was called to administer last rites. Luke Senior survived and days later a photograph of sitting up in his hospital bed with a nurse in attendance was printed in the *Irish Independent*.

Luke Senior lived a long life, working for the Jacobs factory on Dublin's Aungier Street from the age of 16 to 46, playing seven seasons in the League of Ireland and earning widespread respect and positive reviews. That is not to stay he was without vice or mischief. A Bohemian Sporting Life recalls how his swimming prowess got him into trouble with the law in May 1932, when Luke Senior was arrested by a Garda Burns and charged with attempting suicide. In reality, what had happened was after a few pints with his friends, he was challenged to swim across the Liffey from Custom House Quay. At the court appearance, Luke Senior's defence stated that he was an excellent swimmer, which was apparent by the fact he wore a hat throughout the swim, which remained bone-dry. The judge accepted

Luke Senior's defence and pardoned him, but bound him to keep the peace.

Culture

Music and sport are threaded through Irish culture. This thing we call 'fashion' is part of music culture and sport. Therefore is fashion or, to put it more plainly, are clothes not also part of Irish culture? I think they are each intrinsic to the other. Musicians make fashion relevant to wider audiences by making clothes look good. Sport and sportswear are about clothing, jerseys and kits. You can't have one without the other.

Luke Kelly Junior's life story followed in a similar vein to his father's: rebelliousness, song and sport were intertwined. Song and sport especially were pillars of Irish social life in the 1940s. The Kelly family of Sheriff Street were friends with the Giles family of Ormond Square. Luke Senior and Dickie Giles were friends and both played in the League of Ireland. Their sons, Luke Junior and John Giles, would become friends as well, playing against each other in the Dublin Schoolboys League, Luke for Home Farm FC and John for Stella Maris. Their friendship continued into adulthood as their stars rose, Giles becoming a professional footballer for Leeds United and an Irish international at the same time that Kelly's musical career took off.

A musician friend of mine, Ryan Hennessy, is like Luke Kelly of today, excelling as a singer, songwriter, performer and poet. He has a way with words, making

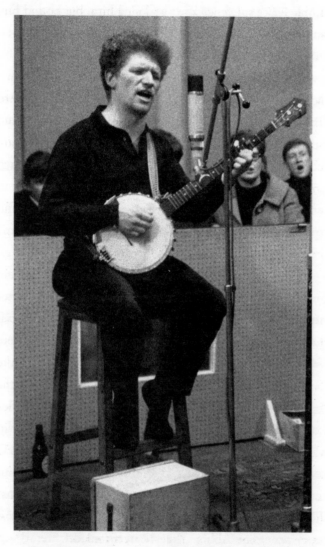

Luke Kelly recording the Dubliners' first LP in 1964

simple lyrics speak volumes and singing songs that make sense to listeners. Like Kelly, Hennessy wears clothes with courage too. Wearing colour is a test of courage in a way. Luke Kelly never shied away from it. Look at any old colour photos of the Dubliners together and you often will see a clash of primary colours. It always strikes me as unusual to see men in 1980s Ireland wear bright blue, red, green, or other strong colours like orange and yellow as the Dubliners did, especially Luke. Ryan has the same sensibility for colour. Maybe it's a frontman thing. He and his Picture This co-founder, Jimmy Rainsford, have been great supporters and collaborators for my brand from the word go, shooting video campaigns for me and helping me to build the business through content and social media support. Their help meant a lot to me at the time and still does. I follow their careers with pride as they travel the world and fill music arenas.

Jesus Christ Superstar

Music and song weren't enough to satisfy Luke Kelly. He was a performer, a reader and a student of the arts. It takes courage to act on screen and another form of courage to act on stage. It comes as no surprise to read that Kelly took the role of King Herod in a stage production of *Jesus Christ Superstar* at the Abbey Theatre in his stride. Herod, or Herod the Great as he was known, was part cruel tyrant and part creative visionary, who ruled Judea by appointment of Rome. He was seen as being responsible for the growth and

prosperity of Judea through the construction of aqueducts, theatres, monuments and roads. Herod governed Judea ruthlessly, ordering the slaughter of all infant boys who might one day have grown to challenge him. What a role for an actor to take on. Reading was a big part of Kelly's life, and he researched the role by reading voraciously. It was, after all, from James Joyce's *Dubliners* that one of the most important Irish bands of all time got its name.

The Dubliners and self-esteem

The Dubliners were leaders. Their leadership was not just tied to their music and lyrics and what they had to say. It was tied to their appearance too. They were leaders for their general expression – the way they dressed. We have learned to trivialise the matter of men's style in Ireland but we shouldn't. Good personal style can be a powerful thing in the sense that it helps with expression and self-esteem. This is not something to make light of, especially in Ireland where many men have low self-esteem. Taking pride in your appearance and in your sense of self is an antidote to negativity.

I lived through this feeling of unwanted attention myself for most of the last decade. Being photographed without permission, pointed at, laughed at sometimes, for the clothes I was wearing. I felt at the time, and still feel, that Ireland had to be a better place than this for sake of the young men coming through for whom self-esteem and expression are important to good mental health. All of these

things can be linked in some way to clothing and taking care of how you dress. We must allow young men that freedom of expression as a means of building self-esteem. Seeing old photos and videos of the Dubliners performing, particularly Luke Kelly and Ronnie Drew, gave me the courage to continue on my journey towards creating a 'fashion' brand that would create a safe space for young Irishmen, to express themselves through clothes. People like Ryan Hennessy and the artist Neil Collins are signs that Ireland is a healthier place for young men to express themselves today in terms of clothes and individual style being more acceptable. These two are leaders of a new pack. I visited Mallow GAA for a club dinner earlier this year and met dozens of young footballers. I was impressed by their body language and posture and their ability to make eye contact and conversation. It was no coincidence they were all well-dressed also. The club had a best-dressed player competition on the night. I don't like to judge people for how they dress but it was worth it to witness the quality of the young men and their obvious high self-esteem. Good self-esteem and clothes are woven together. From the spirit of Luke Kelly through to the spirit of young Ireland today, RAGLAN was all about self-esteem.

How do you capture the essence of a man as spirited as Luke Kelly? YouTube seemed like a good place to start. There is an incredible amount of footage of him in full flow over the years. There are videos of Kelly being interviewed that give even more insight into his mindset. 'The

Night Visiting Song' was the last song Kelly performed live with the band. The performance has amassed an amazing 4.7 million views on YouTube. At the time, Kelly was ill with the brain tumour that would eventually kill him. But the performance was full of spirit and power. The shirts he and other band members wore that night became the centrepieces of the RAGLAN collection. Luke's shirt was so untypically Irish that you had to admire him. To wear a light-yellow, floral-patterned shirt in 1980s Ireland marked him as a man apart. But that was Luke and the Dubliners. We created a range of shirts called The Night Visiting Shirts based on the shirts worn by the Dubliners as they performed together for the last time.

Patrick Kavanagh: shoemaker and poet

I also took some references for the collection from the song 'Raglan Road', which Kelly made his own. It is a song with its own place in Irish culture, so iconic only the brave attempt to sing it. 'Raglan Road' was originally a poem by Patrick Kavanagh, who asked Kelly to adapt it as a song. Luke's version is so ingrained in the hearts and minds of Irish people that it is considered his own work. Kelly recounted the day he met Kavanagh in the Bailey pub in Dublin. Kavanagh, described as an unapproachable, awkward sort, heard Kelly singing and beckoned him over to tell him he had a song for him. Luke took the lyrics of the poem and set them to the music of the traditional Irish

song 'The Dawning of the Day'/'Fáinne Geal an Lae' – and created a piece of Irish folklore.

The poem, originally named 'Dark-Haired Miriam Ran Away', was written about a Kerry woman called Hilda Moriarty, who was a medical student living on Raglan Road near Kavanagh's digs on Pembroke Street. Kavanagh would see her coming and going and would make excuses to talk to her, promising her one day he would immortalise her in poetry. He did so but replaced Hilda's name in the title for the name of his brother's girlfriend, Miriam. Despite Kavanagh's efforts, Hilda spurned his romantic advances, which left him despondent.

Patrick Kavanagh had a profound influence on Irish culture and those around him. From the great poets like Seamus Heaney and Brendan Kennelly, who followed in his footsteps, to the harder-to-define beatniks like Luke Kelly, Kavanagh was an influencer before there was such a thing. Kavanagh was a shoemaker by trade from a young age, like his father, but then turned to teaching before poetry caught a hold of him and didn't let go. He was a keen follower of Gaelic football. Brendan Kennelly tells a funny story of Kavanagh describing to him a performance he had given in a recent club game: it was very good in the first half but awful in the second half because it started to rain and Kavanagh's football boots disintegrated. It turned out they were made of paper.

The Dubliners in 1970

I must away now,
I can no longer tarry

Luke Kelly passed away at the young age of 43 – or 44 – on 30 of January 1984 in Richmond Hospital, Dublin. The brain tumour he was diagnosed with in 1980 had led to collapses, seizures and operations in the intervening years. These were initially put down to excessive consumption of alcohol but two on-stage collapses in Cork in 1980 and the Embankment Tallaght in 1981 led to a medical examination, a diagnosis and two surgeries. By the summer of 1983, the Dubliners were back on the tour circuit. Luke had made what everyone thought was a full recovery. However, when the tour reached Mannheim in Germany, he had a seizure before the show. This was the beginning of a period of ill health, which led to his hospitalisation in early January 1984 – and eventually to his death.

With his death, Ireland lost a Celt and a musical god. His bandmates were stricken, of course, as were his family and his legions of fans. At his funeral, mourners remembered his voice and his words but also his actions, his membership of the Communist Party and his belief in a classless society where common ownership and equality ruled. They also recalled his human rights work for Amnesty International. Luke was a fierce defender of the rights of the working class and for the protection of the disadvantaged. He sang for them, and it was because of this defiance and fight against oppression that he transcended ordinary stardom to become a cultural icon beyond music.

The great Kerry writer and fellow anarchist Con Houlihan summed up Luke Kelly and the rest of the Dubliners as less a group than a *meitheal. Meitheal* is an old Irish word for a group that came together to do a job like saving hay or turning turf. Houlihan described the various members – Luke, Ronnie Drew, Ciaran Bourke, John Sheahan and Barney McKenna – as 'individualists ... leaves from different trees blown together by the wind that changed music a generation ago'. They were a paradoxical collection of independent-minded men who were of a single mind when it came to song. What bonded them all, according to the great mind of Con Houlihan, was 'an artistic honesty'.

Con Houlihan and Luke Kelly were united by a love for soccer and the fortunes of the Irish national team. Luke had been a star player for Home Farm FC as a boy and often played sessions with the Ireland senior team when they decamped to Dublin for international games. Houlihan and Kelly often drank together, and Houlihan said that they would often borrow money from one another. When the time came to repay, Kelly would leave the cash behind the counter of a particular pub in a white envelope marked 'from one genius to another'. In a written eulogy after Kelly's death, Houlihan describes him as 'a primitive' but in the best sense: primitive man sang before he ever spoke and for Kelly singing was a primal instinct. As Houlihan put it, Kelly brought home to all those lucky enough to hear him sing that 'singing had been man's primal mode of expression'. And that is what RAGLAN stood for: free expression.

Luke Kelly in Dublin in 1980

Luke Kelly lies in rest now at Glasnevin Cemetery, Dublin, under the epitaph 'Luke Kelly, Dubliner'.

The collection

The Night Visiting Shirts worn for the Dubliner's last performance were the centrepieces of the collection. There was a detail on Kelly's banjo that became a print feature of the range. A criss-cross pattern from the strap was repeated on shirts, polo shirts and cravats. We also included a leather jacket, boots and flat caps. We even created 1980s patterned knitwear, which was big in the 1980s if *The Sunday Game* and *The Late Late Show* were anything to go by. The presenters of both shows were not shy about wearing patterned jumpers. Michael Lyster, the face of *The Sunday Game*, was a style leader of his time. Archive footage of him presenting game highlights in the 1980s provides good insight into the Irishman's style at the time. Every day seemed to be Christmas for the amount of Christmas jumpers on show. Another key look of the campaign was based on an image of Ronnie Drew wearing a tobacco-coloured overcoat over a black jumper and pants. Ronnie was another leader of Irish life. Michael Lyster, Ronnie Drew, and others, like former Taoiseach and Cork hurler Jack Lynch with his mohair suits, were men of style, men of Ireland, woven into our indigenous sports and music. Luke Kelly was something different again. Singer, musician, actor, drinker, activist: he was a symbol of Ireland, cut from a different cloth.

THE TATTOOED IRISHMAN

JAMES F. O'CONNELL

Tattooed Man

Spring–summer 2019

Tattoo

[ta-too] noun

1. a drumbeat or bugle call that signals the military to return to their quarters
2. a design on the skin made by tattooing
3. the practice of making a design on the skin using a needle and ink

There are many ways to display a willingness to endure pain. Getting tattooed is one. I've had tattoos done and it hurts. There are other ways to display strength and masculinity. Anyone for a game of Knuckles? Knuckles was a game we played at primary school. It was sophisticated. The rules were complex and the techniques involved were beyond many who tried to play. What you had to do was make a fist, rotate your wrist so your knuckles faced skywards, and wait for your opponent to slam his knuckles down as hard as possible across the top of yours. He wasn't allowed to raise his arm over his head, so the motion came from the elbow rather than the shoulder. This would continue, tit for tat, blow for blow, until someone's knuckles bled out and a winner was declared. This game was not for the faint-hearted. Onlookers would gasp, cheeks would redden and eyes would water on every impact.

The skill, if you can call it that, of Knuckles lay not in the timing of your blow or the angle of your wrist, but the toughness of the skin on your knuckles. Rough, calloused, dried-out knuckle skin was ideal for winning at a sport that became so bloody around the yards and shelters of Lixnaw Boys School that it was quickly banned by the principal. With good reason too.

James F. O'Connell knew pain when he landed on the island of Pohnpei about 2,000 miles south-east of Hawaii in the Pacific Ocean in the late 1820s. Shipwrecked and shook, O'Connell had swum ashore and promptly found himself surrounded by the island's inhabitants. His story

is stranger than fiction, featuring a period spent among Pacific Islanders, whom he feared were cannibals, and then in New York City working as the 'Tattooed Irishman' for the circus entrepreneur P.T. Barnum. O'Connell rose to great wealth and fame as the first man in the Western world to 'exhibit' full-body tattoos. How he got the tattoos is a tale worth reading.

Though there is no record of his birth, it is thought the Tattooed Irishman was born in 1808 in the Liberties area of Dublin City. Little is known about his early years. What we do know is thanks to his own short autobiography published in 1845, *The Tattooed Man: The Story of James F. O'Connell*. Some historians believe that parts of O'Connell's story are fictional. Some claim he was a sailor, others that he was a cabin boy. Some even claim he was a convict. According to O'Connell, when he was 21, he was aboard a whaling ship called the *John Bull* with fellow Irish sea-dog George Keenan when the ship struck a reef and sank. (Marine records show the *John Bull* to have still been seafaring four years after O'Connell said it sank.) The pair of Irishmen swam for their lives, landing on the shores of the nearest island, Pohnpei. Whatever he was, when he washed up on the island O'Connell was greeted by a tribe of islanders. Stories of cannibal tribes were common in seafaring lore at the time. The new arrivals had to think on their feet.

O'Connell and Keenan were detained and taken to the tribe's village, where preparations were made for a feast

that evening. Fearing they were going to be on the menu, O'Connell recounts the dread he and Keenan felt seeing the pot of boiling water being prepared as the inhabitants circled them. To try to convince the tribe, led by tribal chief Ahoundel, to spare them both, O'Connell thought fast and smart. Explaining that he had talents and entertainment value worth saving, he started to dance an Irish jig to the tune of 'Garryowen'. This was a drinking song favoured by young Limerick men in the late 18th century and popular with military platoons from there. Towards the end of the dance, O'Connell discovered he and Keenan weren't for dinner: 'Before my dance was finished, the cause for which the fires were built became apparent. The roasting preparations were made, not for us, but for some quadrupeds, which we afterwards found were dogs.'

While Ahoundel had no intention of eating the Irishmen, he had plans for another kind of ceremony. Both men were escorted to a remote part of the island for reasons unknown to them. They were left in huts before a group of island women entered holding spears with tips covered in a black liquid. O'Connell describes it as a small, flat piece of wood with a thorn pierced through one end. He then described how she 'rested the points of the thorn upon my hand, and with a sudden blow she drove the thorn into my flesh'. With that, the men were tattooed in a ceremonial process traditional to Polynesian and Maori cultures. It later became known as 'tapping' and was carried out using a chisel. Keenan suffered badly in the process, which forced

the women to give up on him. O'Connell persevered, and despite continuous screams of painful protestation, over the next eight days, he was tattooed all over his body. The island women then left him to heal in the hut for over a month.

When O'Connell returned to the village, preparations were underway for another feast. The last woman to tattoo him was Laomi, the chief's daughter. O'Connell didn't know it at the time, but the tattooing ritual was a betrothal, and the upcoming great feast was a celebration – a wedding, as we would call it today. O'Connell would be wed to the tribal chief's 14-year-old daughter. In his autobiography, he described his wife as 'affectionate, neat, faithful, and barring frequent indulgence in the flesh of baked dogs, which gave her breath something of a canine odour, she was a very agreeable consort'. The pair lived together on the island for five years, with Laomi giving birth to two children, a boy and a girl – 'two pretty demi-savages', as their father put it. Whether or not O'Connell was happy, when the opportunity presented itself to leave the island, the Tattooed Irishman did not hesitate.

The *Spy* was originally a Royal Navy ship, the HMS *Spy*, captured by the French in 1812, and released and sold in 1813. By the early 1830s, as it sat anchored off the coast of Pohnpei, it is thought to have been American-owned. James F. O'Connell spotted it and wasted no time in rowing out to sea at night and climbing aboard. The ship set off and O'Connell left his old life, wife and kids behind. He got

as far as Manila in the Philippines, where the captain abandoned him due to his troublesome nature while at sea. O'Connell spent a number of years travelling around Asia (he was ahead of his time) before setting off for the United States, where he published an account of his travels. It was here that he would find fame and fortune as the Tattooed Irishman as a storyteller, recounting thousands of visitors with tales of his dangerous Pacific adventure, dancing daily traditional Irish jigs as he had done for the islanders, and showing off his full-body tattoos.

P.T. Barnum

Phineas Taylor (P.T.) Barnum was an American entrepreneur and founder of Barnum's American Museum in Manhattan, New York. Barnum is recognised as the father of the circus as we know it, along with James Bailey, whose financial resources helped Barnum scale his circus freakshow business. Bailey was a businessman, Barnum was a showman – together they did showbusiness. Barnum was also a politician, twice serving as mayor of his home town, Bridgeport, Connecticut, and once leaving the Democratic Party because he opposed the party's support for slavery. He supported abolition and is recognised as a philanthropist who donated money and land to his community, including land for the Bridgeport Hospital, where he passed away in April 1891. He is remembered for his visionary entrepreneurial streak and for creating the first American circus. But some dissenters view him as an opportunist of

P.T. Barnum

questionable morality whose legacy raises questions about the exploitation of vulnerable people.

In telling Barnum's story, it must be remembered that he was willing to sacrifice the dignity of others in pursuit of money and what he termed 'humbug' – a phrase he coined for the hoaxes and tricks he pulled to fool the public, and sometimes his own acts, in order to create a buzz of excitement around his circus. One of the more exploitative acts he put on display for the public was Joice Heth, an African-American woman who was half-paralysed and blind. Barnum claimed that Heth had been a slave of Augustine Washington, the father of George Washington, and that she was the first person to put clothes on the infant George. Barnum's hyperbolic advertising described Heth as the woman who raised the man who would become the first president of the United States. He also advertised her as being 161 years old, and 'the greatest natural and national curiosity in the world'. Her disabilities were used as proof of her supernatural age. Heth was a major attraction and made a lot of money for Barnum. When the public began to question her age, Barnum promised to hold a public autopsy when she died. After her death, 1,500 people showed up, each paying 5 cents, to witness the autopsy. Dr David L. Rogers debunked the age claim, pronouncing her 79 years old. Barnum admitted the hoax and moved on.

'There's a sucker born every minute' is a quote that, though never completely verified, has been attributed to

Poster for the 'Greatest Show on Earth'

Barnum. It doesn't paint him in the best light, but it does offer an insight into the mind of the man known as the Shakespeare of advertising. He was a master marketeer and his mark on American advertising culture has been significant. There are books exploring his life, legacy and the residual effect he has had on the American psyche. A few years ago, *The Greatest Showman*, a film starring Hugh Jackman as Barnum, and featuring a facially tattooed entertainer as James F. O'Connell, celebrated the life and work of Barnum.

Irish invention

People ask a lot of questions about tattoos. In my experience, the questions are mostly well-meaning and genuine. There is uncertainty behind the questions. The same questions would often be repeated as if the answers given aren't being processed – probably because tattoos bewilder so many people. This sums up tattoos: lots of questions, few answers and little sense. *Was it sore? How long did it take? How much was it? HOW MUCH? Do you like it? What does it mean? Will you get more? Where? Why there? I might get one myself.* Tattoos are a source of confusion. They have become a cultural phenomenon over the past 20 years especially. For all the parents out there who see tattoos as a foreign import, the blame for the spread of tattoos lies closer to home. The very first electric tattoo gun, which revolutionised the process and propagated the cult of tattooing, was designed and invented by a man of Irish origin.

There is a stigma attached to tattoos which can make the tattooed man or woman stand out as a person of dubious character in some quarters. Neil Francis's October 2011 column in the *Irish Independent* reveals something about attitudes towards tattoos in Ireland at the time. In it, he wrote: 'It might be a crass generalisation on my part – but every time I see tattoos emblazoned on an individual, my mental ticket machine punches out a second-class card.' Francis was talking specifically about the Australian rugby player Quade Cooper. It is definitely a crass generalisation.

Getting tattooed is not something to be done lightly, though lots of people do that. It is a commitment. If the message of the tattoo means something to you, if the art is clean, then it can be a positive way to express yourself. Tattoos needn't be seen as negative, acts of showing off or attention-seeking, though they can look like these things. They can be seen as acts of mindfulness, a conduit for the expression of a sentiment or a memory which can't otherwise be expressed. If a person, a young man especially, is unable to express themselves verbally or emotionally, a tattoo can serve that function. If we understand the reason for the tattoo rather than make a judgement based on its appearance, we might have a healthier outlook.

Irish entrepreneur

The entrepreneur–inventor of the electric tattoo gun, Samuel F. O'Reilly was born in 1854 in Waterbury in Connecticut, to Irish immigrants Thomas O'Reilly and Mary Ann Hurley.

Back in the 1850s and '60s, Waterbury was known as the Brass City for its brass and clock-making industries. Samuel O'Reilly had a troubled upbringing and started working as a clockmaker at the age of 16. From the age of 19, he took an interest in crime and showed a natural talent for it.

O'Reilly's first prison spell was for burglary of Charles Keasel's General Store in 1873. He served two years' hard labour in the Wethersfield State Prison for that transgression. Upon release, in November 1875, O'Reilly joined the Marines but deserted after four months. There are no records of his being reprimanded for this desertion. His second arrest followed shortly after for his part in another robbery. (His parents and two brothers were also part of the robbery gang.) Knowing there was a warrant out for his arrest, O'Reilly skipped town for Detroit. An issue of the *Detroit Free Press* in October 1878 tells how O'Reilly, unable to find gainful employment, eventually turned himself over to Detroit authorities. He was sent back to Connecticut, where he would spend five more years in prison. It was back at the Wethersfield State Prison that he committed himself to the art of tattooing.

Little is known of O'Reilly's life after he left prison and rejoined society in 1883, but by the end of the decade he had made his name as one of New York's premier tattoo artists. Tattoo folklore and a *New York Evening Post* article from 1898 claim that O'Reilly became a student of a man called Martin Hildebrandt or 'Old Martin', one of the city's first-ever tattoo artists. From Hildebrandt, O'Reilly

The Edison Pen – a precursor to the tattoo gun

learned the art of India ink, which is a black pigment used in lettering and drawing, Chinese vermilion (a vivid red–orange pigment) and how to use hand needles. The idea for O'Reilly's electric tattoo gun was based on the same rotary technology trialled by Thomas Edison in his failed electric pen invention. O'Reilly's gun revolutionised the tattoo industry in 1891 and turned his infamy to fame. He became well known around New York for his shop at number 5, and later number 11, Chatham Street on Bowery. Early in his career, O'Reilly had a reputation for tattooing women only but photographs and early tattoo publications reveal that he also tattooed his own brother, John. 'Professor Reilly', as John was called, was a performer on the dime-show circuit. Dime shows or dime museums were a 19th-century early cabaret phenomenon, highly popular among the working class in the United States, much like P.T. Barnum's freak shows. John O'Reilly was often advertised as the first 'electrically tattooed' man. John was also active on the brutal underground boxing circuit that began to flourish in New York at the time.

An article in the *New York Morning Post* on 8 June 1890 brilliantly described John's body art:

> Proudly he points to the American eagle, which with liberty and truth in its beak, spreads its artistic outline straight across the breadth of his manly bosom. Somewhere in the region of his waist he calls your attention to a noble charger fresh from

the battlefield. The Statue of Liberty rears her proud head on one of his fleshy legs. There are also Japanese scenes, vessels in full sail and Spanish fandangos without number. In the interstices the flesh is so fancifully wrought with coloured inks in lace-like designs, that the man seems really covered as with a garment.

Samuel O'Reilly prospered as a result of the newly invented machine and often found sailors queuing at his door for fresh tattoos to commemorate their journeys, battles at sea and loved ones. Almost all sailors back then were tattooed and tattoo culture was spreading across the US. Many more versions of O'Reilly's tattoo gun came on the market, some of which he challenged for impinging upon his patent. Since that time historical documents and patent office documents have been uncovered that challenge the veracity of his claim to have been the inventor of the first electric tattoo. They question his modification of Edison's electric pen and highlight the use of various modifications of machines, such as a dentist's electro-magnetic mallet, prior to his patent application in 1891, but none carry the weight of argument to truly dispute his status as a pioneer in the tattoo community.

Little is known of Samuel O'Reilly's later life, other than he died in 1909 after a fall while painting his home in Brooklyn. He is buried at Kings Cemetery in Brooklyn, New York.

The collection

The TATTOOED MAN collection focused on the sea. O'Connell travelled the world aboard various ships, so seascapes and marine colours formed the basis of the colour story.

The main pieces were a bomber jacket and gilet, a sailor's deck jacket, deck shoes, cargo shorts, chinos, vests, ringer tees, tattooed man print shirts and a sailor's cap.

We created a brand video that narrated O'Connell's life story. To capture O Reilly's contribution, we made ringer tees which carried a version of the original tattoo gun design he submitted to the Patent Office. Other prints were inspired by the book written by O'Connell, which features a cartoon drawing of a man, presumably O'Connell himself, dancing in front of a tribe of warriors.

Dance was a feature of O Connell's life given he used it to spare himself from the 'cannibals' on the island. The dancing man graphic became the print for the collection, symbolising the Irish jig O'Connell performed to entertain the islanders when he first arrived. That O'Connell was the first fully tattooed man seen in the United States was one thing. That he used traditional Irish dance to save his life when he thought he was in danger, is another. Tattoos and traditional dance: these contrasting traditions were an interesting way to study the contrasted Irishman of today.

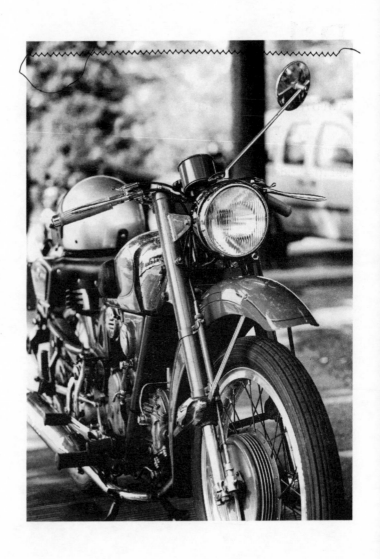

Biker

Autumn–winter 2019

'I realised there weren't many old road racers, but there were old trials riders. I decided I wanted to grow old.'
– *Sammy Miller*

S amuel 'Sammy' Hamilton Miller was a champion
motorbike trials rider who became one of the world's
best motorbike designers along the way. He has lived a life
marked by imagination, innovation and invention. Born
in Belfast on 11 November 1933, Miller took up biking at
16 after attending his first race. Infected with the racing
bug, he sharpened his biking skills by riding on bomb sites
and waste-grounds with his friends. What followed was a
motorcycling career that spanned road racing, track-racing,
dirt-biking and trials. Miller went on to become the most
famous motorcycle-trials rider of all time, legendary among
peers and followers of the sport. He was most successful on
the trials circuit, claiming the British Trials Championship
11 times and winning more than 1,300 titles across his
professional career. Miller still rides to this day, at 88 years
old. But they are not all the achievements of this competitor
and creator. He is as well-known for designing bikes and
bike engines as he is for racing, having designed many of
the bikes he rode and won on.

Miller was 20 years old before he took part in his
first competitive race. In 1953, he rode in the Scottish Six
Days Trial on a bike he had designed and made entirely
to his own specifications using a mixture of parts from
two different bikes. He used a Villiers two-stroke motor
of 197 cc displacement and combined it with a Matchless
frame from the 1930s. The new hybrid creation would be
called the SHS (the Samuel Hamilton Special). That wasn't
the only feat Miller performed to make his racing debut.

Sammy Miller in 1957

The Scottish Trials took place in Edinburgh. To get there, he rode the new hybrid bike to the Belfast Docks, boarded a ship to Scotland's west coast, and from there rode to Edinburgh to compete in a race, repeating the journey back home a week later.

Miller's talents as a biker were quickly noticed in the UK. He moved to Birmingham in 1957 after signing with Ariel Motors as a rider, bike designer and engineer. He re-designed and improved performance elements of the HT5 bike, which he was contracted to race. One of his greatest feats as an engineer, and maybe his greatest service to motorbike racing, was to greatly reduce the weight of the HT5. By 1964, the bike was considerably lighter and faster. He achieved this by using more lightweight wheel hubs, which he took from another of the company's bikes, the Leader road machine, and by making the seat, rear mudguard, front mudguard and fuel tank from fibreglass resin. This was a revolutionary move for its time.

Miller also angled the exhaust pipe slightly outwards to blow any debris – twigs, small branches, leaves or pebbles – away from the back wheel, thus keeping it cleaner and clear of obstructions. He was also one of the first to begin using aluminium alloys in a bid to reduce bike weight. It was around this time, as he was experimenting with bike design and pushing boundaries in terms of materials and ideas, that Miller realised the British motorcycling industry was dominated by executive types: accountants, regulators and rule-makers who saw the sport as a business and never

worked or thought outside the box. These people never considered design work and the improvement of the sport through ideas, imagination and investment. For a man naturally inclined to test the limits of engineering, Miller found the British motorcycling industry stifling.

Spain's Bultaco was the leading team in Europe around this time. When Miller's British team Ariel was acquired by a bigger operator called BSA, Miller took up an offer from Bultaco to both ride and develop their range of bikes further through his design and engineering innovations. Francesco Xavier 'Paco' Bultó, the team's owner, was born into a family which had long worked in the textiles industry in Catalonia. Bultó had been co-owner of a Spanish motorcycling team, Montesa, with a man named Pere Permanyer. Having been accused of wasting company money in his efforts to push the Montesa brand forward, Bultó dissolved the Montesa business. He was then persuaded by former Montesa employees to set up his own team. The arrangement between Miller and Bultó was made by a Dubliner called Harry Lindsay, who was a motorbike rider, a bike dealer and a business entrepreneur. It was Lindsay who imported Bultaco bikes to Ireland, and he has an interesting life story of his own.

Family business

Motorbikes were part of the Lindsay family tradition. Harry was the third generation of Lindsays to work in the industry in some capacity, so bikes were in his blood.

His grandfather, Robert, was a bike manufacturer who produced the Celtic motorcycle in 1898, which became a legend in the motorcycling world. Robert was also influential in the invention of the first pneumatic tyre through his close friendship with John Boyd Dunlop. It is said that Lindsay convinced Dunlop, a Scottish veterinary surgeon by trade, to open up his own tyre shop on Dublin's Golden Lane next door to his own business. These premises are right around the corner from my own office space in Dunnes Stores Head Office on the corner of South Great George's Street and Golden Lane. I enter the old tyre shop every day that I go into Dunnes' underground car park. A plaque marks the site of the shop.

Dunlop changed the nature of cycling – and transport generally – while experimenting with rubber in the backyard of his home in Belfast in the late 1800s. He invented the pneumatic tyre, or the inflatable wheel, for bicycles while experimenting with his son's tricycle. As a vet surgeon, Dunlop was experienced with using rubber, as catheters and breathing devices were made of it. He inflated a tube of sheet rubber and placed it over a wooden disc approximately 96 centimetres in diameter. He took a metal wheel from his son's tricycle and rolled the two across the backyard of his home in Belfast. The pneumatic wheel performed much better, only stopping when it hit the yard gate. The metal wheel stopped much sooner. His next development was to fit the tricycle with two pneumatic tyres, and the results were better again. Soon, he was testing

larger bicycle wheels, and after a performance analysis and testing session at Cherryvale Sports Ground in Belfast, a patent was granted to him on 7 December 1888. Dunlop later discovered that another Scotsman, Robert William Thomson, had already invented the pneumatic wheel. Thomson's Aerial Wheel was showcased in London's Regent Park in 1847 and found to work well, significantly reducing noise and increasing passenger comfort on horse-drawn carriages. Thomson was a prolific inventor, with credits ranging from the fountain pen, the first mobile steam crane used on sugar plantations and the first successful mechanical road haulage vehicle – a steam traction engine – which transformed road haulage in 1867. The last of 14 patents to Thomson's name, registered by his wife Clara, was for the humble trouser belt, which he elasticated in 1873, the year he died.

John Boyd Dunlop re-invented Thomson's pneumatic tyre 15 years after Thomson's death. By then, the world of transport had evolved further and there was more need for tyres. The worlds of motorsport, competitive cycling and later golf and tennis – sports with which the Dunlop name is still synonymous – took hold. A local cyclist called Willie Hume was the first to purchase and use the pneumatic tyre and he proceeded to win his next five competitive races, four in Belfast and one in Liverpool. Among the defeated during the Liverpool race was the son of William Harvey du Cros. Du Cros was a Dublin-born businessman with a background in finance. He became

a patron of Dunlop's, supporting his innovations financially and becoming a father figure in the research and development of the pneumatic tyre. Taken by the comprehensive nature of Hume's victory, du Cros set about finding out all that he could about rider and bike. Discovering the pneumatic wheel, he immediately saw the potentially transformative effect this would have on the world around him. Du Cros sought out Dunlop, and they reached an agreement to mass-produce the pneumatic tyre. Du Cros himself was an active sportsman, becoming an Irish boxing champion at two different weights and forming a competitive cycling team made up of his six sons known as The Invincibles. Harvey du Cros Junior was dispatched to the United States in 1892 to scale the pneumatic tyre business there. At that time, he was 19 years old, and the company he helped to scale would later become the Goodyear Tyre and Rubber Company, which is today a global leader in tyre manufacturing.

Bultaco

Senõr Bultó's determination to create a new winning Spanish outfit was matched only by his resolve to push development to improve machinery and performance. This was just the partner Sammy Miller had been seeking. So confident was Miller in his ability as a competitive biker and as a bike engineer that he inserted a win clause in his contract, whereby if he didn't win at least 50 per cent of his races, Bultaco wouldn't have to pay him.

Sammy Miller aged 85

One of the specific models Bultaco wanted Sammy Miller to re-engineer was the Sherpa N, which had been an off-road model up to that point. Miller's brief was to develop it into a trial bike called the Sherpa T. Months of testing took place on Bultó's farm in San Antonio. Harry Lindsay's confidence in Miller, Bulto's confidence in Lindsay, and Miller's confidence in himself were well placed. Miller won the Scottish Six Days Trial that year, 1965, and twice more in '67 and '68 aboard the Sherpa T. He also won the Scott Trial four times in a row, from 1967 to 1970, and many more titles on the bike he retro-engineered and rode.

Honda: The 125 Hi-Boy

In 1973, Miller left Bultaco for Honda, where he continued to race and pioneer motorbike design and development through engineering, material innovation and experimentation with old design ideas. Miller's next move was to design another iconic motorbike, the Honda 125 Hi-Boy. ('Hi boy' is a common salute, refrain, warning or exclamation in North Kerry, where the Honda 125 and motorbikes generally are popular. For example, 'Hi boy, where did you get that 125?')

Soichiro Honda founded Honda Motor Company in 1948. Honda had had an interest in engineering and automobiles from his childhood. He left engineering school without graduating and started working in a garage. The young Honda won a contract to produce piston rings for

Toyota but subsequently lost the contract due to the poor quality of the pistons. After further testing and other failures, he returned to Toyota in 1941 with a superior piston ring product suitable for mass production. Honda's automation process for production was so refined it could be carried out by unskilled wartime veterans.

By 1973, Honda had turned his attention to the European trial bikes market, which Miller had disrupted entirely with the development of his lighter, faster two-stroke Bultaco. Honda was still developing slower four-stroke bikes, and he identified Miller as the man who could help his company enter, and ultimately dominate, the trials market. Honda's offer was too good for an ambitious man like Miller to refuse, so after months of tension and negotiation with Bultó, Miller was released from his contract with Bultaco.

Miller's first task at Honda was to improve their existing bikes, both commercially and competitively. The TL 125 was already on the market but was a poor version of what Miller would go on to produce. His new design, the 125 Hi-Boy, was a great success based mainly on the implementation of a new frame. The Hi-Boy frame took 11 kg of weight off the original TL 125, while adding perfect balance and streamlining to accelerate performance. Another revolution in bike engineering was about to begin.

The Sammy Miller Museum

Sammy Miller continues to ride into his late eighties as part of special events and bike demonstrations, some 50 years after his first competitive victory. Having moved to Milton, New Hampshire, in the southwest of England, Miller set up his own motorcycle parts business, Sammy Miller Equipe. He later sold it to Richard Jordan and Jackie Drake, who took the company online, launching a mail-order service to go along with the existing services.

Today the Sammy Miller Motorcycle Museum in Hampshire is home to all those bikes and parts that Miller built. It is regarded as the finest collection of motorcycles anywhere in the world. It includes rare café racers, factory racers and one-off prototypes, and it is overseen by a trust that ensures these bikes will be seen by the public for years to come.

Miller has also written two books on the art of trials motorbiking: *Clean to The Finish*, and *Sammy Miller on Trials*.

The collection

Capturing the biker look for the autumn–winter 2019 collection was not difficult. Leather jackets were obviously part of the range, as were biker boots and check shirts. Denim shirts and panelled denim jeans were other critical pieces of the biker identity. To capture the essence of the sport, we used motorbike wheels and biker helmets as prints scaled to various dimensions and repeated on shirts

and T-shirts. Sammy Miller Equipe, the name of his parts business, became a slogan on graphic print tees to carry the storytelling further. The 'Sherpa Motor Club' graphic tee commemorated the bike that changed trial bike racing. We worked with a young racing car driver, motorbike enthusiast and model Lucca Allen from Cork as the campaign model. Lucca is now a Formula 3 racing driver and continues to model part-time.

Scaffolder

Autumn–winter 2020

'I had no special dream … only the ambition not to accept
my initial destiny.'
– *Mohed Altrad*

Mohed Altrad was born into a Bedouin tribe in the Syrian desert. He does not know his age because, as he said, 'when you are born in the desert in a Bedouin tribe moving all the time, there is no register'. As a child, Altrad witnessed his brother being killed by their father, a violent tribal chief. Altrad knows that, like his late brother, he was born of rape and that his mother had died at the age of just 12 or 13, shortly after his birth. His destiny seemed mapped out before him: to roam the deserts of Syria as a shepherd, maybe become a tribal chief, maybe become a violent man. Fate presented him with the opportunity to seize his vision for a greater destiny. It was a destiny that would lead to him becoming a primary figurehead and leader in the Arab world, the World Entrepreneur of the Year, an acclaimed author, a philanthropist, and – although he doesn't like to be described as such – a billionaire.

Seeing his brother die had forged a spirit of determination within Altrad. He was spared this same fate when he was sent to live with his grandmother as a child. She had no ambition for him other than to tend to the herd of family goats and sheep, but the young Altrad had other ideas. He taught himself to read. In the nearby village, he peeked through a crack in the schoolroom wall and saw decorative symbols written on the blackboard. He would later find out that it was calligraphy. Altrad insisted on attending school, sometimes sneaking off without his grandmother's knowledge to attend class.

Altrad's natural intelligence came to the fore at school,

and he finished top of the class. This achievement gave birth to another trauma. Bedouins are seen as an inferior class of people in Syria. When his classmates discovered that the late-comer – the shepherd boy, as they called him – had outperformed everyone else, they were unhappy. Despite his intelligence, Altrad had won no new friends or admirers but instead had jealous enemies who wanted to oppress him further. They decided to put him back in his place, as they saw it, by taking him to the desert and trying to bury him alive, head first. As his classmates ran away, Altrad managed to free himself. He describes his escape as 'the instincts of life' kicking in. That survival instinct would serve him well everywhere he went. He would need it more than ever in his next destination.

The young Bedouin boy moved once more. He left his grandmother's home to live with another relative in Raqqa, once an ISIS stronghold. In Raqqa, he continued his education, passing the baccalaureate to be awarded a Syrian high school diploma. Altrad graduated first in the region. At this stage, the Syrian government were offering scholarships for high-achieving students. Altrad was awarded a scholarship to study at a third-level institute overseas. His initial destination was Kyiv, but he was denied access to the course. Syria had complex sociopolitical and military relationships with the Soviet Union at the time. France, another country with a complex relationship with Syria, was his second option, so he went to study at the University of Montpellier in northern France. Altrad left Syria at 17 years

old and arrived in a cold, wet Montpellier in November 1969. He spoke no French and was without a contact, comrade or acquaintance. He later recounted the difficulty he had understanding lectures in his computer science course. But he persevered, earning a first-class degree before moving to Paris to attain a PhD in Information Technology. Not long after that, he and three friends founded a company that sold portable computers. When they sold the company, Altrad made a profit of 600,000 francs.

While studying for his PhD in 1975, Altrad worked part-time for a military electronics and communications firm, Thomson. Thomson-CSF had been founded by an English-born American engineer Elihu Thomson in the late 1800s and had merged with Thomas Edison's General Electric Company in the USA to become GE, the General Electric Company. Thomson, its sister company, was formed in Paris. It became the main sponsor of Paris Saint-Germain FC in the early noughties, when players like Ronaldinho, Mauricio Pochettino and a young Mikel Arteta (now manager of Arsenal FC) were at the club. Thomson now trades as Technicolor in the creative media, entertainment and communications space. They also have a military electronics division, which is where Altrad worked.

Altrad describes his early years in France as cold and unfriendly. After working for Thomson and some French telecom companies, he moved to Abu Dhabi. He spent years working for the Abu Dhabi National Oil Company, developing telecommunications network systems that

Mohed Altrad

enabled the company to communicate with its offshore rig workers. Like many Irish people who move to the Gulf – Abu Dhabi and Dubai especially – Altrad saved a lot of money.

Altrad noticed the booming construction sector and the thousands of Asian, Middle Eastern and Filipino labourers climbing hastily erected scaffolding on building developments. Most of these sites were unfit for purpose and without the necessary safety certifications. Altrad was inspired to do something after witnessing a scaffolder fall to his death. After this accident, he moved into the construction sector in France, implementing all of the health and safety criteria and the focus on employee well-being that were missing in the Gulf. This sense of humanity would become a feature of his working life. It would form the backbone of his multinational company. His company's manifesto, called 'Pathways to the Possible', placed the well-being of workers at its heart. What makes Altrad noteworthy as a person and an entrepreneur is his dedication to this doctrine, which he updates regularly and views more as a book of poetry than a company manifesto.

Along with a friend, Richard Alcock, Altrad bought a failing French scaffolding company for one franc. The men turned around the fortunes of the company and diversified into providing building site equipment, such as wheelbarrows and cement mixers. This company would become Altrad, the global leader in scaffolding supplies in the construction services industry. Having acquired its biggest competitor, Dutch provider Hertel, Altrad now employs approximately

17,000 people and has operations in 100 countries. All employees are given a copy of and work under the humanistic charter he wrote 30 years ago and still lives by today. 'Pathways to the Possible' explains the humanistic ideals and beliefs that underpin the company spirit and, by extension, the spirit of the man who defied the odds to build it.

Building inspiration

When I walked into the Dunnes Head Office throughout 2019, I couldn't miss the amount of construction happening around the city centre. New hotels were popping up on every corner as the area around George's Street was developed. I walked around bollards and under scaffolding, saluting men in hi-vis vests as I went. The noise was one thing, but the visuals were another: machinery, equipment, trucks, saws and scaffolding – lots of scaffolding. The patterns, lines, angles and shapes made by scaffolding were a gift to someone like me, who sees the world, and especially the urban landscape, as something designed. I started thinking about the construction industry, my own days on the building sites, and the impact of construction on our lives. A building site is a place where design comes to life. Architects, industrial designers and engineers do the pre-design work, and the tradesmen carry out the design to bring buildings to life. What we wore on the sites is specific to the industry but could vary with the trade. Steel-toe boots, heavy-duty trousers, often sweatshirts, T-shirts and shorts in summer, hard hats, hi-vis vests and jackets.

There is a certain style and identity to the construction industry. Workwear is a specialised retail sector of its own, worth $30 billion globally at the time I was designing the SCAFFOLDER collection. Brands like Dickies were built on providing workwear to industry tradespeople but have been adopted by creatives, musicians and especially skaters for the looser fit, structure and shape. You're as likely to see Dickies trousers at Coachella music and arts festival in the Californian desert as on an Irish building site. Dickie's has branched into streetwear. Workwear continues to move through the gears from the sites to the streets.

Technological advances and health and safety requirements have seen innovations in workwear move from waterproofing and shock absorption to micro-controller chips that monitor real-time data on posture, motion, heart rate, breathing and exposure to toxic gases. High fashion – that is the luxury end of the business – has been greatly influenced by the construction sector over the past number of years. The hi-vis trend was adopted by brands like Balenciaga and Yeezy and in sportswear by everyone from Adidas to start-ups. Industrial design details like straps, fasteners, chains, oversized pockets, toughened fabrics and textures are still common. Buildings and architecture are often the basis for designers' collections. In fact, many of the most interesting people working as fashion designers today originally trained as architects. Tinker Hatfield, the architect who became a footwear designer for Nike, inspired a generation of architects to cross over.

Using scaffolding as inspiration is not something I had seen a brand do before, and I enjoyed the originality of what we did in Dunnes. Being original in the design industry is hard unless you have a true design mind. Borrowed thinking is common. Brands and designers often borrow other people's ideas, tweak them slightly and pass them off as their own. In some cases, it's not even borrowed thinking but full-blown plagiarism. But true creativity can't be copied. It takes courage to express something creatively and make it a reality. Just ask the bamboo scaffolders of Southeast Asia.

Bamboo scaffolding

Bamboo scaffolding is commonplace across Asia, but particularly in Hong Kong. Bamboo is extremely strong and resilient, with tensile strength (28,000 pounds per square inch) greater than steel (23,000 pounds per square inch). It was popular in Asia as it grows easily there and, according to some construction industry experts, bamboo scaffolding is lighter and quicker to erect and take down. But others argue against its use for safety reasons, and today the use of bamboo scaffolding is on the wane. There are two types used in Hong Kong today: *Kao Jue*, a pole bamboo, and *Mao Jue*, a hair bamboo. Bamboo scaffolders are highly trained, and the most challenging part of their training is learning the skill required to tie the knots that secure the poles together. It is not unusual for scaffolders to carry out a *Bai San* ceremony for good fortune before beginning work at new sites. Visually, bamboo scaffolding

creates interesting shapes on the urban landscape as it surrounds city skyscrapers. In 2022 in Ireland, there has been an increase in the use of bamboo to make hurleys due to a shortage of traditionally used ash timber.

Sporting philanthropy

For someone who couldn't speak French when he arrived in Montpellier, Mohed Altrad quickly became a cultural phenomenon, making his presence felt in the fabric of France's seventh-largest city. His benevolence can be seen everywhere. One of the great philanthropic acts he performed for the city was to buy its ailing rugby union team, Montpellier Hérault Rugby (MHR). The club was drowning in debts when Altrad was asked to play his part in resurrecting it. He bought the club and breathed new life into it – just like he breathed new life into himself all those years ago when he escaped being buried in the desert as a boy.

Since Altrad bought Montpellier in 2011, the team has achieved some success, winning the European Challenge Cup in 2016 and finishing runners-up in France's Top 14 in 2011 and 2018. As ever with Altrad, rugby and ownership are about much more than on-field activities. Buying the club was a commitment to the city and its people. The partnership with Montpellier was founded on ideals similar to those of the company he founded.

As part of the deal, Altrad regenerated the local community around the club's home ground, investing in infrastructure and community facilities and renovating

Montpellier president Mohed Altrad and Marvin O'Connor
during the Challenge Cup final match between Harlequins and
Montpellier at Stade des Lumieres on 13 May 2016

the stadium itself. The Altrad Group were soon the main sponsor of not just Montpellier but the French national rugby team. In 2017, the company and the French Rugby Federation announced a five-year shirt sponsorship deal, making Altrad the French team's first-ever shirt sponsor. This deal has since been extended to include the upcoming 2023 World Cup, which will be held in France.

The company's involvement in rugby has not been without controversy. Former French rugby coach Bernard Laporte, then President of the French Rugby Federation, was accused of pressuring the federation's appeals committee to reduce a sanction against Montpellier. In 2017, Laporte's company had signed an image rights deal with Altrad. The French newspaper *Le Journal du Dimanche* discovered and reported the proposed arrangement. Laporte subsequently pulled out of the deal.

Mohed Altrad is a highly respected philanthropist. He estimates that the Altrad Group's €3 billion turnover provides for the livelihoods of some 500,000 people (when employees' families are taken into account). That is some going for a company that is just over 30 years old. Altrad's other charitable endeavours include providing financial support for Doctors Without Borders (Médecins Sans Frontières) and the French League Against Cancer. He also leads Agence France Entrepreneur, a government organisation that promotes entrepreneurship in impoverished communities that exist on the edges of big cities. The organisation caters to a region that is home to an estimated

12.8 million people across 1,500 low-income communities.

Altrad has authored almost a dozen books, ranging from business management books to novels. The novel *Badawi* (Arabic for 'Bedouin') was the most important and successful. *Badawi* follows the story of the main character, the hero Maïouf, a fictionalised version of Mohed's young brother who was killed by their father. It is semi-autobiographical and deals with matters of family, land and the transience of time. It has sold millions of copies worldwide and is on the French secondary school curriculum.

The collection

SCAFFOLDER was an industrial collection based on clothing worn on building sites. Combat trousers, hoodies, padded jackets and gilets with oversized pockets were the key styles. Hi-vis neons were part of the colour story. Scaffolding was the basis for the print story in the range. We took images of scaffolding erected around buildings in Dublin City and used the patterns made by the poles and crossbars as print patterns on shirts and tees. We also used bollards as a print. I enjoy creating print ideas that you wouldn't usually see in fashion because it extends the story-telling behind the collection and starts a conversation. I like the idea of someone asking the wearer if that's a bollard on their T-shirt. Bollards were one of my favourite print ideas. They are a recognisable and visible piece of industrial design, yet you never see them referenced in clothing. They certainly beat a hibiscus or a banana.

Boland

Spring–summer 2021

'Only a tramp tailor.'
– *A political rival for Roscommon South describing Boland
during the Dáil Eireann election campaign of 1918/19.*

James Boland, father of Harry Boland, was born to
Irish immigrant parents in Manchester, England, in
1856. He moved to Dublin in 1881 to work as a paving
foreman and became an active member of both the early
Gaelic games movement and in political circles, joining
the Irish Republican Brotherhood (IRB). It is said that
he had involvement with the IRB's more militant splinter
group, known as the Irish National Invincibles. These were
a group of radical Republicans who aimed to assassinate the
leading members of the British government sent to Ireland
to administer British rule from Dublin Castle. In 1882, the
Invincibles were responsible for the assassination of Lord
Cavendish and Thomas Henry Burke, Chief Secretary
and Permanent Undersecretary for Ireland, respectively.
An informer identified James Boland as a member of the
Invincibles and as the man who had issued the orders to
Joe Brady, one of the men found guilty of the two fatal
stabbings. A warrant was issued for Boland's arrest, so
he fled to New York with his wife, Kate. He returned to
Ireland in 1885 but remained under surveillance and was
named number 59 of 63 'dangerous Fenians' in the Dublin
Metropolitan Police District.

James Boland is also known to have been present in
Hayes Hotel in Thurles on 1 November 1884 as a member
of the General Council, which was fundamental in the
formation of the Gaelic Athletic Association. Boland's
links to the GAA ran deep. He was elected president of the
Dublin Central Committee of the GAA in 1892 and was

central to the formation of the Nally GAA club in Dublin, named after Patrick Nally, who was a founding member of the IRB. Nally had also been an early advocate for seeking to inculcate the population with a sense of Irish pride and fitness through sport as a means of promoting nationalism. An active athlete himself, Nally had attempted to set up a National Athletic Association before meeting Michael Cusack and inspiring the formation of the GAA. James Boland and Nally were close friends and conspirators from their days in Manchester. Boland organised Nally's funeral when he died in Mountjoy Prison.

James Boland's own death at the young age of 38 was caused by several blows to the head from a baton. The first happened as he was protecting Charles Stewart Parnell from assailants during a trip to Wicklow, causing an undetected skull fracture. The second blow occurred during a raid on Parnell's *United Ireland* newspaper office, which was stormed by allies of Tim Healy, an influential anti-Parnell politician of the time. Boland's passing left a lasting mark on his eight-year-old son, Harry, who would follow his father's lead in becoming active in the GAA and Irish politics at an early age.

Harry and the GAA

Harry Boland is a remarkable figure in Irish sport, with a unique history of achievement and service to the GAA. At the age of 20, Boland hurled for Dublin in the 1908 All-Ireland final. He became chairman of the Dublin

Central Committee (the equivalent of the Dublin County Board today) in 1911. Boland refereed the 1914 All-Ireland football final between Kerry and Wexford, which ended in a draw. Incidentally, the equalising point was kicked by Kerry captain Dick Fitzgerald, who would later become close friends with Harry's brother, Gerry, when the two were interned in Frongoch in Wales in 1917. Harry also trained UCD Collegians to win the 1917 All Ireland hurling title.

Many Gaelic footballers of that time were imprisoned after the 1916 Rising, just for having a loose attachment to Gaelic games and the Gaelic Athletic Association. Between them, Fitzgerald and Gerry Boland led the organisation of football matches played between Kerry, Dublin and Louth players on a patch of open grass within Frongoch, which the players called Croke Park. Fitzgerald led a team called the Leprechauns (because they were small in stature) to victory over Louth in the final. The Louth team contained many All-Ireland-winning hurlers and footballers. During the organisation and playing of these games, and other prison activities like quizzes and debates conducted as Gaeilge, the prisoners – Michael Collins included – made plans for further resurgence when they returned home to Ireland.

Growing up in the Phibsboro area of Dublin, on Dalymount Terrace, not far from Croke Park itself, the young Harry had been aware of his father's political beliefs. After James's death, Charles Stewart Parnell and

his supporters raised funds to spare the Boland family from destitution. With the money, Kate Boland bought a tobacconist on Wexford Street and ran her own business. Harry spent a brief spell at Synge Street boys' school around the corner but ran into trouble with one of the Christian Brothers and refused to return. His school life was tumultuous partly due to James Boland's passing and partly due to young Harry's relationship with authority. He was sent to De La Salle College in Laois in 1902, where he found the kinship and a common nationalistic spirit that made him feel at home. Playing Gaelic games was a daily part of the De La Salle boys' lives, and it was here that hurling became Harry Boland's passion.

After three years at De La Salle, Boland moved to Manchester, his father's hometown. He worked odd jobs and remained in constant contact with the political scene in Ireland, joining the IRB in 1904 with his brother Gerry. When he returned to Dublin around 1905, he worked as a tailor's cutter at Todd, Burns & Co. on Mary Street in Dublin, which was then Ireland's largest department store. Tailoring was a career that would serve Boland well later in life.

Boland became well-known as part of the Dublin team that lost the 1908 All-Ireland hurling final to Tipperary after a replay on a scoreline of 3-15 to 1-05. Tipperary was captained on the day by Tom Semple from the Thurles club. A two-time All-Ireland-winning captain (1906 and 1908), Semple had moved to Thurles from his home parish of Drombane at 16 to work for the Great Southern & Western Railways.

On retirement from playing in 1909, Semple organised a committee to develop a proper hurling pitch in Tipperary. They raised funds to buy the Showgrounds in Thurles, redesigning it and developing it as Thurles Sportsfield, which became a renowned hurling ground. In 1971, the sports field was renamed Semple Stadium in his honour and is regarded as the finest hurling surface in the country today. Tom Semple played a key role in the War of Independence from 1919 to 1921, as an organiser and dispatcher of messages for the Republican Army via the railway network.

Around the time of the 1908 All-Ireland final, Harry Boland made regular trips to London to meet with other republican figures. It was in London that he met the secretary of the Geraldines GAA Club, one Michael Collins. Boland introduced Collins to another leading republican figure, Sam Maguire, who inducted Collins into the IRB. On the sporting side, Maguire was regarded as a polished footballer, playing in three All Ireland finals – 1900, 1901 and 1903 – for the London Hibernians. He later became chairman of the London County Board and a regular delegate at the annual GAA congress, where decisions on the game's future were made. Sam Maguire is the name given to the All-Ireland football trophy today.

Boland continued to influence political and sporting matters in Ireland after he retired from playing. He joined the Irish Volunteers, a military organisation established by Irish nationalists in 1913. He was now a leading figure in the republican movement and Irish politics.

All three Boland brothers – Harry, Gerry and Ned – were active during the Easter Rising of 1916. Harry was one of the last soldiers to leave the GPO on Dublin's O'Connell Street, the republican headquarters, during the uprising. He even disarmed three unused bombs before leaving the building. Unlike his father, Harry did not escape prison for his activities. He was identified by a musketry instructor whom he had incarcerated in the GPO. Though Harry was not an officer in charge, he was sentenced to 10 years in Dartmoor Prison in Devon, with five years suspended.

Harry exerted considerable influence over fellow prisoners, Éamon de Valera included, in the organisation of meetings, exercise, football matches and plans related to political scheming. He was quickly identified as a leader and man of charisma who could bring others with him. These traits, coupled with his ability to generate mischief and mockery at the expense of prison officers, meant he was moved from Dartmoor to Lewes Prison outside London and later to Maidstone, where he served the remainder of his time. Upon release from prison, he would revisit a profession he had learned as a young man: tailoring.

If Boland's sporting prowess is not particularly well known, his profession as a tailor is even less so. The combination of military politics, GAA and tailoring makes Boland a compelling reference point for Irish men.

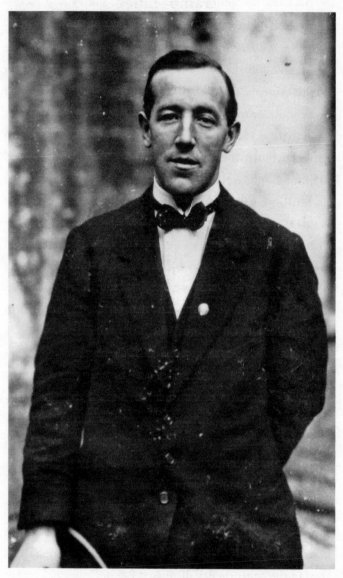

Boland in 1919

Tramp–tailor

Harry Boland first met Kitty Kiernan in the Greville Arms
Hotel in Westmeath. Any Gaelic football nerds out there
will remember the Greville Arms as the primary sponsor
of the Westmeath football team during a period of great
success under manager Páidí Ó Sé in the early noughties.
Long before this, the Greville had stories to tell. It is a
historic venue in its own right, built between 1865 and
1870 for Lord Greville, who had bought the whole town
of Mullingar in 1858. His architect was a man named
William Caldbeck, who designed much of Mullingar
town, including Market House. Caldbeck built the hotel
around an interior monument known today as the Greville
Monument, which still stands in the hotel. James Joyce
was known to frequent the Greville. The Ulysses pub to
the right of the hotel is named after Joyce's famous novel
and contains a monument to the author.

When Harry Boland showed up, Kitty Kiernan was
taken by his stylish attire and storytelling. Michael Collins
was with him at the time, and both men became smitten
by Kiernan. Boland and Collins – friends in politics, sport
and drinking – became rivals in her pursuit, with Collins
eventually becoming engaged to her.

In 1918, Boland ran for election as a Sinn Féin candidate
for the inaugural Dáil Éireann in the Roscommon South
constituency. In an echo of today's political climate, his
rival in the constituency dismissed Boland as 'only a tramp
tailor' during the election campaign. Boland had the last

laugh, winning convincingly by 10,685 votes to 4,233.

By now the 'tramp-tailor' had his own tailoring business at 64 Middle Abbey Street, which he opened with some of the proceeds from a hurling game he had helped to organise in Croke Park. Boland's underground activities continued. He loved Gaelic games and saw them as crucial cultural components in the fight for independence and national identity. Within the GAA, he found many kindred spirits who could be depended upon to carry the fight and the message intelligently. Using soft power and influence, Boland ensured the GAA would be politically aligned with his goals and that of the nationalist movement. From the tailoring shop, Boland would plan military activities, whereby messengers would deliver messages from various commanders and battalion leaders. The messengers would come and go in disguise, arriving in one suit and leaving in another.

In researching this book, I learned from Boland family relations that from his Middle Abbey Street store, Harry Boland made suits for Michael Collins and Éamon de Valera as well as other political leaders. These are the same suits we see these men wearing in the many grainy black-and-white photographs displayed in online museums and historical archives. It is this strand of Boland's life story – Boland the tailor, with his combination of sport, war and style – that makes him most compelling to me.

Ambassador of style

Historical records recount Boland as a man of quick wit, charm and style. His personal style and easy manner gave him an ambassadorial air. In this capacity, Éamon de Valera used him to penetrate Irish America as a special envoy. Boland was dispatched to New York in May 1919 on behalf of the Dáil. His time there overlapped with de Valera's, and Boland carried out all manner of duties for de Valera, who had replaced Cathal Brugha as President of Dáil Éireann. Boland's time in New York was high risk, involving planning, fundraising and arms smuggling. His reputation as a gunrunner soared as he sent arms back to Ireland by various methods: he used secret agents and an intricate network of contacts at ports around New York. However, he lost face with the capture of 495 Thomson sub-machine guns in Hoboken, New Jersey. This loss of arms meant Boland had to go back to Ireland to explain himself and to attend the second Dáil. He conducted himself so well that he returned to New York with increased diplomatic credentials.

Boland was so highly regarded by his peers because of his ability to raise funds. Along with de Valera, he raised $5.5 million, equivalent to €55 million today, through public speeches in capital cities around America where Irish emigrants, especially wealthy ones, abounded. One famous image of Boland shows him speaking to 50,000 people at Boston's Fenway Park. Russian diplomats on the ground in New York heard of the Irish revolutionaries in

town on the same mission as they were: to raise funds and support for their own home revolution. They sought out Boland for a loan. Some $20,000 raised by the Irish movement went to Russia to support their 1917 uprising against the Romanov monarchy. Boland's abilities as a dealmaker shone through. He acquired possession of the Russian crown jewels as collateral. He brought them to Ireland by boat, arriving in Cobh on 27 December 1922 with fellow envoy Sean Nunan.

Nunan later described to the Bureau of Military History the series of events that led Boland to hide the Romanov jewels in his mother's chimney at 15 Marino Crescent, Fairview. After they left Cobh, Boland and Nunan made straight for Earlsfort Terrace in Dublin, where the Dáil was in session debating the Anglo-Irish Treaty. After the debate, Boland gave the jewels to Michael Collins, who threw them back at him and left. Tensions were rising between the pair. Boland hid them in the fireplace of 15 Marino Crescent, where they lay behind a brick until the family brought them with them when they moved to 315 Clontarf Road. There they remained forgotten for years until they were mentioned during the 1948 general election campaign by Dr Patrick McCartan, an election candidate from Cork. McCartan had also been a Sinn Féin envoy in New York at the same time as Boland in 1920 and knew of the loan. Laois–Offaly politician Oliver J. Flanagan then raised the matter of the outstanding Russian debt and the missing crown jewels in the Dáil. This led to media attention

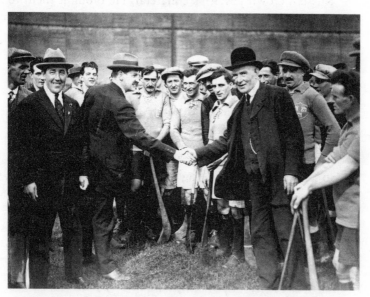

Collins shakes hands with James Nowlan, president of the GAA, at the 1921 Leinster Hurling Final. Boland is at the front left of the photo.

and an enquiry into their whereabouts. Once found, the jewels were set to be auctioned at Sotheby's in London for a fraction of their value. The Russian government got late word of this and bought them back for the cost of the initial loan.

Uncivil war

By June 1922, Boland and Collins had become estranged. Dáil Éireann had passed the Treaty and established the Irish Free State. Both Boland and de Valera opposed the Treaty but Collins supported it, leading to enmity, divided loyalties and ultimately to the outbreak of the Civil War. Boland's movements around Dublin in the time he spent back in the country had to be stealthy and well-planned. He was effectively on the run as an anti-government, anti-Treaty operative in charge of the IRA's Eastern Command, which was situated around Wicklow. Stories and conspiracies abound about his eventual death. What is known is that, on the afternoon of 31 July 1922, he headed north to Skerries by train. Making his way to the Grand Hotel in Skerries, Boland was shot by Free State soldiers when they attempted to arrest him. He died the next day in St Vincent's Hospital, Dublin. Boland left a rich legacy as a man who transcended Irish life and became a cultural icon through sport, politics, diplomacy and his unique personal style. GAA clubs located worldwide now carry his name, the oldest being Harry Boland GAA club in Chicago, founded in 1925.

The collection

The BOLAND collection combined sport and tailoring. Boland himself, like most men of his time, mainly wore suits. His profession as a tailor was a factor in how he dressed. Wool blend overcoats, an everyday item for men of the early 1900s, also featured in the collection, as did grandfather shirts and flat caps. Aran jumpers were a feature of the Irish man's wardrobe at this time and were included in the range.

The bolero cap that Harry regularly wore became the print pattern for the collection. To reflect his sporting story, we used the terraces of Dalymount Park, close to his childhood home, as the location for the campaign shoot. Fleece jackets, brushed sweatshirts, trainers and beanie caps brought Boland the sports fan back to the terraces.

Dancer

Spring 2021

'How can we know the dancer from the dance?'
From 'Among School Children' by William Butler Yeats

B obby and P.J. Reynolds from Edenderry, County Offaly, started it. When I saw these two brothers on TikTok, dressed head to toe in their GAA club gear, dancing to hip-hop, R'n'B and pop music, I knew things had changed for young men in Ireland. That they could dance was one thing; that they had the confidence to choreograph moves and lip-sync lyrics and then post these videos online was another. They led the way for young Irishmen to push things forward in terms of self-expression, self-esteem and style. And they did it in a very organic, natural way, which I found inspiring and refreshing. This was the kind of culture I wished to create for young Irishmen when I was starting out with Dunnes all those years ago: a space where free expression, pursuit of one's interests, strong identity and self-esteem could prosper, as opposed to the negative, inhibited, almost oppressive culture I encountered myself when navigating my entry into the creative industry from a GAA background. The Reynolds brothers proved that the culture I once experienced had changed and become more relaxed, accepting and forward-thinking. Technology had enabled this progression and expression, but so too had clothing and the emergence of reference points such as myself and Conor McGregor. The Irishman could be confident and stylish.

The emotional handbrake

The Reynoldses challenged the Irishman's relationship with dance. Dance engages us on an emotional level, which

affects our physical expression, which in turn impacts us emotionally. Dance just keeps changing, and change – or managing change – is the great challenge we face as humans. It keeps evolving into new forms, routines and trends. To evolve with it requires time and interest, which a lot of men don't have. I've found that women are more natural dancers and more attuned to the rhythm of music. Most men of my generation would like to be the best dancer in the room, moving in perfect time to the beat, knowing all the lyrics and having rhythm. Many are inhibited by the attention they garner, which is the emotional handbrake – the mental barrier preventing expression. The requirement to let go and fully express ourselves through dance and music is too much of an ask for some. You don't have to dance to have a good time, we tell ourselves by way of cop-out. We can do other things. If we don't want to dance, we blame the music. Whigfield? Who dances to that? As this internal conversation runs, what we might do instead is stand by the bar and drink alcohol as a reflex action, our elbows bending in perfect time to the beat as we convince ourselves we are actually dancing and having an enjoyable time expressing ourselves. All the while, we are overwhelmed by the alcohol and the fear that has engulfed our bodies this close to a dancefloor. The fear might turn to anger when, say, 'Rhythm is a Dancer' comes on, and it's our favourite tune, the one that was playing in our heads during the daydreams we had about impressing every woman the minute we walk into a party. Dance can do

funny things to a man, impacting us in different ways. For many men I know, it stifles them emotionally and they feel unable to express themselves because of shyness or paranoia, but for others, it releases them emotionally and they feel fully able to express themselves without fear. You could say the difference between the two relates to understanding male behaviours, moods, relationships and mental health. Dance could be prescribed as an antidote to negativity, inhibition and bad mood.

Dance and/or sport

Dance has become so visible on social media and in sport. I wonder if it has now become part of sports culture as well as being its own entity. Rather than being something sportsmen and women might do to warm-up or celebrate, is dance now baked into sport? These questions were inspired by observations made over lockdown when young Irish men like the Reynoldses embraced new dance trends and performed choreographed routines for social media audiences via TikTok. That they performed these routines together, in public, or at least for public consumption via their social platforms, spoke volumes. The confidence this takes is so far removed from the lack of confidence many men felt when it came to dancing in nightclubs or at weddings when I was growing up. It is a great sign of self-esteem and self-belief and bodes well for today's Irish male youth. The other interesting takeaway from these videos was the fact that many wore sportswear – GAA jerseys and shorts – to do so.

Dance in Ireland has transformed from the days of outdoor wooden platforms at crossroads (like the one outside McCarthy's Bar in Finuge, where I played football), where rural communities came together to socialise. The Public Dance Halls Act of 1935 restricted dancing to licensed premises, and the indoor dancehalls soon became commonplace. They made money for showbands and dancehall owners and made many marriages. Every weekend, men, wearing suits and ties, visited the dancehalls of Kerry, Cork, Limerick, Galway and Dublin, and the halls for the Irish communities in England, such as the Galtymore in Cricklewood, London. Fast-forward to today, and dance has left the halls and entered our homes. But gone are the days of men wearing suits for their weekend dance – unless there's a wedding.

I took up traditional Irish dance as a young boy but rejected it in favour of sport as a schoolboy. It felt like a choice. You could either be a dancer or a sportsman. I chose sport. That dichotomy no longer exists. Today's young Irish dancers wear sportswear, team jerseys, shorts, socks and tracksuits. Top sportsmen are using dance in their game preparation, in the cultivation of team spirit and in team celebrations. Sportspeople have embraced expression through dance in various forms, and dance has jumped the cultural divide to become an intrinsic part of sports and team culture.

During lockdown, it was so interesting to watch teenagers, 20-somethings and even their parents adapting

to TikTok. Like any other social media platform, TikTok has positives and negatives. A big positive is the ability it gives users to express themselves in whatever form they choose – dance is just one outlet. It is the most expressive of all social media apps, and Irish people have adapted to it very quickly.

The shared platform has also changed how we perceive dance genres, in that certain genres no longer belong to particular eras or age demographics. For instance, before TikTok, I would have thought of dance styles as being generational. My parents had their style of traditional dancing at the dancehalls and bars. It was a social thing, a pastime, and they enjoyed it. They also dressed accordingly for it at weekends. My generation had a different relationship with Irish dance. For me, it was less of a social pastime and more something we had to learn rather than enjoy. Irish dance was part of my secondary school curriculum during the week, and céilithe, with all their pomp, costumes and intensity, were part of the weekend. Like most of my friends and boys my age, I ran from it, choosing sport as my outlet instead.

Dancehall days

Ten years ago, I watched a TG4 documentary called *Damhsa an Deoraí*, which translates as 'The Emigrant Dance'. The programme brought viewers on a journey back to the days of the dancehalls and explored the vital role dancing played in the lives of Irish immigrants in London. Central to the show

Dancing at the crossroads

A typical Irish dancehall

was the Galtymore dancehall in Cricklewood, North London. Built by John Byrne, from my home parish of Lixnaw in County Kerry, the Galtymore became a second home for the London Irish community, a meeting place where they could feel part of something communal and spiritual. Traditional Irish dance was central to the Galtymore experience, as were the great showbands and performers of the time like Big Tom and Joe Dolan.

The Galty, as it became known to its regulars, opened in 1952 and ran until 2008. It hosted its biggest-ever crowd one night in 1967, when 6,850 people paid in to see Larry Cunningham and his band The Mighty Avons perform. Larry, from Mullinalaghta, County Longford, was a builder by day and a country singer by night. He holds the distinction of knocking the Beatles off the number one spot in Ireland in September 1965 with his version of 'Lovely Leitrim'. Mullinalaghta, with a population of fewer than 400 people, shot to the national spotlight in 2018 when it became the first club in Longford football's history to win a Leinster football title, beating Dublin's fancied Kilmacud Crokes in a shock win. Larry Cunningham was also the first Irish artist to have a top ten hit in Britain and the first Irish act to play on *Top of the Pops* on the BBC. In an interview, Cunningham recalls sitting backstage in the band room of the Galtymore before that 1967 sell-out show and seeing the queue, four abreast, snake down Cricklewood Broadway for two miles. That was a measure of the importance of this meeting place for the Irish in

London. Dance was intrinsic to how Irish people connected, expressed themselves and lived their lives.

John Byrne was a visionary who created and nurtured London-Irish identity. Tea dances were another Galtymore phenomenon. They catered for non-drinkers in a manner that was empathetic, socially aware and morally conscious. Even after alcohol licences became widespread and dance-halls became more like pubs and drinking alcohol became part of the dance experience, the tea dances remained for those who abstained. It used to be said that more Irish marriages and families were born and more job inter-views were conducted in the Galtymore than anywhere in Ireland. On Monday mornings, construction bosses drove up Cricklewood Broadway to collect labourers and workers who stood waiting outside the Galtymore, hoping to get a week's work on one of the many Irish building sites dotted around London.

Byrne's vision transformed the Dublin skyline also. He was summoned home from London in the early 1960s by Taoiseach Seán Lemass to construct office buildings around Dublin, including O'Connell Bridge House, D'Olier House and Parnell House, for the growing public sector workforce. Before this, Byrne built more dancehalls around Ireland, where more families and memories were made. His prowess as a developer is still renowned amongst peers and commentators. He passed away in 2013, aged 94.

Another man from my parish, and a neighbour of John Byrne's, was Bill Fuller. Fuller left for London at

16 and went on to build dancehalls and music venues all over the world. He started with the Buffalo in Camden, a notoriously rough venue that the police closed down after one fight too many. (Dancing and fighting are cousins, and dancehalls have been the scene of many a combat.) Bill Fuller managed to acquire a licence to re-open The Buffalo by promising the police he would man the doors himself and that if he ever had occasion to call the police, he'd close the place himself. It helped that Fuller was an amateur boxer and wrestler who could handle himself in such situations. The Buffalo became a meeting point for Irish immigrants to enjoy music, dance and song. Fuller left the ballroom business in the 1970s for rock and roll, re-naming the Buffalo the Electric Ballroom. The opening night hosted the Sex Pistols, and huge bands such U2, The Clash and Oasis have played there over the years. The Electric Ballroom is still going strong in Camden today and was owned by Fuller until he passed away in 2008.

Another of Fuller's famous venues was the Fillmore in San Francisco, which is still an iconic music venue. He also opened ballrooms and venues in New York, Boston and Las Vegas. In Vegas, Fuller became well-connected enough to help Irish showbands play big arenas. An acquaintance of his, Frank Murray, recalls the story of Fuller being offered the chance to meet Elvis Presley one night: Fuller responded to the offer with, 'Fuck Elvis, I want to meet the Colonel.' The Colonel was Tom Parker, Elvis's manager and the man responsible for all bookings. Parker famously

earned 50 per cent of all Presley's commercial income. Branching into music management and promotion made Bill Fuller wealthier and better known. Amongst the acts he promoted were Johnny Cash, Jerry Lee Lewis, Willie Nelson, Patsy Cline and Billie Holliday.

Crossroads dancing

My home Gaelic football club, Finuge in North Kerry, is situated just outside Listowel on the banks of the River Feale. Football is not the only key to our identity here – so too are literature and performance. Finuge is one of the only places in Ireland that still promotes and actively pursues outdoor crossroads dancing. In the 1950s, it became a local pastime, but in places like Drumshanbo and Effrinagh in County Leitrim, Leap and Laharn in County Cork, Ballynaglogh in County Wexford, it goes back much further. Records show accounts from the early 1800s of crossroads dancing in Leitrim, where farmers were unhappy that their grass was being damaged and flattened by young couples gathering to dance in their fields. This opposition from farmers forced the dancers to gather on the roads.

In his 1813 book, *Tour Through Ireland*, Reverend James Hall wrote about the challenges dancing presented to farmers:

> Not willing to have their grass spoiled by the feet of
> a crowd of dancers, the farmers will sometimes not

permit the young people, who meet for the purpose, to dance on their field on Sunday afternoon. Hence it is no uncommon thing to see groups dancing on the roads on Sundays and holy days, after prayers; no house being able to contain the numbers which, in fine weather, generally meet on those occasions.

It often happens that some innkeeper, in the vicinity of a dance, sends a loaf, of less or more value, not exceeding five shillings, to be given as a premium to the best dancer; in other words to the person who spends most money at the inn. Many times men spend more than they can spare to have the pleasure, and, as they esteem it, honour of dividing the loaf among the dancers.

Later on, raised timber platforms were constructed for outdoor dances as traditional set dancing flourished. The tradition of crossroads dancing, followed by dance-halls and the various new styles of dance thrived until the government and the Catholic Church intervened. In the 1930s, the Catholic Church was vocal about its opposition to these dances, which often ran late into the night. The Church viewed them as providing opportunities for the devil's work. Priests admonished those who attended such gatherings. They warned of the ills such dances were visiting upon local communities, especially when young men from out of town who had motor cars began to visit several dances in the locality on the same night, spending

Dancing at the crossroads in the 1950s

the hours after the dance courting local women. Father Browne of Listowel parish in North Kerry was a regular opponent of dances, announcing that 'persons who come to these dances from outside towns in motor cars' were 'scoundrels of the lowest type and were devils incarnate'. The dancehalls themselves, inanimate and inoffensive buildings, didn't escape the Church's wrath. In one of many court hearings held in relation to complaints around the organising and running of dances, Father Browne described them as 'the curse and ruin of the country'.

The Church was so serious about dancehalls that bishops got involved. Bishop Patrick McKenna of Clogher in Derry described them to a packed crowd outside a confirmation in Bundoran in 1935 as 'conducive to temptation and an occasion of sin'. Bishop McKenna called for a ban on all dancehall gatherings unless permission was granted by the local priest.

The priests and bishops didn't stop until they had brought the tyranny of dance under control by way of regulation. The Public Dance Halls Act was passed in 1935 and meant organisers had to meet and follow strict, stringent regulatory guidelines in order to keep operating. Particular regulatory rigour was brought to the newer dance fads, which allowed for too much close body contact. The Gaelic League took issue with any imported form of dance as it threatened traditional Irish dance.

Off the back of regulation and the subsequent demise of the dancehalls countrywide, dance schools were introduced

by Comhaltas Ceoltoiri Éireann in an effort to promote and preserve traditional Irish music and dance amongst the younger populations. With these céilithe came traditional dance uniforms and dance schools. Ironically, these uniforms put many young boys off the idea of taking up traditional Irish dancing. Many kids my age were sent for lessons, but either didn't enjoy the dancing or the uniforms that came with it. While I see the importance of preserving this aspect of Irish cultural heritage today, I didn't back then, nor did most of my friends. We chose sport and that became our way of preserving and practising a different aspect of our cultural heritage. It is fair to say we would all like to be able to dance and play musical instruments today as well as we can pick up a hurley or kick a football.

Dance from home

TikTok has seen dance enter the home in a way we haven't experienced before. The living room is the new dancehall, families perform together, and hip hop routines and choreography are the new performance styles. The arena has changed. We don't have to look very far for evidence. It's on our TV screens during most live sporting events, on our smartphones and tablets, on Twitter and on Instagram Discovery – but mainly on TikTok.

Dance has taken its seat at the table, re-joining the cultural conversation while wearing a tracksuit. Where once young men got together to practise, train or play hurling or football, more and more nowadays we see them

get together to practise the arts. Choreographed dance routines, movie scenes, comedy sketches, voiceovers and songs are performed by young lads, many of them wearing their local GAA club jerseys and gear. What will this shift mean for the next generation of young Irish men? It may help with changing Irish mindsets to something more expressive and at ease with itself. The fact that whole families have joined this home dance movement makes the possibilities for change more possible and palatable. The Fleming family from Kerry are one example of many, where dance performance, clothing, technology and social media have combined to create a new family dynamic through dance and performance at home.

Is dance sport?

The DANCER collection sought to ask and understand the agents of change driving this new behaviour. What did this change mean for men and how they dress? Is dance still a cultural pursuit and artistic endeavour, or is it now a sport?

Some sports were always closely related to dance. Boxing, tennis, martial arts, and fencing are some of the more artistic pursuits. From Premier League soccer to American NFL and NBA, we can see a loosening of the rigorous mindset that placed dance in a separate class to sport. Nowadays, dance is very much part of the game. This kind of expression by players before and after the game and in celebrating scores is more common than ever before. Dance is a part of some teams' preparation

for games. Australian hurdler Michelle Jenneke became a global sensation when a video of her dancing at the blocks before her 100-metre hurdle race at the 2012 World Junior Championships in Athletics in Barcelona went viral on YouTube.

American sports have always embraced dance more readily than European sports have. It is very much part of the National Football League. Never mind the cheerleaders; the players also dance before, during and after games. They see it as part of their performance, from preparation through to how they celebrate scores. Players like Odell Beckham Jr have taken it to a new level – some say a level too far, but players in every NFL team see dance routines as part of their enjoyment and expression of the sport. The same is true of basketball, where the top players and most successful players perform a dance before games and often during them. LeBron James, arguably the best player in the NBA, regularly performs dance routines in pre-game warm-ups and during practice. Sports psychology has proven that finding this level of calmness and relaxation allows athletes to move more freely. Expressing yourself fully is key to reaching peak performance levels as it helps athletes to reach that 'flow state', where the game feels effortless and simple.

Manchester United striker Edinson Cavani undertook ballet dance classes as he prepared to join the club from Paris Saint-Germain. Cavani, who was 34 when he joined United, took these classes to condition his aerobic system

Maradona danced at the 1986 World Cup

and to sync body and mind. It also helped to improve his balance and movement for his position as a striker. Cavani has been a major success since he joined, with his energy and work rate for the team being commended, as well as the quality of his movement.

Perhaps the most famous example of a sportsperson using dance in preparation for competition is Diego Maradona's famous 'Live is Life' pre-game warm-up while playing for Napoli in the 1980s. Maradona skipped, shuffled, shimmied, swayed and stepped in time with the stadium tannoy playing 'Live Is Life' by Austrian band Opus. As his teammates went through their regular routines, Maradona stayed with the music, dancing and juggling the football in time – body, ball and song in perfect rhythm. In doing so, he created an iconic ahead-of-its-time cultural moment where dance met sport, and performance followed.

Warm-up routines like skipping, bounding, lateral movement, fast-feet ladder work, step work, hurdles, balance and proprioceptive work show the athlete as dancer. SAQ (speed, agility, quickness) is a fundamental part of the physical training programmes of most field sports. The practice of it is a lot like dance. Combinations of shuffles, sudden lateral movements and sprints are designed to improve how a player's body responds to different brain stimuli and replicates a lot of the actions, movements and combinations that might come naturally to a traditional Irish dancer.

The collection

DANCER became a collection for the new world of lockdown when everyone stayed at home. I call it home-wear, but it is really sportswear for the home. Tracksuits, socks, shorts and sweatshirts, all those casual lounge items you might wear for a trip to the gym or a long-haul flight, have been adapted for home life. It raises the question, what has sportswear become without sports?

I used time as the print story, given that time was so prominent in the collective consciousness in 2020. Clock hands and roman numerals were scaled and experimented with to create a visual expression of the constant focus on time during the Covid-19 lockdowns.

I based the collection upon the looks I saw young men – home-athletes – wearing as they performed their dance routines on TikTok. This is not to say that dance is all they do and that they don't also practise their sports every day too. But now they do both.

Doc

Spring–summer 2022

'I am glad of my victory, not for the victory for myself, but for the fact that the world has been shown that Ireland has a flag, that Ireland has a national anthem, and in fact, we have a nationality.'
– *Irish Olympic gold medallist Pat O'Callaghan speaking in Amsterdam in 1928*

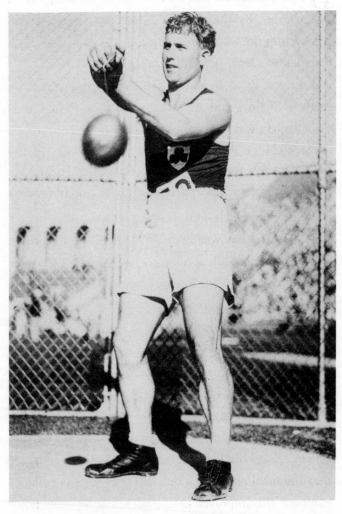

Pat O'Callaghan competing in the 1932 Los Angeles Olympics.

Pioneer

Pat O'Callaghan was born in Banteer, County Cork in 1906. By the time O'Callaghan was a teen, he was cycling the 48-kilometre round trip to school in the Patrician Academy in Mallow, where he had a scholarship and thrived. By 16, he was studying medicine at the Royal College of Surgeons in Dublin. Fully qualified at 21, O'Callaghan was too young to practise in Ireland so spent 12 months at an RAF base in the UK before moving back to Ireland in 1928, where he opened a medical practice in Clonmel in County Tipperary. Sporting ability ran in his family: his uncle Tim Vaughan was a national sprint champion and renowned Cork footballer, and his brother Con was also a prolific sprinter and footballer. Pat and Con played football and hurling for nearby Banteer GAA club, their natural physicality allowing them to excel.

While studying in Dublin, O'Callaghan's interest in hammer-throwing grew. There are many stories about his creative approach to training and preparing. One anecdote tells us that O'Callaghan's physical strength and prowess at hammer-throwing owed much to the fact that as a boy he had practised using a cannonball taken from Macroom Castle. A local blacksmith attached a handle and chain to the cannonball, making it much heavier than a regulation hammer. This improved O'Callaghan's upper body power and throwing technique to allow him to achieve greater distances. Another story tells of his drilling a hole in a hammer and filling it with ball-bearings to increase the

weight and develop his power while he practised. He built his own throwing ring in a nearby field. He also credits ballet lessons from a local dance teacher for helping to improve his footwork and throwing technique. During an interview with RTÉ reporter Brendan O'Reilly, the doctor put his natural physical prowess down to nutrition and the fact he grew up on the family farm eating fresh produce like vegetables and potatoes. He made particular mention of the family being able to grind their own flour for bread.

O'Callaghan put this physicality to good use. Winning national championships in 1927 and 1928 meant he qualified to represent Ireland in the hammer at the 1928 Amsterdam Olympics. Amsterdam was a remarkable games for several reasons. It was the first time the Olympic flame was lit, the first time women's athletics was allowed, the first time a parade of nations was held and the first time the Olympics were sponsored. So a pioneering games met a pioneering man, and an already remarkable life story would get even more interesting. O'Callaghan and his two brothers, Seán and Con, paid their own fares. Con was also competing in the decathlon. Pat won the hammer-throwing gold with a distance of 51.39 metres, becoming the first athlete from Ireland to win an Olympic medal under the Irish flag rather than the British flag. For the winning throw, he used the hammer belonging to his Swedish rival Ossian Skiöld, who finished third. The two men would compete head-to-head for medals over the next five years. At the medal presentation ceremony in Amsterdam, the tricolour was raised

and the Irish national anthem played for the first time at an Olympics. Before 1924, Ireland could not present athletes for Olympic competitions. Britain and the US claimed Ireland's elite competitors, and the Irish flag was never flown. That it was flown in 1928 is another testament to the courage and fortitude of O'Callaghan: he had spent a full day scouring the streets of Amsterdam with fellow Irish athletes to find a tricolour. The mission was successful: he located one and the Irish flag flew on the Olympic flagpole for the first time.

O'Callaghan's interview after the win showed the depth of feeling that was expressed through sport at the time. He summed up what Ireland was experiencing when he said, 'I am glad of my victory, not for the victory for myself, but for the fact that the world has been shown that Ireland has a flag, that Ireland has a national anthem, and in fact, we have a nationality.'

In Ireland, O'Callaghan was recognised as a rare athletic talent but one who committed himself to honing his raw technique further. He admitted his early ignorance around the sport of hammer-throwing and how this led to inconsistencies in performance for a while. His interest in the sport and his natural curiosity led him to improvise and improve. By then, fellow hammer-throwers were seeking O'Callaghan out to learn more of his practice and preparation. While they could ask questions and watch on, no one could match the intuition he had for experimenting with the sport. Normal practice around this time was for

hammer-throwers to make two circular motions before releasing. O'Callaghan added a third and sometimes a fourth to push the boundaries of hammer-throwing even further.

Los Angeles, 1932

By the time O'Callaghan arrived in Los Angles for the 1932 Games, the Irish contingent were a lot more professional in their preparation. They no longer had to fund their own travel, and the almost-10,000-kilometre trip by ship and train was funded by church gate collections around Ireland. The trip to Los Angeles was eventful in itself. Doc, as O'Callaghan was widely nicknamed at the time, was held at US customs when bottles of poitín were found in his bag. Thinking on his feet, he explained to customs officers that he was a medical professional and the poitín was for rehabilitative purposes.

The reigning gold medal holder was caught cold later on, however. On arrival at the LA Coliseum arena, he discovered newly developed cinder material on the running tracks, unlike anything he had competed on before. The Olympic Committee of Ireland had failed to notify him of the new surface, which created a live problem for O'Callaghan. He was so used to performing on grass, where his spikes afforded him grip and momentum to rotate and generate power, but now his spikes were sticking in the foam-like cinder material, inhibiting his ability to turn. His first three throws fell well short of a medal position. Here

Medal winners for the hammer-throwing in the 1932 Olympics.

is where the Irish Olympic spirit of camaraderie kicked in. Fellow Irish athlete Bob Tisdall, fresh from winning gold himself in the 400-metre hurdles, came to watch the final of the hammer. Seeing his countryman's predicament, he took O'Callaghan's spikes to the Coliseum janitor's shed nearby and filed the spikes off. They had just 30 minutes to file down the spikes before O'Callaghan's final throw but managed it. The smoother surface of the sole glided across the cinder surface without friction or sticking. O'Callaghan's final throw won him gold again. It was a triumph of the Irish spirit.

The Los Angeles story didn't end there. The 1930s was the beginning of the golden era of Hollywood movies. Producers present at the medal ceremony watched the barrel-chested Irishman receive his second Olympic gold and were taken by his presence. After the ceremony, Louis B. Mayer sought O'Callaghan out and offered him the lead role in their upcoming blockbuster, *Tarzan*. Mayer was a film producer and co-founder of Metro-Goldwyn-Mayer, a legendary film studio which became home to Hollywood's best writers, producers and actors. O'Callaghan declined and returned to Ireland to continue his medical practice.

Thousands lined the streets of Kanturk, Cork, to welcome Doc home. He continued to devote himself to the hammer, but 1932 would be his last Olympics. O'Callaghan could not compete in Berlin in 1936 due to a fallout between the British Amateur Athletic Association and the NACAI (National Athletic and Cycling Association of Ireland). Britain claimed

jurisdiction over athletics in Northern Ireland, while the NACAI claimed jurisdiction over the entire island regardless of politics. In the lead-up to the Berlin Olympics, the International Amateur Athletic Federation disqualified the NACAI. O'Callaghan remained loyal to the NACAI, bringing an end to his international athletic career.

It later emerged that O'Callaghan had a secret fan in Adolf Hitler, who invited him to the games as his guest. Hitler was a fan of hammer-throwing. In the year before the games, he instructed the German Olympic Committee to travel to Ireland and study everything about O'Callaghan's technique and preparations. They went so far as videoing him, x-raying him and interviewing him with a view to helping Germany win gold at the 1936 Berlin games. The Germans did win, though the winning throw fell two metres short of Doc's best.

Hitler, Owens and Adidas

O'Callaghan may have got an indication of Hitler's tyranny in that private box when he witnessed him and his two most powerful Nazi allies, Joseph Goebbels and Hermann Göring, shake hands with winning white athletes, while purposely ignoring Black American champion Jesse Owens. James Cleveland 'J.C.' Owens had moved to Cleveland from Alabama at nine years of age. He owed his track name to a teacher who misunderstood his Alabama drawl on his first day at his new school and thought he had said 'Jesse', when he had given him his initials 'J.C.' Owens would win

four gold medals at the 1936 Games. He was a supreme hurdler and sprinter who had dominated American track and field for years. There was fierce opposition to his participation in the Berlin Games in some quarters of American society. The National Association for the Advancement of Coloured People (NAACP) wrote (but did not send) a letter to Owens, who was by then a high-profile American celebrity, asking him not to indirectly support the Nazi regime by attending the games. Owens did attend, arriving to fanfare and excitement.

A nascent sportswear company saw a sponsorship opportunity and sought out Owens. Adi Dassler, the founder of German company Adidas, persuaded Owens to wear their new running spikes, the first time a footwear company had sponsored Olympic athletes in such a way. Dassler was friendly with Josef Waitzer, coach of the German athletics team, and between them they designed a leather running shoe with long spikes and distributed it to as many athletes as possible. When they tracked down Owens in the Olympic village, he was suitably impressed, saying he would wear these shoes or no shoes. Dassler himself showed courage in even talking to Owens under the eye of Hitler's regime, which he knew could punish him and his company for such a move. But Owens later denied that Hitler snubbed him at the medal ceremony. He pointed the finger at American president Franklin Roosevelt, saying, 'Hitler didn't snub me – it was our president who snubbed me. The president didn't even send me a telegram.'

An Irish giant

After the 1932 games, O'Callaghan was a celebrity in the US, not just with film producers. Invites poured in from boxing and wrestling promoters for him to join the circuit Stateside. Newspaper reports from New York to Los Angeles trumpeted his return to the US. The *LA Times* described him as:

> an Irish giant whose feats rival those of the mythical Brian Boru. They say of O'Callaghan that he is the greatest all-round athlete in the world. O'Callaghan can run the 100 in 10 seconds flat. He can hurdle close to the Olympic marks. He can pole-vault with the best and high-jump around six foot four inches. He excels at the discus and weights and is the best hammer-thrower in the world.

O'Callaghan showed up on the US wrestling circuit and made his pro-wrestling debut at the Olympic Auditorium in Los Angeles. His opponent was a Mexican nicknamed El Pupo, who suffered a broken arm after being thrown through the ropes by The Irish Hammer. More offers rolled in from promoters, and several more victories were enjoyed by The Wild Irish Rose, another of O'Callaghan's nicknames. The wrestling came to an end after a heavy defeat to George 'KO' Koverly in Los Angeles in 1938.

While in the States, O'Callaghan enjoyed a global profile but returned home to continue his medical practice.

He trained the Clonmel Commercials football team to win three county championships in a row from 1965 to '67 and was later both chairman and president of the club. Today the club's playing pitch is named Dr Pat O'Callaghan Park.

The collection

Olympic-inspired sportswear based on the uniform worn by Dr Pat O'Callaghan at the 1932 LA Games was the basis of the DOC collection. We tried to balance the looks between what athletes wore in competition and what they wore as they relaxed in the Olympic village. His competition number, 218, was a print slogan on T-shirts. Arches and columns from the interior architecture of the LA Coliseum were other print ideas used on tees and shirts. Lightweight running singlets, running shorts, tracksuits, windcheaters and T-shirts based on his Irish jersey of the time make up the key story items.

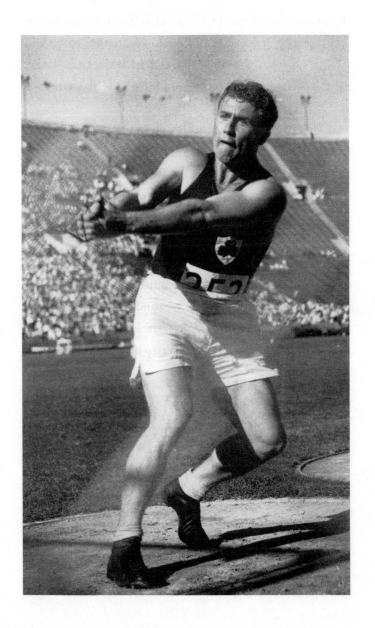

Jack

Autumn–winter 2022

'No one creates. The artist assembles memories.'
– *Jack B. Yeats*

Art + Sport

Pierre de Coubertin is known as the father of the modern Olympic Games. Born into a French aristocratic family, de Coubertin founded the International Olympic Committee in 1894 and oversaw its mission to lead the Olympic movement around the world.

The IOC mission statement aspired to achieve the following goals:

- to support the organisation, development and coordination of sports and sports competitions
- to ensure the regular celebration of Olympic Games
- to place sport at the service of humanity, and thereby to promote peace
- to act against any form of discrimination
- to encourage the support of women in sport at all levels and to promote equality between men and women.

De Coubertin was led by a belief in the combination of sport with education and academia. He had studied at the famed Paris Institute of Political Sciences, achieving a degree in law and public affairs. Early in his career, he campaigned for the introduction of sport and physical education to school curricula in France. Inspired by the British education system, de Coubertin obsessed over the physical fitness of young French men and how training at school might help the country develop stronger soldiers,

if nothing else. He believed sport could unite a country divided by a class system, which he saw as unworthy and elitist. De Coubertin didn't achieve his goal in that physical education was not made part of the school curriculum in France at that time, but the failure led him to a greater ideal: the resurrection of the Olympic Games.

De Coubertin was inspired by Ancient Greek culture and the emphasis it placed on sport and fitness. He laid out the set of values that would underpin the IOC. One of the leading values mirrored the most fundamental value of the GAA – that athletes would compete on an amateur basis. Peace and the pursuit of global empathy was another core value: nations would compete but in doing so embrace the ancient practice of sacred truce. De Coubertin felt that this was fundamental to uniting nations and preventing the threat of war.

Ode to Sport

One of de Coubertin's most famous quotes is: 'The important thing in the Olympic Games is not winning but taking part.' He determinedly pursued his vision for an inclusive Games where sport, education and the arts might prosper. De Coubertin's father was a notable artist, and de Coubertin himself was obsessed with art. From 1912 until 1952, painting, sculpture, architecture, literature and music were Olympic disciplines. The artworks had to be inspired by sport. De Coubertin himself won a gold medal for literature at the 1912 games. His poem, 'Ode to

Sport', written under the pseudonyms Georges Hohrod and M. Eschbach, was published in French and German. Its essence can be translated as follows:

> O Sport, you are peace,
> You promote happy relations between peoples,
> Bringing them together in their shared devotion
> To a strength which is controlled, organised and
> self-disciplined.

George Orwell disagreed with de Coubertin's vision of the unifying force of sport, and I might be inclined to agree with Orwell in part. In 1945, he wrote an essay, 'The Sporting Spirit', in which he recounted the visit of a soccer team from the USSR to the United Kingdom as part of a campaign to improve Anglo-Soviet relations. Four matches were played around the UK, two of which descended into violence. In his essay, Orwell decried the violence and described sport as 'an unfailing cause of ill-will'. He went on to say that 'nearly all sports practised nowadays are competitive. You play to win, and the game has little meaning unless you do your utmost to win.' I can't fully agree with the first statement, but I would agree with the second. My experience of sport isn't quite as pacific as de Coubertin's. I grew up playing hurling and football in north Kerry. The north Kerry edition of 'Ode to Sport' might read something like this:

O Sport, you are war,

You promote relations to become enemies for 70
minutes plus injury time, and there is a lot of
this.

Bringing these relations together in the first place
was a bad idea,

Their shared devotion stretches only as far as the
parish boundary,

After that, control, organisation and self-discipline
will only get you so far.

I write this with tongue in cheek. North Kerry sport is
tough, but it offers a highly valuable education also. It was
the perfect place of learning for me. The perfect north
Kerry hurler and footballer is a hybrid of brain and brawn.
The brainy part is linked to our rich literary heritage. We
breed writers, linguists, wordsmiths, poets, playwrights and
players. And farmers: the brawny part is possibly linked to
agriculture. It is a rich agricultural territory, and farmers
are the epitome of brain and brawn. A good north Kerry
footballer is easy to love if you are from Kerry, and easy to
hate if you are not. (In the context of Kerry football, north
Kerry produces the artisan footballer and south Kerry tends
to produce the artists.)

De Coubertin had great difficulty persuading the early
host cities of Athens, London, and his own Paris to include
the arts as credible competitions in the first place, but he
won over the Stockholm organisers in 1912. The first gold

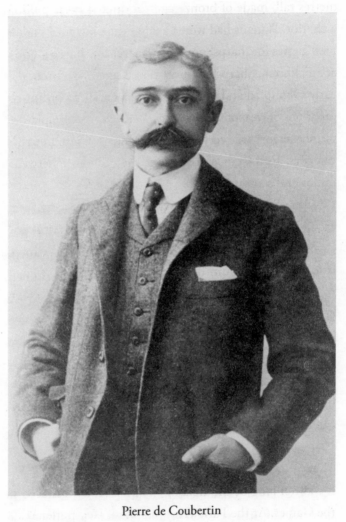

Pierre de Coubertin

won in 1912 was for a sculpture, entitled *An American Trotter*, by American Walter Winans. The sculpture was 50 centimetres tall, made of bronze and captured a horse pulling a chariot. Winans had won a gold at the previous London 1908 games for sharpshooting and silver for sharpshooting at Stockholm. Sharpshooting was a category right from the early Olympiad and included sub-categories according to variations of weapons and distances. The 30-metre rapid-fire pistol category was very different to the 60-metre free rifle category, for instance. That's like the difference between minor and senior.

Other winners at the 1912 games were Swiss design and architecture duo Eugène-Edouard Monod and Alphonse Laverrière for 'Building Plan of a Modern Stadium', a futuristic take on stadium design. A piece of music, *Marcia trionfale olimpica* ('Triumphal Olympic March'), by Italian composer and pianist Ricardo Barthelemy, also won in its category. Three interconnected friezes by Italian artist Carlo Pellegrini, called 'Winter Sports', won gold in the painting category. The competition can't have been that fierce, as no silver or bronze medals were awarded in any category other than architecture.

The Liffey Swim

It was not long before Ireland's instinct for art surfaced at the Games. At the Paris Games of 1924, Jack Butler Yeats won silver for a painting called *The Liffey Swim*, though French organisers called it *Natation*, the French word for

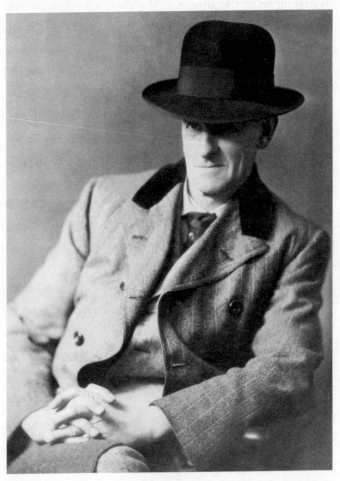

Jack Butler Yeats

swimming. Painted in oil on canvas, it is 61 centimetres high and 91 centimetres wide. It depicts spectators riverside, watching on as the annual Liffey Swim takes place in the heart of Dublin City. Art experts regard the work as one of Yeats's best for its use of emotive colours to capture the competition and drama of the race but also for the historical context beyond the race. Dublin's Custom House can be seen in the background, minus its domed roof, which had been badly damaged during the Civil War that raged in 1922 in Dublin. Experts also suggest two of the figures spectating are Yeats himself wearing a fedora, and his wife. The Royal Hibernian Academy acquired *The Liffey Swim* for £300 in 1925. It now hangs on display at the National Gallery of Ireland with the following description:

> In this painting, Yeats captures the atmosphere and thrill of an event that has been part of Dublin's annual sporting calendar since 1920. His depiction of the occasion also represents a return to the sporting themes that had inspired much of his early work. He invites his audience to engage with the event by placing them amongst the spectators, who lean forward for a glimpse of the swimmers as they surge towards the finish line.

The Liffey Swim still runs today and attracts hundreds of participants. Its origins go back to 1920 when a Dublin Corporation analyst and swimming enthusiast named

Bernard Fagan was the first to organize the event. He charted a course from Victoria Quay, with swimmers entering the river from a Guinness barge, to Burgh Quay. Originally, the course ran for a mile and a half, from Rory O'More Bridge to the Customs House. Today, it runs from Loopline Bridge beside Butt Bridge and finishes beside the East Link Bridge near the 3Arena.

The winner of the art category in 1924 was Jean Jacoby from Luxembourg, who submitted a triptych of sports-inspired watercolours. *Étude de Sport* – 'Corner', 'Depart' and 'Rugby' – captured action scenes from three sports: a corner kick being contested in soccer, athletes at the starting line of a race, and a rugby player carrying a ball in full flight. Jacoby followed up with gold at Amsterdam in 1928 for another rugby-inspired painting. He would go on to work as an illustrator in the Berlin publishing industry and founded the magazine *Sieben Tage*, which reached a circulation of 300,000. Hitler put an end to Jacoby's work as an illustrator and picture editor when he seized control of the publication.

Jack B. Yeats was an unsung Irish hero. Sports-mad, inspired by rural Ireland and living in the shadow of his esteemed brother William, Jack is now receiving more and more recognition for the humility and accessibility of his work. Sport is a constant theme of his paintings, from swimming to horse racing and especially boxing. Yeats was exposed to the delights of bare-knuckle boxing in the East End of London in the early 1900s. His *Master*

of Ceremonies painting depicts a moustachioed, tuxedo-wearing MC standing at the ropes, announcing to the crowd, white hanky in hand like a magician. The theatre of boxing appealed to Yeats.

The Tailteann Games

Yeats was not the only Irish winner at the 1924 Games. The poet Oliver St John Gogarty won bronze for 'Ode to the Tailteann Games'.

> Empyrean is the source,
> Of indomitable will
> God the runner to his course,
> Holds, and urges on until,
> Lips and face of blood are drained,
> And fainting limbs are numb:
> Till the heart, by God sustained,
> Bravely to the end is come.

The Tailteann Games became a major part of the Irish sporting and cultural calendar and mirrored de Coubertin's Olympic mission when he proclaimed:

> the moment has come when we enter a phase and intend to re-establish the original beauty of the Olympic Games. In high times of Olympia [...] the fine arts were combined harmoniously with the Olympic Games to create their glory.

The first Tailteann Games took place in 1924. The games had political significance and were seen as a means to establish or re-establish Irish identity at a time when an independence of sorts had been won by the Irish Free State after the War of Independence. The games were inspired by the ancient Irish funeral games held at Teltown in the middle of County Meath, where clans would gather to hold athletic events in honour of those recently deceased. Archaeologists believe the first Tailteann Games, or Aonach Tailteann, could date back as far as the Bronze Age. Funeral games in honour of the dead were also common in Ancient Greek culture but were confined mainly to wrestling.

De Valera also sought to marry the arts with sport. Inspired by de Coubertin's sporting and artistic ideals, de Valera established the Tailteann Games, in an effort to replicate the Olympics for athletes and artists from Ireland or of Irish origin. The first games were held just after the Paris Summer Games of 1924 and four years later after Amsterdam in 1928. Athletes travelled onwards from both Olympics to compete in the Tailteann Games. Croke Park held the 1924 opening ceremony, with the Hogan Stand opening just in time for the event. The athletic categories included hurling, boxing, swimming, horse racing, running, spear-throwing, sword-fighting, long jump and archery. The artistic categories were storytelling, singing, dancing, and craft-making for jewellers, goldsmiths, weavers and armourers. The games ended in 1932, but there have been variations of them, such as the Rás Tailteann cycling event

and more recently, the Tailteann Cup, an intercounty Gaelic football competition which started in the summer of 2022 as part of the GAA championship schedule. The Tailteann Cup will offer counties not involved in the Sam Maguire competition the opportunity to win a secondary national title.

The collection

JACK captures the essence of Irish culture, encompassing art and sport, creativity and competition. Art meets sport. The artist as an athlete. Yeats the Olympian. The medallist. Translating Yeats's love of sport into clothes means loose-fitting shirts and trousers for the studio, sports jackets and sweatshirts for his sporting pursuits. The colour story leans on the palette found in *The Liffey Swim*. Print details are taken from the cover of a Paris 1924 Olympic Games magazine of the time and details from Yeats's silver medal itself. With very few archive photographs of Yeats himself to reference for personal style, other artists stood in, including David Hockney, Jean-Michel Basquiat, and more modern examples such as Damien Hirst and actor Jonah Hill, for their loose, artistic personal style. Neil Patrick Collins, the former Roscommon inter-county footballer and prolific artist, is the modern Irish embodiment of the story.

KEOHANE
ATHLETIC CLUB

Keohane Athletic Club:

Running on memory

Christmas 2021

'Design is thinking made visual.'
– *Saul Bass, American graphic designer*

I started Keohane Athletic Club sportswear to serve GAA clubs and other sporting organisations with meaning and a sense of themselves. The local GAA club and community are built on local spirit, meaning and identity. Teamwear should reflect this but doesn't always. Keohane is a design and storytelling service that brings that local identity and spirit to life. I see its role as creating a club identity, uniting players, coaches, managers and the wider community in a common spirit. Saul Bass, a pioneering American graphic designer, once described design as thinking made visual. I would describe my design as thinking made spiritual.

The Keohane of the brand name is Joe Keohane, a former John Mitchels Tralee and Kerry footballer. He was one member of a very successful generation of Kerry football teams of the 1920s and '30s, many of whom were active soldiers during the wars of those times. After speaking to young footballers around Tralee, I learned most had no idea who these players were. This might be under-standable, given that it was almost 100 years ago, but the names of these players are dotted around the county on street signs, roadways, roundabouts and stadia. Keohane Athletic Club seeks to remember all these past players and teams. We do this by creating original prints as a form of commemoration, serving clubs all over Ireland with a kind of spiritual design service.

I also started Keohane Athletic Club to provide gear for Finuge, my home football club. Some rural clubs don't have the means to support themselves. I wanted to provide

teamwear that meant something to just us, so that meaning could be passed along to the next generation. Through design, we have created something spiritual and valuable at less than the market rate.

In researching the culture of Gaelic games, I started at home, with Kerry GAA. There are many great archive websites which house memories of past teams, players, games, jerseys, events, achievements and stories that are barely known. One of the best is the late Weeshie Fogarty's Terrace Talk (www.terracetalk.com). Weeshie was a noted footballer from Killarney town who had a successful sporting career of his own, winning multiple county championships with his club, Killarney Legion, and an All-Ireland with Kerry. After a serious eye injury brought his playing career to an end, he began the dangerous life of a referee. He also lived the even more dangerous life of a linesman, running the line in the 1983 All Ireland semi-final between Cork and Dublin. He achieved even more renown as a media personality. As a broadcaster, Weeshie presented the multi-award-winning *Terrace Talk* sports chat show on Radio Kerry on Monday evenings from 6 p.m. to 8 p.m. for nearly 20 years. From 1998, he was also a fixture at games as a commentator locally and nationally, covering Kerry matches and the local club scene with the same level of enthusiasm. Weeshie won several medals at county championship level and an All-Ireland medal in 1969.

Weeshie also did a service in curating the cultural archive that is the Terrace Talk website. As someone invested in

Kerry's cultural life, I find it an invaluable resource. Its range of historical records is vast, from imagery to reading material. I have learned a lot about Kerry from searching the site, not only about sport but also about history and politics. One day while browsing Terrace Talk, I came across an image from the late 1960s of Joe Keohane, flanked by two players, Mick O'Dwyer and Mick O'Connell. I recognised the two Mickos and believed the man in the middle to be Joe Keohane, but I wasn't certain. I figured that if someone like me, who had an interest in GAA history, had to double-check who such a big figure in Kerry football was, others of my generation would too. And I was sure that many more names of past figures of Kerry life, not just sporting ones, must have been forgotten too.

As time went by, the more I mentioned names like Joe Keohane, Paul Russell and Dr Eamonn O'Sullivan to young people, the more I realised decades of names and teams had been forgotten. And the more I read, the more I discovered that many of these men were special leaders in life beyond sport. Men like Dick Fitzgerald and Austin Stack are hardly known and rarely spoken of. Not many would make the association between Fitzgerald Stadium in Killarney and Dick Fitzgerald the man, the footballer, the author and the activist. Austin Stack is associated with the great Austin Stacks club in Tralee and Austin Stack Park, but most people don't know why. Stack was part of Kerry's first All-Ireland-winning team in 1903 and captain of our second in 1904. Stack played a bigger role beyond football,

one that extended into national politics and policy-making. He was one of a breed of soldiers and strategists who served county and country. These figures exist in every county, of course. What also became apparent was the very identifiable style associated with the GAA around the time of its formation in 1884: three-piece suits, waistcoats, blazers, braces, flat caps, pocket watches, ties, bow-ties and bicycles.

After more conversations with today's sportspeople about yesterday's sportspeople, I was pushed to start up the Keohane Athletic Club. I sometimes call it a 'memory brand'. The brand tagline is 'Running on Memory'. Remembering these forgotten names of the past was my mission, and leading with design was my method. What follows are some stories and jerseys inspired by memory.

Transatlantic

'Go west, don't go east'
From 'Apple of My Eye' by Damien Dempsey

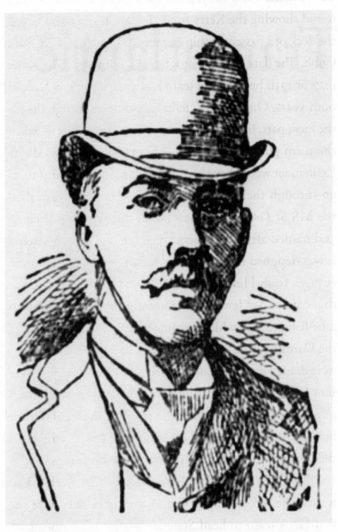
Engraving of Ted Sullivan, published in *The Tennessean*
newspaper in 1893.

TRANSATLANTIC is the first chapter in the Keohane Athletic Club story. It is based on an archive image I found showing the Kerry football team training on board the deck of a passenger ship en route to New York City from Cobh. The date of the photograph is estimated to be either 1927 or 1931, because the team made trips to New York in both years. On the deck, fellow passengers, emigrants for the most part, line up at a variety of vantage points to watch the team go through physical exercises fully togged out. Excitement would have been high to see such a lauded team go through their paces in the flesh. The ship was called the MS *St Louis*, a German ocean liner built in Bremen and named after the American city of St Louis, Missouri. It was designed to carry cruise passengers on transatlantic voyages from Hamburg to the US. It was the same ship that carried 937 Jews from Hamburg to the States in 1939, a hellish journey which became known as the 'Voyage of the Damned'. The Jewish emigrants fleeing Nazi Germany were denied entry to Cuba, the US and Canada, and were sent back to Europe. Three weeks later, they were given refuge in the UK, the Netherlands, Belgium and France, but later it was discovered that 255 of the Jewish emigrants died during the war, most in concentration camps.

This picture wasn't the first time a GAA team had toured the US, however. The Tipperary hurlers were the first GAA team to head Stateside to play when they took part in a sequence of games across major US cities in 1926. Kerry followed in 1927. In *Forging a Kingdom*, his definitive

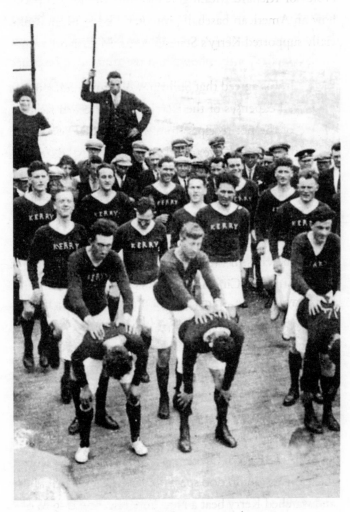

The Kerry team on the deck of a passenger ship in 1927 or 1931.

study of the GAA in Kerry football from 1884 to 1934, Professor Richard McElligott recounts the 1927 trip and how an American baseball promoter, Ted Sullivan, financially supported Kerry's Stateside tour. McElligott writes:

> It was agreed that Sullivan would undertake to pay all expenses of the Kerry team in return for 60% of the net receipts from matches. The rest would be handed over to the Kerry GAA. Extensive arrangements were made for the 11-week tour with the team scheduled to be present at a large banquet in their honour in New York on 26 May. Following this, it was hoped that Kerry would play matches in New York, Boston, Chicago, Detroit, St Louis, Cincinnati, Pittsburgh, Philadelphia, and Washington DC with the first being against a New York selection in the city's Polo Grounds on 29 May.

The 1927 tour brought mixed results, with the team losing several games against combined New York teams before small crowds. The 1931 tour was different. The team was at the peak of its power, playing a spectacular brand of football. The Eastern Division of the United States welcomed the team, as did 60,000 spectators in the Yankee Stadium, and watched Kerry beat a New York selection 0–9 to 0–6. This was the largest crowd to ever watch a GAA game in the States. Captained by John Joe Sheehy, Kerry remained unbeaten throughout the remainder of the tour. What is

most remarkable about the 1931 transatlantic tour was the return to Cobh. McElligott describes a festival in Cobh upon Kerry's return, with an official reception held by the GAA.

Large crowds gathered in Cobh for the reception, and once the team reached Kerry there were more huge crowds congregated in Tralee and Killarney to catch a glimpse of the team. The 1931 team were lauded by the GAA Central Council, whose president, Seán Ryan, christened them 'champions of the world'.

Ted Sullivan

The patron of the 1927 tour, Ted Sullivan, was born in Kerry in 1856, the second of eight children born to Timothy and Catherine Sullivan. The Sullivans were a farming family who left their homeland and travelled to America in 1858, settling first in Illinois and then in Muscatine, Iowa. Some archive materials give Sullivan's home place as County Clare but in a handwritten letter to American sportswriter Ernest Lanigan in 1912, Sullivan confirmed Kerry as his birthplace and 1856 as his year of birth. Lanigan had contacted Sullivan as part of a book he was writing on the great living players of American baseball at the time.

According to the research journal, the *Society for American Baseball Research* (SABR), Sullivan was a self-made baseball entrepreneur, travelling to middle America to set up baseball leagues and pitching to investors to back his patented trademark for the sport. SABR describes him as follows:

A small man with a fine moustache and features, and often sporting a bowler hat, Sullivan worked middle America from the Gulf of Mexico to Northern Wisconsin, promoting baseball and selling investors on new leagues, referring to the game as 'The Show' —a term still widely used today.

Sullivan played baseball at college in Iowa for St Louis University and then at St Mary's in Kansas. It was there he met Charlie Comiskey, son of an Irish emigrant, who went on to become one of the most influential figures in the history of baseball. Beginning his playing career as a pitcher at Dubuque, Iowa, Comiskey moved to the St Louis Brown Stockings in 1882. A year after joining them, at 23 years old, he was appointed manager and won four pennants (American Association titles) in a row. In 1892, he joined the National League's Cincinnati Reds, which he managed for three years before buying the franchise outright.

As is the way in some professional sports in America, sporting organisations operate as franchises and can move base from city to city, with the National League's agreement. Comiskey applied for permission from the National League to move his Cincinnati organisation to Chicago. The league agreed, on the condition that he didn't use the city's name when renaming the franchise. Comiskey agreed and named the club White Sox, a play on the name of a local team, the Chicago White Stockings. His franchise would grow to become the Chicago White Sox organisation we know

CHARLES COMISKEY.
ALLEN & GINTER'S
Cigarettes.
RICHMOND. VIRGINIA.

An 1888 baseball card of Charlie Comiskey

today. Uniquely, Comiskey was a player, manager and team owner, as well as a founding member of the new American League in 1901. Over a 55-year career in baseball, he left a lasting legacy on the game of baseball. From 1910 to 1990, the Chicago White Sox played their home games at Comiskey Park.

The print

The TRANSATLANTIC print was based on that image of the Kerry team training aboard the *St Louis*. There are three TRANSATLANTIC jerseys: a dark-green one is based on the jerseys worn in the picture, a black version of this, and a print version in Atlantic blue with a print of the *St Louis* ship itself placed on the flag that flew from the ship's deck.

GREEK ATHLETE THROWING THE
DISCUS.

LA/32

'I knew the great Duncan Edwards of Manchester United had a stained glass window dedicated to him, but I had never before heard of one to an Irish sportsman. This Fitzgerald chap must have been good, I thought.'
– *Weeshie Fogarty on Éamonn Fitzgerald*

Éamonn

É amonn Fitzgerald was born in Behihane, Castlecove not far from Cahirciveen on the Ring of Kerry on 27 October 1903. He was one of seven children and came to prominence locally as an athlete and academic of potential. At the 1932 Los Angeles Olympics, Fitzgerald competed for Ireland in the triple jump (or hop, skip and jump as it was called at the time) in front of 101,000 people at the Los Angeles Coliseum. He finished in fourth position, one place behind Kenkichi Oshima of Japan who measured a distance of 15.12 metres to Fitzgerald's 15.01. The gold medal was taken by another Japanese athlete Chūhei Nambu, who jumped 15.72 metres, a world record for the time. The Irishman was hampered by a heel injury picked up in practice in Denver where the Irish contingent stopped off en route to Los Angeles. They went to stretch and train at a local high school where he found the long jump pit and began practising. He returned to the main group limping and had further treatment in Los Angeles but carried the injury throughout. Kenkichi Oshima was a world record holder for both the triple jump and the long jump before the Games, making him the first athlete to ever hold world record jumps simultaneously. Fitzgerald's final jump of 15.01 metres would have won him a gold medal at each of the previous seven games.

Apart from athletics, where he enjoyed consistent national success, Fitzgerald was also an All Ireland winner in football, taking three medals between 1924 and 1931.

An *Irish Times* report suggests that shortly after the LA Games Fitzgerald was also part of Kerry's 1932 All-Ireland victory also, though this is disputed elsewhere. Fitzgerald also won several National League and Railway Cup medals. Despite all of his achievements, little is known of Fitzgerald's exploits today and even less was known before 2003, when his unmarked grave was located and uncovered in Deansgrange Cemetery in South County Dublin after three years of searching. It had lain overgrown and forgotten for more than 40 years after his death. It was Weeshie Fogarty, the former footballer, referee and broadcaster of *Terrace Talk*, who led the discovery of the man nicknamed in south Kerry as 'Ned Seán Óg' Fitzgerald.

Weeshie first learned of Fitzgerald's Olympic exploits in 2001 as he cycled the Ring of Kerry, stopping for a quick break on his way through Castlecove. As he walked about the small, picturesque tourist village, Weeshie came upon the local church. When he walked, in he discovered a stained-glass window, as he explained to Daire Whelan of the *Irish Times* in May 2004:

> I took a walk into the church to have a look around and the sun was streaming in through the beautiful stained-glass windows and to the left of me one particular window caught my eye, for underneath it was written the words: 'Erected in memory of Éamonn Fitzgerald.'

I had vaguely heard of Fitzgerald before but I didn't know anything about him. I knew the great Duncan Edwards of Manchester United had a stained-glass window dedicated to him but I had never before heard of one to an Irish sportsman. This Fitzgerald chap must have been good, I thought.

I went outside to take a stroll and have a further look around when I saw a stone plaque outside the shop across the road and on it, written in Irish, 'Éamonn Mac Gearailt, Los Angeles, 1932.' These were the first two clues hinting at someone remarkable hailing from the village.

Talking to the locals, Fitzgerald's achievements were the stuff of legend: brilliant Gaelic footballer, All-Ireland winner, national hop, step and jump champion, he was Castlecove's most famous son. But as to what happened to him when he went to Dublin to teach, none could say.

The mission to find out what had happened to Éamonn Fitzgerald began. Weeshie enlisted the help of Eugene O'Sullivan from the Kerry Association in Dublin and between them they gathered a crew and began the search for the grave. They eventually found it unkempt in a corner of Deansgrange. Further research into his life after Los Angeles and Kerry found that the young Fitzgerald had been sponsored by a patron in Castlecove, a woman called Lady Albinia Lucy Brodrick, a local landowner with

nationalistic sympathies, who sent all of the most talented local young people to further their education in Dublin. Fitzgerald went on to further study at UCD, where he held six different university championships for athletics. He qualified to become a school teacher and went on to work at Saint Enda's, the famous school founded by the republican leader Padraig Pearse in Rathfarnham from 1927 to the school's closure in 1935. The search mission discovered all the medals and trophies Fitzgerald had won were stored in a press in the school. He had contracted tuberculosis just before he was due to get married, resulting in the cancellation of the wedding arrangements. He died in 1958 at the age of 55 without any family, which explains why there was limited information or recall of his life story and sporting achievements.

The people of Kerry, led by Weeshie, honoured Fitzgerald's memory with a commemoration service held before a large crowd gathered at his graveside in Deansgrange on the Saturday morning of 15 May 2004. The service pledged to remember 'Kerry's forgotten Olympian'.

The athletics kit Éamonn wore at the LA Games hangs in the Muckross Park Heritage Centre in Killarney.

The LA Games

The 'City of Angels' was the only applicant to host the games in 1932. That year's Olympics were poorly attended due to logistical issues related to Los Angeles's west coast location and the fact the US was in the midst of the Great

The LA Coliseum

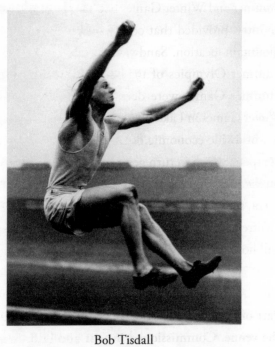

Bob Tisdall

Depression. The commercial aviation industry was in its infancy, so only half the number of athletes who took part in the games in Amsterdam in 1928 competed in Los Angeles. In total, 1,334 participants from 37 different countries competed in 117 different events. An Olympic Village was used for the first time and a number of other benchmarks were established that helped to improve future Olympic events.

While LA was the site for the Summer Olympics, Lake Placid in Adirondack State Park, New York State, provided the base for the Winter Olympics earlier in the same year. The International Olympic Committee ruled that both Summer and Winter Games had to take place in the same country, provided that country could provide a suitable mountain location. Sandwiched between the Amsterdam Summer Olympics of 1928 and Berlin in 1936, the LA Summer Games were deemed a massive success. The Winter Games in Lake Placid were viewed as less successful. A worldwide economic depression saw only 17 countries compete, which in turn generated little interest among the public. The organisers, who built a new stadium for the event, suffered significant financial losses. But the Olympic Centre was used again for the 1980 Winter Olympics and will host the 2023 Winter World University Games.

The LA Coliseum

Part of the reason for the success of the LA Games was the venue. Commissioned in 1921 and built in 1923, the

Memorial Coliseum was considered the most impressive stadium ever built at that time. When the games began, the Coliseum's capacity had increased to 105,000, with the addition of upper tiers of seating. The Olympic torch stood 32 metres high in the specially-designed Olympic cauldron on top of the central arch of the peristyle, where it burned for the two weeks of competition. The Los Angeles Memorial Coliseum, more commonly known as the LA Coliseum, is an iconic venue in line for a world record of its own. Having hosted the 1932 and the 1984 games, it will become the first venue to host Olympic opening and closing ceremonies on three separate occasions when it hosts the 2028 games.

Other venues around Los Angeles used in the 1932 games became a lasting part of LA culture. The 15,000-seat Grand Olympic Auditorium was the biggest indoor arena in America at the time and the iconic Rose Bowl in Pasadena was converted into a velodrome for the track cycling competition. The Olympic Village itself was an innovation for its time, including amenities like a cinema, post office, bank and hospital. There were other important innovations. Updated timekeeping equipment tuned to the nearest 100th of a second was introduced to help officials, and the tiered podiums, which we see athletes stand on to receive their medals today, were used for the first time. The opening ceremony was equally impressive: a 300-strong orchestra and a 1200-strong choir performed and doves were released at the end.

Gold

The life story and Olympic legacy of Bob Tisdall, who won the 400-metre gold, are remarkable. He was born in Sri Lanka and raised in Nenagh, County Tipperary. A son of Irish landed gentry, Tisdall attended school in Shrewsbury and Cambridge University, where he took up athletics. It was there that he realised his athletic talents, winning four events in the annual Cambridge–Oxford athletics meeting. Upon leaving school, Tisdall worked as an aide to a young Indian Maharaja, showing him the sights of Europe. Following this, Tisdall took his dreams of being an athlete more seriously. He left his job as an aide in the middle of the Great Depression and began to train daily, running laps of an orchard near to where he lived. His accommodation since leaving the Maharaja was a disused railway carriage.

To make the most of his Olympic dream, Tisdall wrote to General Eoin O'Duffy, head of the Irish Olympics, requesting a trial for the Irish Olympic 400-metre hurdling team for the Los Angeles Summer Games. The trial took place in Croke Park, but it didn't go well for Tisdall. O'Duffy offered him a second chance. This went much better, as Tisdall won the national 440 yards title at the Irish Championships, also held at Croke Park. Tisdall showed the same creativity, curiosity and appetite for improvement as Pat O'Callaghan had by improvising wherever necessary to improve his preparations. Having qualified for the Irish team at Croke Park, Tisdall ramped

up his training, using a greyhound track to run laps over makeshift hurdles, which he made from beach driftwood. When he heard there was an athletics team at a local school, he went there and borrowed their hurdles.

Tisdall's 400-metre finals race at Los Angeles went down in Olympic folklore for the fact that Tisdall set a world record, which wasn't granted at the time because he knocked the last hurdle. The record went instead to Glenn Hardin of the US, who finished second. The decision was later reversed and Tisdall was acknowledged as a world record holder.

After winning gold, Tisdall then rushed across the arena to witness his friend Pat O'Callaghan win in the hammer event. Both men trained together before the Games at what is now the fifth fairway at the renowned Ballybunion Golf Club, where a plaque marks their memory.

Tisdall lived most of his adult life in South Africa. The relationship between military and sport showed up again as Tisdall played a part in World War II, organising a South African Irish Brigade to serve in the North African desert. His enthusiasm for athletics never wavered, even in old age as he ran the Sydney Olympic torch relay in 2000, aged 93.

The print

The LA/32 jersey from Keohane Athletic Club carries a Roman numeral print, X for the 10th Olympiad, found on the stub of an entry ticket to games at the LA Coliseum. The rear hem carries the following text:

Remembering Éamonn Fitzgerald, Kerry footballer & Irish Olympian. This jersey print is taken from the entry tickets to the LA Coliseum where he competed in the triple jump at the 1932 Los Angeles Games.

The logo for the Los Angeles Games 1932 comprised the American flag in the form of a coat of arms, with the Olympic rings placed across the front and a laurel wreath, a symbol of victory, interwoven through the rings. The Olympic motto 'Citius, Altius, Fortius' ('Faster, Higher, Stronger') frames the logo to the sides and underneath.

The jersey carries an amended version of this Olympic logo on the chest, with the accompanying text '10th OLYMPIAD LA GAMES' on both sleeves.

Places

'Wars of nations are fought to change maps. But wars of
poverty are fought to map change.'
– *Muhammad Ali*

Service

Ireland has its own military history, and as is the case in many other countries, our sport and our sportspeople are intertwined with military service. In Italy, for instance, where military service was compulsory until 2004, many of the top footballers of the recent past – Paolo Maldini, Roberto Baggio, Luca Vialli, and Francesco Totti to name a few – have given military service. Mohamed Salah, Liverpool's Egyptian striker, was spared mandatory military service in 2014 after intervention by Egypt national team manager Shawky Gharieb.

Muhammad Ali stated that wars are fought to change maps. He famously refused conscription to the military on the grounds of his religious beliefs and his ethical opposition to the Vietnam War. In 1967, he was found guilty of draft evasion, stripped of his boxing titles, banned from the sport and sentenced to five years in prison. Ali avoided prison time as the Supreme Court overturned his conviction in 1971. The saga saw him lose four years of his career when he was at his peak. Ali's actions were pioneering as they brought global attention to the Vietnam War and paved the way for sportspeople to become activists, voices and change-makers for those persecuted by war, for minorities in general and for the oppressed. Today, the sporting world has more and more outspoken activists. American football player Colin Kaepernick serves as a modern-day example. He lost his career as a top-level player at the San Francisco 49ers for 'taking the knee' when the US national anthem

was played before NFL games. He was protesting police brutality against people of colour in the US and was joined by teammates and players from other teams. The stance caused deep divisions within the NFL, where franchise owners are often very wealthy and often very white, with their own partisan political beliefs.

Challenging owners so publicly comes at a price. The price in Kaepernick's case was his playing career. The US president at the time, Donald Trump, was no help. At a rally in Alabama in 2017, as the Kaepernick saga raged, Trump addressed the issue of NFL players taking a knee for the national anthem:

> Wouldn't you love to see one of these NFL owners, when somebody disrespects our flag, to say 'Get that son of a bitch off the field right now. Out! He's fired. He's fired!'

Was Kaepernick fired? He opted out of the final year of his contract at the San Francisco 49ers, where he had been the franchise quarterback for six seasons, after new team management informed him he wasn't in the team plans for the upcoming season. He and Eric Reid, the first teammate to publicly join him in kneeling in protest at the national anthem, remained unsigned free agents for a period of time until Reid signed for the Carolina Panthers. Kaepernick, despite continuing to train and try out for teams, remains an unsigned free agent.

Colin Kaepernick

All across the country, where the US anthem is a symbol of particularly deep patriotism and respect for military veterans, serving military officers and their families, people were divided about whether he had been blacklisted for his protest, whether he was good enough to be an NFL quarterback and whether he really wanted to be one. Nike eventually took a position on it: they created an ad campaign featuring Kaepernick's face with the text, 'Believe in something. Even if it means sacrificing everything.' NFL spokesperson Jocelyn Moore responded to the ad saying Kaepernick's social justice campaign, 'deserve[s] our attention and action'. It was unusual for big brands to engage in political matters up until recently. Today, racial equality and social justice are live topics for CEOs, consumers, commentators and brand communities, thanks in large part to Colin Kaepernick.

War and sport

The Gaelic Athletic Association is similarly patriotic. The map of Ireland, with its borders and county boundaries, tells the story of war as much as of sport in this country. A war was fought to change the map of Ireland, as Ali put it. Our shared history is littered with names who served the country in a military context while playing Gaelic games for their county. Historian and author Donal McAnallen recounts the life and times of Cavan footballer Thomas Mulligan of the Virginia Gaels club, who was conscripted into the British Army during World War I. Having moved

to Portsmouth to pursue a teaching career in March 1905, Mulligan travelled home again in April to represent Cavan in the Ulster final, which they won, beating Armagh after two replays. Living and working in Portsmouth, Mulligan was considered an English resident and was conscripted. Though he resisted, Mulligan eventually relented, trekking to India as part of the Hampshire Regiment. He died in 1917 at Simla Army Hospital after contracting an illness and was buried at Deolali Government Cemetery, 8,000 km from his home in Virginia. For all his sporting achievements in life, Mulligan's passing merited a bare mention in the Cavan *Anglo-Celt* newspaper. His death served as notice to nationalist organisations, including the GAA, who opposed the introduction of mandatory conscription in Ireland in 1918. They succeeded, sparing the lives of many thousands of Irishmen and would-be Gaelic games athletes.

Crossmaglen

If any GAA club in Ireland embodies patriotism, place and how to represent a people, it is Crossmaglen Rangers in south Armagh. Crossmaglen is known as 'the town the army took over'. Its playing pitch is overlooked by a British Army watchtower and was requisitioned several times throughout the war-torn 1970s and '80s when Northern Ireland was caught up in the Troubles. Many games were cancelled or moved from the pitch at late notice as British Army helicopters flew overhead and sometimes even landed on the pitch as games were being played. In the BBC

documentary *True North Crossmaglen: Field of Dreams*, the full extent of the daily struggle endured by club officials and players to simply access their own ground was laid bare. The army requisitioned a right of way at the front of the club entrance and part of the playing pitch for use as a helicopter pad. This meant the British Army had the right to enter and use part of the pitch and club premises whether the club members liked it or not. There were also incidences of club members and teams being denied access to the ground to watch games.

The reason for the requisition and the location of a British Army headquarters in Crossmaglen was precisely because of the Gaelic games heritage of the town and the role the GAA played in lives of the republican community there. The British authorities viewed the GAA and repub-licanism as two sides of the same coin. To manage one, they felt they had to manage the other. Cross, as locals call the town, was seen as a republican hotbed, harbouring dangerous hitmen who were responsible for the deaths of British soldiers year after year.

Crossmaglen Rangers had appealed to Gaelic Games Congress, the GAA's rule-making body, for years for the return of its land. In 1999, Galway man Joe McDonagh, in his role as GAA President, made the first manoeuvres, leading to an agreement between club and Crown forces for full ownership to be handed back. By then, Crossmaglen were on their way to becoming the greatest club side in the history of the GAA, winning the second of six All-Ireland

club titles and forming the backbone of the Armagh side which won the county's historic and sole All-Ireland title in 2002 under Joe Kernan. Kernan was the man who had led Crossmaglen to several of those club titles a few years earlier.

Rivals

Military mindsets, military training, and in the case of Crossmaglen, a constant military presence do much to strengthen the mindset of a GAA player. There is a lack of compromise in military men when it comes to achieving goals. Modern-day player-soldiers include Kilkenny hurlers Paul Murphy and Eoin Larkin, former Kildare footballer Dermot Earley and former Dublin football manager Jim Gavin. The Curragh, a training base for the Irish Army, has served as a training base for many a GAA team too. Counties all over Ireland have produced soldiers who played Gaelic games on the side. In the past, many county teammates were political and ideological rivals off the field. Historical records tell of Kerry football teammates parking deep political differences in pursuit of victory on the playing field.

Throughout the 1920s and '30s, teams were divided into pro-Treaty and anti-Treaty factions. In 1924, Con Brosnan, a Free State guard, guaranteed the safety of his republican teammate, John Joe Sheehy, who was on the run from the Free State Army, so they could both play a Munster Final for Kerry. Brosnan held firm on his promise despite

intense political pressure at the time. Sheehy arrived for the game in disguise, entering with the spectators and slipping out onto the pitch from the terrace. On the final whistle, having won the game, Sheehy disappeared again into the crowd and was smuggled out of the city. A year earlier in 1923, Sheehy had been hiding in Ballyseedy Woods, where he witnessed the Ballyseedy massacre in which nine republican soldiers were tied to a land mine and blown up by Free State forces. After the blast, Sheehy investigated the scene to find a lone survivor, Stephen Fuller. Fuller would become a prominent figure in Kerry GAA and political circles himself, founding the Tullig Gamecocks hurling club in North Kerry, a neighbouring club of my own Lixnaw, which still competes today as Crotta O'Neills.

As a gesture of gratitude towards Brosnan for keeping his promise to Sheehy in 1924, Joe Barrett, another republican Kerry footballer, offered Brosnan his place as Kerry captain for the 1931 season. Brosnan accepted and led Kerry to All-Ireland victory that year as he approached the end of his own playing career. The playing pitch in Moyvane, 8 kilometres north of Listowel in the heartland of Kerry football is called Con Brosnan Park in memory of the man. It is interesting to compare the mindset and psyche of north Kerry people in sporting and military contexts to that found in the North of Ireland. I sense there is a commonality and sympathy in both communities.

Tipperary GAA has particularly close ties to the War of Independence. Michael Hogan, a Tipperary player in

the 1920s, was killed on the field of play at Croke Park during a game between Dublin and Tipp organised in aid of the Republican Prisoners Dependents Fund. Eyewitness accounts say an aeroplane circled above the ground a few minutes after throw-in and released a red flare as a signal to ground forces to commence an attack. British Army troops stormed the ground and opened fire, killing 14 people in total, including one player, Michael Hogan. The Hogan Stand where the Sam Maguire and Liam McCarthy trophies are presented after All-Ireland finals is named in Michael Hogan's memory.

In 2020, the GAA marked the centenary of the shootings with a series of special events before, during and after games, including the final itself. The Covid-19 restrictions meant supporters could not attend any games that year. The empty terraces, with flames burning brightly at the location of the shootings in memory of the dead, appeared even more poignant. Author and *Irish Times* journalist Michael Foley has written extensively and excellently about the stories of the individuals lost on what became known as Bloody Sunday. On 21 November 1920, Croke Park was a place where the impact of military politics on sport became explicit and lasting. While Michael Hogan's name was best remembered for years after the event, the other victims were less so. In recent years with the publication of Foley's *The Bloodied Field*, an account of the context and consequences of the shootings, the names, families and backgrounds of the other victims were officially recognised and remembered.

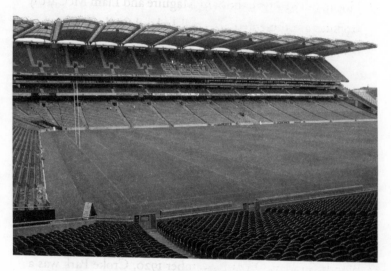

The Hogan stand

For some reason, eight of the fourteen killed were buried in unmarked graves and the GAA weren't sure how to deal with the issue correctly. Foley, who serves on the GAA's History Committee, has gone to great lengths to research the family histories, birthplaces and living relatives of those killed as part of the commemorative process. Books, events, ceremonies, podcasts, documentaries and plays now serve to shed light on a dark day and allow families closure and comfort. The full list of those killed is as follows: James Burke, James Matthews, Jane Boyle, Daniel Carroll, Michael Feery, Michael Hogan, Tom Hogan, Tom Ryan, Patrick O'Dowd, Perry Robinson, Jerome O'Leary, John William Scott, James Teehan and Joseph Traynor.

Football boots and a suit

Tipperary were also one of the first counties to embark on post-season trips to the US for exhibition games. As All-Ireland champions, they were invited by Chicago-based, Tipperary-born barrister PJ Cahill, to come over and represent Irish culture to the immigrant community. According to an *Irish Times* article by Mark Duncan in 2016, amongst the instructions sent before departure was to train earnestly and pack appropriately. Four hurleys each, training gear, football boots and a suit were advised.

After ten days on board a ship, the party arrived in New York City harbour in the early hours of 20 May 1926 on a mission to spread the gospel of the GAA across the US. These tours were often convenient for political lobbying and

military fundraising by some teams, though this doesn't seem to have been the case with Tipperary. Records show they played a series of games across the States and were met with fanfare by ex-pats and dignitaries alike. The tradition of GAA teams visiting the States to promote the game and sometimes raise funds still holds today. New York, in particular, is a place with a strong history of GAA participation. Those who left Ireland to make a future over there were often imbued with an even stronger nationalistic streak and republican ideals which made their passion for Gaelic games even more fierce. Politics, military, emigration and sport are close cousins.

Military maps are a source of design inspiration, information and reference for Keohane Athletic Club – not just in terms of commemorating place but also in terms of shape. Parishes, towns, counties, cities, and country borders all carry shape. People can identify with their county on a map, recognising its shape and visual identity, but less so with our local towns and parishes. How many of us would recognise the outline or shape of our own local area on a map? How many times have you referenced a map to remind you of where a certain place is in the world? How many times have you been lost? How many times has a map reminded you of a memory?

Place is commemorated on maps, bringing meaning and identity to communities, reminding us of who we are, where we come from and what we stand for.

The print

The PLACES camouflage print comprised military maps of Ireland, Munster, Kerry and Tralee town. It is designed to unify divisions and commemorate the service given to county and country by players from all sides.

Acknowledgements

Ten years ago, I set out to create stories through clothes and then write a book on the stories told. Nearly twenty collections later, here is that book.

Self-esteem, words, clothes, shoes, man. Man, shoes, clothes, words, self-esteem. These concepts are intrinsically threaded. The way I see it, these threads make the man and the fabric we call culture. With the help of a cultural institution like Dunnes Stores, and with this book, these words, these stories, these clothes, I want to create a healthier culture for Irishmen: a more breathable fabric than the one I encountered when I started in the creative industry. I want to contribute to a culture in which young Irish men can find their self-esteem, use their words, wear their clothes, walk taller in their shoes and become men.

Thank you to those who have made this work possible: to all the team at Dunnes Stores, from the front desk to the buyers, designers, marketing, studio store staff and shareholders.

And to all those who have helped me along the way, thank you.

Photo Credits

For permission to reproduce photographs, the author and publisher gratefully acknowledge the following:

© Alamy Stock Photo: 187, 249; © Allan Cash Picture Library/Alamy Stock Photo: 143, 163; © ANL/Shutterstock: 195; © AP/Shutterstock: 127; © Biblioteca Virtual de Defensa/Wikimedia Commons: 87; © Bob Thomas Sports Photography/Getty Images: 254; © Brian Shuel/Redferns/Getty Images: 163; © DeAgostini/Getty Images: 243T; © Dino Panato/Getty Images: 236; © DMc Photography/Alamy Stock Photo: 93; Courtesy of Eddie Dawson: 42, 46, 54; © Edward Olive/Shutterstock: 26; © GAB Archive/Redferns/Getty Images: 169, 172; © Greg Vaughn/Alamy Stock Photo: 174; © Giles W Bennett/Alamy Stock Photo: 201; © Gisele Freund/Photo Researchers History/Getty Images: 58; © Hugo Pfeiffer/Icon Sport via Getty Images: 206; © Hulton Archive/Getty Images: 280; © Ian Dryden/Shutterstock: 62; © Independent News And Media/Getty Images: 228; © INPHO: 7; © iStock/Getty Premium: vi, 38, 118, 129, 156, 191, 192, 220, 288, 272, 292, 302; © James Crombie/INPHO: 30; © Jean Paul Thomas/Icon Sport via Getty Images: 213; © Joe Amon/The Denver Post via Getty Image: 318; © John Locher/AP/Shutterstock: 125; © Kambiz Pourghanad/Shutterstock: 229; © Ken Sutton/INPHO: 5; © Kraddy/Shutterstock: 26; © Landmark Media/Alamy Stock Photo: 106; © Lars Baron/Bongarts/Getty Images: 90; Courtesy of Manel Tomas Belenguer/FC Barcelona Museum/ The Patrick O'Connell Memorial Fund: 71; © Matt Winkelmeyer/Getty Images: 13; © Megapixel/Shutterstock: 69; © Michael Regan/Getty Images: 79; © Miguel Mendez/Wikimedia Commons: 314; © Nationalmuseet/Wikimedia Commons: 147; © National Library of Ireland: 233; © National Museum of Ireland: 154; © Niall F/Shutterstock: 243B; © Olliebailie/Wikimedia Commons: 339; © PA Images/Alamy Stock Photo: 308B; © PASCAL GUYOT/AFP via Getty Images: 211; © Photolink/Alamy Stock Photo: 67; © Roger Viollet/Getty Images: 68; © Ron Reiring/Wikimedia Commons: 308T; © Seán Sexton/Getty Images: 260; © Smith Archive/Alamy Stock Photo: 265, 281; © TCD/Prod.DB /Alamy Stock Photo: 117; Courtesy of Terrace Talk Website: 296; © The History Collection/Alamy Stock Photo: 34, 112; © Wikimedia Commons: 136, 181, 183, 278, 294, 300, 325; © World History Archive/Alamy Stock Photo: 94, 101.

The authors and publisher have made every effort to trace all copyright holders, but if any have been inadvertently overlooked we would be pleased to make the necessary arrangement at the first opportunity.